Understanding Cultural Taste

Understanding Cultural Taste

Sensation, Skill and Sensibility

David Wright
University of Warwick, UK

First published 2015 by
PALGRAVE MACMILLAN

Palgrave Macmillan in the UK is an imprint of Macmillan Publishers Limited, registered in England, company number 785998, of Houndmills, Basingstoke, Hampshire RG21 6XS.

Palgrave Macmillan in the US is a division of St Martin's Press LLC, 175 Fifth Avenue, New York, NY 10010.

Palgrave Macmillan is the global academic imprint of the above companies and has companies and representatives throughout the world.

Palgrave® and Macmillan® are registered trademarks in the United States, the United Kingdom, Europe and other countries.

ISBN 978–1–137–44706–7

This book is printed on paper suitable for recycling and made from fully managed and sustained forest sources. Logging, pulping and manufacturing processes are expected to conform to the environmental regulations of the country of origin.

A catalogue record for this book is available from the British Library.

A catalog record for this book is available from the Library of Congress.

Contents

Figures

Acknowledgements

The first part of this book was written during a term of study leave from the Centre for Cultural Policy Studies at the University of Warwick, UK, in the spring of 2014. I'm grateful to colleagues there for supporting this, and especially to Clive Gray and Jerry Ahearne who both offered helpful comments and advice on the book proposal. Some chapters have been aired in seminars at the centre, and I extend my thanks to students on the Global Audience and Research Methods in the Cultural Sector modules over the last few years for indulging this, even if it was marginal to their interests. 'Producing Tastes' (Chapter 5) was aired both in a brown-bag research seminar at the centre and in a seminar at a meeting of the Cultural Distinctions Generation and Change research team in Madrid in November 2013. I'm grateful to Semi Purhonen of the University of Tampere, Finland, and the rest of that team for the invitation and their hospitality. 'Globalizing Tastes' (Chapter 4) was also informed by work with Semi Purhonen and Riie Heikkilä of the University of Helsinki, Finland, on a British Academy project entitled 'Comparing Cultural Capital in the UK and Finland'. 'Digitalizing Tastes' (Chapter 6) was presented at the event Cultural Participation in the Twenty-First Century in January 2015, which was organized by Simone Varriale and the Institute for Advance Study at the University of Warwick. My thanks go to all of the participants of these events for their comments, suggestions and questions.

A significant intellectual impetus for this work was my experience as a research fellow based at the Open University in Milton Keynes, UK, and in collaboration with colleagues from Manchester University, UK, while working on an empirical study of British tastes, which was published as *Culture Class Distinction* (Bennett et al., 2009). I'm grateful to the members of that team – Tony Bennett, Modesto Gayo, Mike Savage, Elizabeth Silva and Alan Warde – and the associated fellow travellers with whom the work brought me into contact, for their continuing companionship and inspiration.

I was especially pleased to receive permissions from Andrew Birch to reproduce the cartoon in 'Measuring Taste' (Chapter 2), from Taylor and Francis and Harvard University Press to reprint the image from *Distinction* in the same chapter, and from Grayson Perry, the Victoria Miro Gallery, London, and the Dakis Joannou Collection, Athens, Greece,

to reproduce the image of *The Lovely Consensus* in 'Producing Tastes' (Chapter 5).

Chapter 5 will outline my belief in the significance of various support workers to cultural work. This is doubly the case for academic work, so my thanks go to Felicity Plester for taking the time for an initial conversation, and to the editorial and copy-editing team at Palgrave for their assistance *en route*. A close reading of that chapter might also suggest some insincerity in my expression of the traditional authorial disclaimer about mistakes, but they are certainly all my own.

Finally, thanks to my partner in life, and companion in tasting, Alison. This book is for her most of all.

Introducing Taste

What does it mean to be a person of good taste in the early twenty-first century? How does one become one, and why should one bother? This book is an attempt to explore what is still at stake in these questions and to consider why cultural taste remains a matter of concern for both social life and academic scholarship. It should be made clear at the outset that the book does not claim to act as any kind of manual or guide to good taste. Such manuals, and their early twenty-first century equivalents, remain a lucrative genre for popular publishing, and experts in tastes – in food, wine or home decoration – are a significant feature of television schedules. Various other professional critics and guides steer us, on a daily basis, through the complex minefield of contemporary culture in which, in the arts, music, literature and film, notions of *good* or *bad* are not simply, as they might have been a century ago, categories in the bestowal of academic authorities but also strategies in the quick-moving worlds of fashion and 'cool'. Like everyone else in the early twenty-first century global North, I try, but repeatedly fail, to navigate myself in relation to these material and social pressures and call on these various forms of trusted authority so to do. The motivation for this book is, in this light, an abiding perplexity with the persistence of the importance of taste to both participating in and understanding social and cultural life. This perplexity involves curiosity not only about what is going on when experts make their pronouncements about the relative value of the objects under their consideration, but also about what the people who receive or take this advice are hoping to achieve by doing so. Such interactions are the very stuff of contemporary *consumer society*, and the prevalence of public debate, discussion and anxiety about these kinds of choices might indeed reflect the further cementing of the latest version of this form of social organization. A host of academic

disciplines and forms of knowledge of various degrees of abstraction or practical application have developed to account for and understand this kind of society, and this book aims to make a contribution to these ongoing debates with an emphasis on those accounts which have emerged from sociology. The focus on *taste* as the book's organizing concept, though, is a deliberate one, with two starting assumptions.

First is the observation that the use of 'taste' as a synonym for consumer choice and preference denies some important complexities in that concept which are worth preserving and foregrounding in the ongoing analysis of contemporary societies. The historical relationship between taste, the senses and morality has established, over centuries, the idea that good taste is a valuable thing to attain and train in others, rather than simply a form of well-conducted consumerist expertise. As significantly, this relationship has allowed bad taste to retain a set of social and political connotations which extend beyond flawed or irrational choices and into a still socially acceptable form of pathologizing prejudice about marginal groups. It is, in the early twenty-first century in the tolerant liberal democracies of the global North, thankfully, no longer acceptable – at least officially – to belittle someone on the basis of their gender, skin colour or sexuality. Pronouncements about taste, though – especially exemplified by the othering of the behaviours and pastimes of the working class – remain relatively fair game. The formation of tastes, the acquiring of good taste and the judgement of bad taste have been – and might well remain – processes through which idealized versions of the person are imagined, through which people are trained for social life and through which identities are formed. So what kinds of people might be being *formed* by contemporary processes of taste and tasting, what kinds of people might be being *imagined* by contemporary practices of the classification of people through their tastes and what is at stake in these processes?

The second assumption follows from this – that taste reveals an important tension in consumer societies. The repeated assertion that debatable questions of quality, choice or preference are 'just a matter of personal taste' also seems to cement a relationship between taste and the individual consumer, with all of the semantic imaginaries that are attached to that version of the person in that version of society. At the same time, though, work in the sociological tradition and the empirical research and tacit professional judgements of professionals in the cultural industries have, in various ways, established that taste is also *socially* patterned. This is in itself a powerful challenge to the myth of consumer societies in which our choices and preferences are idealized

as part of a contemporary form of agency. Released from the assumed constraints on identity of the pre-consumerist past, we are free to craft ourselves by our skilful manipulation of consumer goods with various degrees of symbolic or semiotic forms of meaning so that who we are is shaped by what we like. A focus on taste, and its social patterning, leads to a different and less comfortable assumption – that what we *like* is shaped by who we *are* and by what powerful symbolic producers assume us to be, even if we feel little affinity with the categories in which we might be placed, or even resent the idea of being categorized at all. How can these patterns and classifications, as they are revealed through cultural tastes, survive the liberating power of consumer society?

There are two further imperatives that are relevant to a reflection on these issues at this point in time. The first concerns the central sociological contribution to the debates about taste – Pierre Bourdieu's *Distinction* (1984) – which has now helped to frame the terms of this debate for four decades. Coming across this work as a first-generation university student of cultural studies from a provincial outpost of the north west of the UK (and sadly even a 50-minute bus ride from either of the great cities of that most creative and energetic of the UK's cultural crucibles) helped me to understand both an initial discomfort and an eventual accommodation with the game of culture as it is played through the exhibition and performance of tastes. An ongoing critical dialogue with this complex work underpins this book, and the subsequent chapters will outline its continued importance. Despite this significance, it is timely to reflect upon the standing of Bourdieu's insight now that it can no longer claim to be an insurgent challenge to orthodoxy so much as emblematic of a kind of orthodoxy itself. Within sociological accounts of taste, Bourdieu, reduced to a kind of intense essence, is used as shorthand for social struggle, or for the synonymous – homologous, in the terms of the debate – relationship between cultural and social hierarchies. This remains a powerful contribution, and indeed a persistent relationship, but as a single lens through which to look at taste today it is limiting. Partly this reflects its success, such that 30 years of teaching of the perspective in the social sciences and humanities, and its subsequent take-up by policy-makers or even cultural producers keen to resolve, subvert or challenge the homology has made the role of tastes in social struggle a kind of received wisdom, at least for those of us 'in the know'. We *know* that our tastes are implicated in such struggles, so expressions of tastes for what we know to be tasteless have, paradoxically, *less* social risk, and indeed can be interpreted as a strategic play in those struggles. As Nicholas Dames has evocatively described

it in the post-*Distinction* world of tasting, confessions of bad taste – at least among the urbane, educated middle classes – are 'closer to the half-ashamed pleasure of being able to furnish the authorities with the proper identity papers' (Dames, 2009). We might recognize the power of these authorities, but we also suspect that they are elitist, exclusionary, corrupt, morally bankrupt and lacking in legitimacy. We can move on. Not everyone can of course – and the recognition that the nature of homology has changed does not equate to claims for classlessness, or denial about the deepening inequalities of contemporary societies, but recognizes that the role of taste in relation to inequalities is altered by these kinds of reflexive awareness. More than this, though, it reflects the fact that sociology and indeed its attendant disciplines with an interest in questions of culture, including media and cultural studies, have also moved on to continue to capture the complexity and dynamism of social life and the role of culture within it, and to provide useful tools and concepts with which to reconsider and reformulate questions of taste.

The second point relates to this and concerns the various forms of flux which the complexity and dynamism of social life have generated to challenge and encourage reflection on the orthodoxies of taste. From among these forms of flux I have selected six dimensions – the theoretical, the methodological, the political or governmental, the global, the industrial and the digital – and suggest that changes to each of these need to be taken account of both in scholarly understanding of tastes and tasting and in making sense of the continued importance of questions of taste to contemporary social life. This means that the fundamental social dimensions – of class, gender, ethnicity and age – are not the object of my analysis although each, in different ways and in different instances, shows up in the subsequent discussion. These choices – and indeed the qualification of *cultural* taste that is understood as the taste for cultural goods rather than for food – are partly an attempt to put some manageable, if semiporous, boundaries around the analysis. This reflects the experience that a discussion of tastes can – like all good, meaty sociological concepts – quite quickly extend to be a discussion of *everything*. My claim is not that these chosen dimensions explain the shape of contemporary taste in its totality, but that some focused attention on each of them in turn is helpful to understanding its complexity. As I hope the discussion shows, each of these dimensions has been the subject of important reflection in isolation. The attempt to bring the insights of these reflections together and identify links but also tensions between them illustrates an abiding belief that a wider sociological lens

is needed to capture all of the features of the contemporary landscape of tastes and tasting.

In approaching these dimensions I draw on three concepts which again help to define and refine my interests. These are concepts which underpin and help give some supporting structure to the dimensions in that they are present in relation to each of them and provide the means through which the links across and between them can be made sense of. They also put some boundaries around the concept of taste, which can itself be variously defined as a characteristic which individuals possess, a property that is inherent in certain objects but absent from others, or indeed a process or social practice. For my purposes, then, taste is understood as primarily relating to questions of *sensation, skill* and *sensibility*.

The term 'taste' describes a *sense* which, along with sight, hearing, smell and touch, operates as the primary tool through which an individual apprehends the material world. It is also a *sensibility* – an orientation towards and away from the things and, importantly, people in that world. Finally, taste has become conceptualized as a *skill* – a capacity that can be cultivated as people learn how to make judgements and choices within and between these things and people. The coexistence of these three meanings allows taste to mediate between the individual and the social, between the biological or physiological and the symbolic and, ultimately, between the natural and the cultural. Concepts which bridge these kinds of binary divides are especially powerful in placing the world into useful and meaningful categories (Douglas, 1966, Levi-Strauss, 1983). In relation to taste, there is a journey of categorization that begins from what does or does not feel pleasant in the mouth, and moves towards what does or does not look, sound or smell attractive to the other sensory organs. This move is overlain in everyday social life and language with questions of aesthetics and with judgements of quality as related to works of art, literature and decorative or symbolic goods. We'll consider these in subsequent discussions, but a further move in the journey of the categorization of taste is towards or away from the tastes of, and by extension the bodies of, others. Such questions about the attractive or divisive aspects of *cultural* taste might seem of a different order to the reactions of membranes in the mouth, eyes or ears, but they are conceptually and etymologically linked to the first physiological move. Some awareness of and attention to the social and cultural history of tastes and tasting, and some reflection on how the sensory apprehension of the world is overlain with social histories and processes, are essential to an understanding of how this move is achieved. Just as,

as Bourdieu suggests, 'the eye is a product of history' (Bourdieu, 1984: 3), so are the taste buds. The individual experience of categories such as sweet, sour and bitter are filtered through the social and historical contexts in which they occur and inform subsequent forms of categorizing. The sensory experience of the world may be biological in its origin but the naming of that experience and the general purchase of that naming beyond an individual nervous system and into a wider societal context requires more than the senses. It requires the *skill* to differentiate good from bad and, in the context of the social life of tasting, it requires the *sensibility* to judge the consequences of these good or bad judgments of taste, whether real or imagined, for oneself and for others. Through the intersections of sensation, skill and sensibility, a recurring theme of this book will be that taste is implicated in both how we understand and appreciate our experiences of the world, and how we live together in it.

The book proceeds, then, by addressing in turn how tastes have been, and are, *theorized, measured, governed, globalized, produced* and *digitalized*. The first two chapters aim to set out what might be understood as the problem of taste. Chapter 1 aims to summarize and critique some key theoretical perspectives on taste. It is organized around a central engagement with the work of Bourdieu, prefaced by some reflection on scholarly accounts that preceded, and partly inspired and provided, a context for his intervention. This includes some summary discussion of how sociology, in the process of its formation as a discipline, and before this how philosophy, and in particular debates about aesthetics, came to mark the relations between taste and social life in modern societies. It tries too to place Bourdieu in a mid-twentieth-century context in which mass culture was changing the nature of the *problem* of taste. Subsequent discussion, emerging from the critique of Bourdieu from within the French academy, from the cultural studies tradition and, most recently from the rediscovery of sensory affective bases for theoretical work, asks important questions about taste and its continued role in social life.

Chapter 2 moves on to consider how taste has been, and continues to be, constructed as a problem of identification and measurement and made *knowable* by various research techniques. In part this is an attempt to place the problem of taste within the great epistemological and ontological debates of the social sciences (what kind of *stuff* is taste anyway?) and within the perhaps less great skirmishes between the quantitative, qualitative, empirical and interpretivist traditions of social and cultural inquiry (once we know what it is, how do we measure or understand it?). Here again there is some summary and critique of *Distinction* as

the exemplar of methodological complexity in relation to the empirical exploration of taste, as well as some reflections on the contributions of subsequent scholars, most notably Richard A. Peterson and his various co-writers and researchers, who, through the development of the concept of the 'cultural omnivore', have done most to keep alive the idea that the *empirical* problem of taste is one that is worth attempting to solve. Here accounts are also settled with debates about the apparent limits of the established sociological toolkit in the light of emergent ways of knowing taste from both commercial interests and increasingly influential methodological visions emerging from the natural sciences. In this light the chapter suggests that the apparently flawed vision of the person who emerges from sociological understanding is still one worth our attention.

Subsequent chapters build on these theoretical and methodological dimensions of the problem of taste. Chapter 3 considers the extent to which the production and management of taste has been a problem for states and policy-makers. Here the discussion centres on the reasons why tastes – interpreted in relation to choices and preferences in both national canons of art and literature, and between the manifold leisure pursuits and distractions of contemporary life – have come under the lens of governments as an issue for policy. The example of literacy and literary taste, their relations to the training of the senses, skill and sensibility, and to the ways in which the good and useful citizen has been and continues to be imagined by policy-makers, provides some empirical ground for this reflection. Chapter 4 brings a spatial dimension to the understanding of taste by considering how the processes of globalization have transformed, and continue to transform, our experience and understanding of taste. This entails reflections on the methodological nationalism of the empirical study of taste in a context in which the nation is an increasingly inadequate and porous container for the things which circulate to be tasted and for the people who taste them. This movement of things and people also has an *infrastructure*, and this chapter reflects on the relations between the possibility of a global taste culture and the global cultural industries which feed it. Given the skills and sensibilities that are needed to live in and with this complex global world of taste, the chapter concludes with a reflection on the cosmopolitan as a type of person who is imagined to thrive within it – and the hopes and limitations of that imaginary.

The final two chapters reflect on other infrastructural dimensions. First, in Chapter 5, the concern is with how tastes are produced and managed by the structures and techniques of the cultural industries. The

'production of culture' perspective that emerges from US cultural sociology is reviewed here to examine the importance of cultural workers whose skills and sensibilities make them specialists in taste with varying degrees of status and standing. These insights feed into a subsequent discussion of the strategies of evaluation employed by producers and consumers in choosing between what is good or bad, and the forms of management and regulation of cultural choices that are generated and utilized by the cultural industries. Whether through the pronouncements of expert knowledge, the celebration of quality through prizes or the appearance of apparently objective rankings, these strategies of evaluation of taste share important characteristics with – and indeed might provide models for – strategies in the wider social world. Chapter 6 brings this concern with the wider relevance of taste to social life to a consideration of the relations between the modes of cultural production, circulation and distribution of cultural goods that are wrought by new technologies. These new modes are understood as facilitating a new kind of cultural abundance, and an accompanying new version of intellectual anxiety about how to cope with abundance. They have also generated new modes of managing abundance, exemplified by the algorithmically organized modes of recommendation and circulation that have been developed and operated by powerful players in the cultural industries. Moreover, such technologies attempt to capture the affective, sensory aspects of tasting and transform the act of *liking* such that taste becomes even more loaded in contemporary strategies of measuring and managing social life.

In approaching this most contemporary manifestation of the problem of taste, and those that precede it, I want to take some furtive glances back to the established tradition of sociological work, and to keep in mind that taste is a concept with an in-built historical dimension, that is associated with longer narratives about people and their formation. Theory is really the best tool to allow us to generalize across time and space, so it is with concerted attention to that dimension of taste that I will begin the discussion.

1
Theorizing Taste

This chapter sets out to provide a summary and critique of the foundations of the theoretical problem of taste. It has a central preoccupation with the *sociology* of taste, but arriving at this requires reflection on accounts of taste which pre-date the establishment of a coherent discipline of sociology, including philosophical and historical accounts of the role for taste in abiding questions for the social sciences in the Western, European tradition. In attempting to reassert the utility of a sociological understanding of taste for contemporary and future scholarship, the chapter also engages with accounts which problematize and trouble the coherence of what has become the dominant sociological account of the relationship between taste and social life. The aim here is two-fold: first to lay out how taste has emerged as a subject for sociological study and to indicate the kinds of question that scholars of taste have been concerned with; and second to suggest which of these questions might still be worth asking as part of the ongoing project of understanding the role of taste in contemporary social life.

The chapter proceeds with reflection on the problem of taste in relation to the sensory responses of the human body and, subsequently, in the attribution of cultural, artistic or aesthetic worth. This shift is achieved as a consequence of how concerns with taste have been framed historically, in relation to philosophical questions about the formation of people and societies in Western Europe. Such reflections provide the background to the entrance of sociology and for consideration of how taste can be understood as an exemplary *sociological* problem, mediating between the personal and the social in modern, urban, market-oriented life. This discussion also prepares the ground for the entrance of Pierre Bourdieu and *Distinction*, the work which looms large over the study of taste and which will be a touchstone for each of

the subsequent dimensions of taste discussed in this book. This chapter lays out three central aspects to Bourdieu's contribution: the specific engagement with the Kantian version of sensory aesthetic experiences; the 'conceptual triumvirate' of *capital, habitus* and *field*, which have been Bourdieu's most abiding contribution to the sociological toolkit; and finally the central question of the relationship between taste and social class which has done considerable work in shifting our understanding of the role and consequences of class as a cultural as well as an economic category. These are sketched outlines here, to be filled and revisited in subsequent discussion. The chapter moves on to consider some challenges to Bourdieu, principally from the philosopher Jacques Rancière's reassertion of the politically progressive possibilities of an aesthetic engagement with the world and, by extension, the possibility it suggests of an egalitarian, rather than hierarchical, conception of taste.

Refining taste: From the natural to the cultural

One central difficulty that this book seeks to address is the very fluidity of the concept of taste which allows discussions of taste to become, very quickly, discussions of cultural and social life in general. We might start by discussing *taste*, and end up by considering how taste infiltrates discussion of a range of social, political, artistic, cultural and even economic topics, discussing *everything*. The actual experiences of taste and tasting can fall away in this move. Retaining and foregrounding this experiential aspect of taste as a useful analytic category in itself requires some refining of the terms of the debate. All analytic procedures should begin with a consideration of the terms they use – and the polysemous nature of the words and concepts that are conjured up by the term 'taste' make this an especially important starting point for this endeavour.

Bourdieu's magisterial empirical exploration of taste begins with a clear assertion that any sociological understanding of the role of taste in social life needs to consider how 'the elaborated tastes for the most refined objects is re-connected with the elementary taste for the flavours of food' (Bourdieu, 1984: 1). He goes on to explain how the words we use to describe phenomena act as 'programmes for perception' (Bourdieu, 1984: 3), giving energy and impetus to the social meanings of their application. This shaping of the social meanings of the very sensations in our mouths can also be demonstrated powerfully through consideration of a conceptual fellow traveller of the concept of taste, the notion of *disgust*.

Miller (1997) opens his discussion of the social and psychological history of disgust with some reflection on Darwin's account of the relation between the sense of taste and disgust, suggesting, through his observation of the reaction of a 'native' of Tierra Del Fuego to the soft touch of a piece of cold meat, that there is 'a strong association in our minds between the sight of food, however circumstanced, and the idea of eating it' (Darwin, quoted in Miller, 1997: 1). This association is partly a function of the Anglophone etymology of taste in which, for Miller, 'taste is made to stand as a metonym for the fact that disgust is often indicated by facial expressions and interjections that denote spitting, vomiting or rejecting contaminants that have gotten past the lips' (Miller, 1997: 85). The linguistic association of the sense of taste with disgust allows all forms of negative sensory reactions to be reviled as *dis*tasteful and disgusting. Disgust here can be understood as an evolutionarily valuable response for keeping poisonous or harmful substances out of our bodies. It becomes, as a result, a powerful, biologically based, mode of classification of what is good and what is not that feeds through into other forms of classification. As interesting, though, is the change in the historical lexicon that Miller, who is suspicious of such purely biological understandings of disgust, describes. What counts as disgusting is not simply a constant or reflex response to external stimuli but shifts over time. In the time of Shakespeare, for example, it was not foul tastes that were disgusting but the excesses of oral sensual pleasures that might accompany *too good* a taste. The label of disgust was attached, in the European tradition, to the sensory sins of the flesh – with gluttony and with lust. The meaning of the word 'taste' in relation to a 'newly recognized capacity for refinement' (Miller, 1997: 169) emerged in the seventeenth century, at the same time as the meaning of the word disgust assumed its more contemporary meaning. The emergence of a cultural category of good taste as the operation of *restraint* accompanied the shift in meaning of disgust more exclusively towards the foul or distasteful. Examining historical processes that underpin the shift can indicate how the concepts of taste and disgust have become complicit in the management of both personal behaviour and social life across time.

The most comprehensive attempt to chart these processes in Western Europe is provided by Norbert Elias's *The Civilizing Process*. First published in 1939, this work represents an exemplary piece of historical sociology that charts the relationships between the rise of the institutions and practices of the modern social world and the shifts in the public management of various forms of biological process, including eating, sleeping, sex and the technologies and rituals of defecation. Elias

reminds us that modern questions of taste are not just questions of aesthetics or indeed questions of choice or preference. These dimensions of taste are always bound up with rules of *conduct*, which identify and demarcate the acceptable management of the body and the persistent difficulties and tensions of living with other people and their bodies. The establishment of such norms of conduct as taken for granted has taken centuries and cannot be understood at the level of individual sensory responses alone. The 'sociogenetic' process of the development of what we now recognize as 'civilization', beginning in the Middle Ages, can be crudely summarized as one of 'segregation', and 'the hiding "behind the scenes" of what has become distasteful' (Elias, 1994: 99) and the development of taboos which 'are nothing other than ritualized or institutionalized feelings of displeasure, distaste, disgust, fear or shame, feelings which have been nurtured under quite specific conditions' (Elias, 1994: 104).

There are, from the position of the twenty-first century, commonsensical explanations for these developments which relate them to the developing human understanding of the relations between hygiene, germs and illnesses. Such a belief is strengthened by the relation between processes of bodily training that are evident in contemporary society and the important work of socializing children into the world of adults, often accompanied and justified through admonishments about what kinds of behaviour are 'good for you' and why. As Elias explains,

> much of what we call 'morality' or 'moral' reasons has the same function as 'hygiene' or hygienic reasons': to condition children to a certain social standard. Moulding by such means aims at making socially desirable behaviour automatic, a matter of self-control, causing it to appear in the consciousness of the individual as a result of his own free will, and in the interests of his own health or human dignity.
>
> (Elias, 1994: 123)

The self-evidence of contemporary rules of conduct about eating or defecation belies, for Elias, the processes underpinning their establishment as taken for granted, which have been as much to do with broader historical changes in how society is ordered and how people have managed the difficult processes of living together. We might see a 'hygienic' relationship surrounding, for example, rules pertaining to the expulsion of spit or sputum from the mouth. However, for Elias, such rules are better understood as a result of changing norms of conduct which *precede* the

widespread knowledge of any relationship between saliva and the trans-
formation of germs – that is, *before* there was knowledge that germs
even existed. Instead, 'what first arouses and increases the distasteful
feelings and restrictions', he suggests, 'is a transformation of human
relationships and dependencies' (Elias, 1994: 130).

In early modern Europe, these transformations included the chang-
ing relationships of power between the royal courts and the emerging
professional intelligentsia – relationships that were experienced differ-
ently in Elias's account in France, Germany and Italy. These changes
are accompanied by the development of a material infrastructure for
the management of the body (e.g. the handkerchief), or for conduct
at mealtimes (e.g. the plate or cutlery). These have become taken for
granted aspects of human social life in Western Europe but were the
product of struggle, and uneven and contested processes of change. Elias
describes how, in the eleventh century a Venetian dogaress is rebuked
by ecclesiastics for using a fork to eat her food as an 'excessive sign
of refinement' that offended God (Elias, 1994: 55). The emergence of
these infrastructures of conduct were also signs of wealth and power,
and their spread an indication of the slow processes of the more general
acceptance of norms of behaviour within a population. Elias analogizes
these processes with the accretion of particles onto a central body that
takes place in the development of a crystal. The handkerchief emerged
in Renaissance Italy and France, for example, and was precisely a symbol
of wealth and prestige. A courtly inventory of the possessions of Henry
IV of France (1589–1610) reveals that he owned only five; by the time of
Louis XIV there were too many to count (1643–1710); and, of course, in
the contemporary period they are, like the most self-evident elements of
any social infrastructure, disposable and abundant enough to be almost
invisible.

There were at least two impetuses to these changes which are useful
in shaping a contemporary theory of taste. First was the establishment
of rules and norms of behaviour through which royal courts could
emphasize their *difference* from other sorts of people – albeit that these
differences could subsequently be imitated and the conduct itself could
spread through aspirant individuals and groups. Elias's analysis is itself
largely based on instruction manuals in conduct and etiquette which
aim precisely to foment this kind of imitation; as one suggests from the
sixteenth century when eating, 'in good society one does not put both
hands into the dish. It is most refined to use only three fingers of the
hand. This is one of the marks of distinction between upper and lower
classes' (Elias, 1994: 46). Second, these norms of conduct established the

symbolic means through which relationships of respect *between* strata of society were conducted. There are, as Elias has it, 'people before whom one is ashamed, and others before whom one is not' (Elias, 1994: 113). He explores this with an example from a sixteenth-century Italian instruction that the

> members of the human body should be covered except in the presence of people before whom one is not ashamed: 'It is true that a great lord might do so before his servants or in the presence of a friend of lower rank; for in this he would not show him arrogance but rather a particular affection or friendship.'
>
> (Elias, 1994: 113)

Such an emphasis on the management of the body and its relation to social hierarchy and rank, and of the establishment of norms of refinement between status groups, serves to indicate the extent to which questions of taste move from the biological to the cultural. Such examples imply that approaches to taste, and especially to notions of good and bad taste, need to take account of the social and historical contexts of tasting, and pay attention to the ways in which questions of taste have been, and remain, bound up with processes of *categorization*, and with questions of *conduct* – and that both these elements are bound up with the structure of human relationships. These are both themes that are further explored in the following section.

Aesthetics and the senses

The previous section establishes two important elements of a theory of taste that help to underpin the argument in this book: first that the criteria of taste in relation to cultivation or refinement can be seen to shift historically; and second that taste is more than an individual sensory experience, albeit that sensory experiences still provide the language through which the forms of categorization and conduct attached to the concept of taste are articulated. In this section these elements are explored further in relation to the senses and *aesthetics*. This moves us, to the relief no doubt of some readers, away from questions of bodily management and disgust, and towards notions of *beauty*. Again this reflection is in a historical mode with engagement with the dominant philosophical figure in this debate, Immanuel Kant and his *Critique of Judgment* – a key work in the development of Western philosophy, in the establishment of aesthetics as a sub discipline and, as we shall see, the

key stepping-off point for more contemporary *sociological* engagements with the question of taste. Highmore (2010) explains how aesthetics emerged as a distinct area of study in the mid-eighteenth century as an attempt to bring the *sensory* and *affective* into philosophical study which had previously been largely focused on the *logical* and *rational* – and had thus seemed not to capture the total experience of human life. In this initial formulation, aesthetics 'is primarily concerned with material experiences, with the way in which the sensual world greets the sensate body, and with the affective forces that are generated in such meetings' (Highmore, 2010: 121). This has echoes of our earlier iterations of the significance of the senses in understanding taste, indicating the existence of a relationship, which became of critical interest to thinkers of the period, between what *feels* (tastes, smells or looks) good and what *is* good. More recently – and specifically since the intervention of Kant – aesthetics has been concerned less with judging whether the sensory experience of the world was good or not in a moral sense but in the detached identification and appreciation of what is *beautiful*.

Such a move also echoes the importance of sensory restraint as laid out by Elias in the development of modern societies. An experience of tasting is not necessarily judged to be *better* if it produces more or more intense sensory responses of a particular type. Indeed, in relation to some cultural artefacts – sentimental music, a melodramatic television drama or even a pornographic film – the deliberate attempt to stimulate or manipulate sensory responses is more likely to be judged *dis*tasteful to modern sensibilities. Kant's philosophical intervention provides some explanation of how this shift has been achieved. Crucial in it was the development of a distinction between *higher* and *lower* forms of apprehending the world – with lower forms being more connected with the senses and higher ones being within the realms of thought and reflection. This immediately sets up a distinction between thinking and non-thinking people, which, as we'll see, has both a longer philosophical history and a more contemporary application in debates about taste. For now, though, it is noteworthy that accompanying this distinction is another, shared by Kant and outlined in his writings on anthropology, between the higher and lower senses. Taste and smell are the *lower* senses. As Gronow describes (1997) in his discussion of the philosophical arguments surrounding the possibility of social forms being beautiful, these senses are essentially subjective, not least because they require immediate physical contact between an individual tasting or smelling subject with the things that they taste or smell. They therefore work against studied contemplation as opposed to immediate

sensation. The ear and most especially the eye, by contrast, allow distance from the object of interest and therefore are better suited to the kinds of contemplation which allow for the cultivation of higher forms of understanding.

While we might describe a meal or a perfume as 'beautiful', they cannot be beautiful in the same way as music (or perhaps a songbird) or art (or a landscape or sunset) can be. Indeed, strictly for Kant, it is unlikely that a taste or smell can be considered beautiful at all because of their association with the biological needs of the body for nourishment. Such apparent judgements of 'beauty' are better understood as descriptions of the sensations that accompany the feelings of approval of the particular phenomenon being judged or experienced. It is this distinction, laid out in the *Critique of Judgment*, which generates two types of judgement: of the agreeable and of 'pure beauty'. Both of these are *aesthetic* judgements in that they both pertain to the apprehension of an object through the (high or low) senses which was the concern of the developing science of aesthetics. It is the latter which is the closest to the contemporary meaning of aesthetics in relating to those characteristics of the form of an object which allow it to be judged as beautiful or not. Judgements of the agreeable, which might be referred to as 'beautiful' in everyday language, are really judgements of *sense*. Judgements of *pure* beauty are judgements of *taste* – that is, of a higher order than sense judgements alone.

Two components of this Kantian version of the judgement of pure beauty are important to the subsequent role for aesthetic judgement in the sociological discussion of taste. First such a judgement generates a feeling – of approval or pleasure – that is of a different order than judgements of sense which are agreeable (a nice taste on the tongue, for example, or the satisfaction from a nutritious meal) or indeed from judgements of the good (which are bound up with moral precepts about knowing and doing the right thing and the consequences stemming from this knowledge). It is a feeling of approval that is *disinterested* – that is, it does not relate to anything other than the contemplation of the thing itself – and not, for example, to how it was made or who made it. Second, given this disinterestedness and its removal of the concept of beauty from the subjective whims of human desire or interest, objects which are judged to be beautiful are beautiful for everyone. As Wicks describes it,

> since all modes of sensory gratification, along with utilitarian and moral interests, have been disconnected from judgments of pure

beauty, nothing related to the specific structures of one's taste buds, eyes, ears, nose and nerve-endings in general can enter constitutively into the satisfaction that grounds such judgments... for this reason [Kant] maintains that we can expect – or certainly begin to expect – every person to experience this feeling identically in relation to any beautiful object.

(Wicks, 2007: 30)

The judgement of beauty, then, does not relate to individual values or preferences but to a *sensus communis* or a common sense of the beautiful that constitutes a universal standard to which all people can assent. Beauty is part of a universally shared mode of awareness, which includes the shared experience of time or of space, through which we make sense of the world.

This conception of beauty, as it emerges from a philosophical and logical exploration of the sensory, has been a controversial starting point for the sociology of taste. Sociology as a discipline has taken up as one of its primary aims to probe and empirically examine the social patterning of apparently eternal categorical elements of human experience. The space between the ideal type of disinterested 'pure' judgement of beauty as it emerges from the thought experiment of the philosopher, and the forms of everyday judgements of things we like as beautiful or good, is precisely one that sociology can inhabit in exploring how and in what ways these judgements are 'interested' or not in Kant's terms. Similarly, the distinction between the lower sensory response to objects or phenomena and the higher studied contemplation of them implies questions about how phenomena and the sensory responses to them can be categorized. The following sections will begin to explore this tension in considering sociology's contribution to the understanding of taste.

Sociologies of taste

Taste is an exemplary *sociological* phenomenon which straddles the boundaries between the individual and society such that the immediate experience of the world is filtered through various social lenses. Tastes, while experienced subjectively at the level of the individual, can also be seen to have objectively social patterns which sociologists have sought to explore. The figure of Pierre Bourdieu is the central coordinating point of these explorations in this section. Bourdieu's work is contextualized first through some discussion of the place of taste in the general project of sociology as it emerged in the late nineteenth century,

and then through some reflection on the particular problem of cultural taste as it emerged in the mid-twentieth century.

Before Bourdieu

As Elias's account of the shifting norms of conduct in pre-modern societies demonstrated, one key focus for sociological inquiry is the deceptively simple question of how people live together. This focus becomes particularly keen at historical periods of significant change. It is perhaps no surprise, then, that the social sciences in general, and those thinkers who have done most to establish the discipline of sociology, emerged most forcefully in the mid- to late nineteenth century – a time in which the ways in which people lived together were altered by the establishment and spread of the transformative powers of the Industrial Revolution. These transformations included urbanization, the rise of specific and new kinds of mass workplace, new forms of social stratification emerging from intensifying relations between capital and labour and, following the political developments of the previous century, the spread of a public sphere which had begun to transform the operations of the state in Western Europe. It is clearly beyond the scope of this book to do adequate analytic justice to the complexity of these processes. A more modest and achievable endeavour is to suggest some of the ways in which questions of taste might be bound up with them, and also to indicate how questions of taste can be read into some attempts by foundational sociological thinkers to think through the implications of the emerging modern, urban, market-oriented life.

A general anxiety, shared by a range of thinkers at this period, is with the identification of the very texture of the social and its relation with the individual, based upon a largely imagined comparison with the pre-modern past. This is identified most strongly in the history of urban sociology with Tonnies' (2002) influential distinction between *gemeinshaft* – the kind of community characterized by deep forms of social bond often assumed to exist in rural, agrarian societies – and the *gesselschaft* of the modern, urban 'society', characterized by weaker social bonds. These different ways of living together are also at play in a key thinker with more direct relevance to the problem of taste as it has been conceptualized so far, Georg Simmel, whose concerns straddled the sociology of the senses and the emergence of the phenomenon of fashion in modern, urban society. Simmel prefigures Elias's analysis by seeing how the sensory experience of the world and the aesthetic judgement of it are intertwined through the phenomenon of taste. Returning

to the examples of food, for example, Frisby explains how Simmel's concern with the *aesthetics* of a meal also recognizes that food satisfies the basic biological needs of the body for nourishment. These two levels of experience coexist, and 'the higher level, which often seeks to affirm its independence, is still intimately connected to the lower level as it were. The aesthetic dimension and its elaboration hides the more basic organic dimension' (Frisby, 1997: 10). The sensory is especially important for Simmel as the means through which we identify and judge different intensities of experience or relationship with the external world – both its objects and its people. Such forms of judgement become more pressing in the context of modern urban life in which people who might historically have been separated were required to mix. He notes the consequences, for example, of the sensory interaction between 'higher strata' and those 'to whom the sweat of honest toil clings', and concludes that 'the social question is not only an ethical one, but also a question of smell' (Simmel, 1997a: 118).

The tacit sociological judgement of the nature of working-class life contained within this comment is a theme to which we will return, but the mixed social reality of modern urban life has further consequences for Simmel. First, it exacerbates the distinction between the sensory and the aesthetic. Modern life and the refinement of culture lead to a diminution of the 'perceptual acuity' of the senses but increase the social significance of liking and disliking. This is a consequence of what is identified as the individualizing tendency of modern life in which

> the person cannot immediately enter into traditional unions or close commitments in which no-one enquires into their personal taste or their personal sensibility. And this inevitably brings with it a greater isolation and a sharper circumscribing of the personal sphere.
>
> (Simmel, 1997a: 119)

Second, it places considerable emphasis on the means by which individuals can distinguish themselves from one another and claim what scholars of this period and since have insisted they need – a sense of personal identity or what might amount to the same thing, a sense of *distinction* to counter the modern urban sphere's mixing and blurring of statuses. As Simmel contends in his influential essay on fashion, 'the whole history of society is reflected in the conflict, the compromise, the reconciliations, slowly won and quickly lost, between adaptation to our social group and social elevation from it' (Simmel, 1997b: 187). The modern subject is, for him, under competing psychological pressures to

integrate themselves into the norms of the social group in which they are located, to help to police the boundaries of that group but also to preserve and maintain some form of coherent, individual, self. Fashion is a response to all of these pressures, operating 'the double function of holding a given circle together and, at the same time, closing it off for others' (Simmel, 1997b: 189). The desire to be fashionable is part of a desire for higher strata to distinguish themselves from those who share the urban space; fashions change as aspirational members of lower strata appropriate and adopt them, and consequently higher strata look elsewhere for new styles. This dynamism of fashion is felt more within the middle classes, who are both driven to aspire to the status of their betters and keen to maintain their superiority over their subordinates.

The role of taste in the psychology of late nineteenth-century modern subjects is also a concern for Thorstein Veblen (1899), who sees in the USA of a similar historical period a determining role for the choices of symbolic goods in social patterns. Veblen, strongly influenced by Darwinian thinking, conceptualizes social life in this period as a development from a predatory period of more brutal violent struggle, translated into a quasi-peaceful period of social struggle in which societies are stratified by their differential capacity and taste for leisure. The ability to consume things beyond the satisfaction of material needs, and the time to do more with one's life than simply work to reproduce it, have, for Veblen, been a feature of dominant social groups throughout human history. Unproductive leisure and the consumption of luxury goods have been restricted historically, through either law or convention, for the lower social orders. By the late nineteenth century the development of strategies for the public display of the consumption of luxuries – 'conspicuous consumption' as it came to be known – had become the principal means for the demonstration of pecuniary strength. In these conditions the 'gentleman of leisure' is 'no longer simply the successful male – the man of strength, resource and intrepidity. In order to avoid stultification he must also cultivate his tastes' (Veblen, 1899: 47). As with Simmel's reflections on how the distinguishing role of fashion emerged from the mixing of urban life, so the utility of the consumption of luxury goods 'is at its best where the human contact of the individual is widest and mobility of the population is greatest' (Veblen, 1899: 197) – that is, it is again precisely a function of the individualizing anonymizing tendencies of the modern city.

Veblen's reflections contain two further important emphases which set the scene for a contemporary understanding of taste. First, central to the possibility of conspicuous consumption is *time*, and the power to

'waste' it, or to spend it away from attending to the immediate material desires of the body. As he describes it,

> refined tastes, manners, habits of life are a useful evidence of gentility, because good breeding requires time, application and expense, and can therefore not be compassed by those whose time and energy are taken up with work. A knowledge of good form is prima facie evidence that that portion of the well-bred person's life which is not spend under the observation of the spectator has been worthily spend in acquiring accomplishments that are of no lucrative effect.
>
> (Veblen, 1899: 31)

This identification of taste as a *capacity* that is refined over and through time recurs in subsequent theorizing. Second, Veblen identifies a key modern phenomenon that results from this – the slippage between a definition of the beautiful which is based purely on the application of trained aesthetic judgement of objects and the location of those objects within conditions of market exchange. Thus beautiful things become expensive things to the extent that *expensive* and *beautiful* begin to stand for one another. Access to beauty becomes financially restricted, and therefore restricted by social class. As he describes it, in the context of urban society life in the late nineteenth century,

> The marks of expensiveness come to be accepted as beautiful features of the expensive articles. They are pleasing as being marks of honorific costliness, and the pleasure which they afford on this score blends with that afforded by the beautiful form and colour of the object; so that we often declare that an article of apparel, for instance, is "perfectly lovely", when pretty much all that an analysis of the aesthetic value of the article would leave ground for is the declaration that it is pecuniarily honorific.
>
> (Veblen, 1899: 80)

These are clearly not, then, the disinterested claims of beauty of Kant's ideal type of judgement, but a result of a process of the appropriation of the notion of beauty as an ally in struggles for status in a developing consumer symbolic economy.

The contemporary echoes of this shift are heightened by consideration of a final foundational voice in the sociological understanding of taste, Gabriel Tarde (1903, 2007), writing at a similar time in France. Recently reappraised as a neglected member of the sociological canon

(Barry and Thrift, 2007), Tarde offers three important perspectives to develop an understanding of taste. First, as an early theorist of the social and the social fact, he is less concerned than his contemporaries with the fundamental ontological differences between the individual and the social. This allows his perspective, as Barry and Thrift outline, to resonate with the inter/post-disciplinary social scientific understandings that draw upon psychological or geographical research. The 'basic social fact', as Tarde describes it, 'is the communication or modification of a state of consciousness through the action of a conscious being on another' (Barry and Thrift, 2007: 514, quoting Tarde, 1898). Second, in keeping with Simmel, there is a strong role for *imitation* in Tarde's analysis of social life – the profound ways in which we watch and respond to the lives of others in making the decisions which shape our own. This is an aspect of social life that drives emerging consumer capitalism. Writers such as Veblen and Weber had emphasized the extent to which new forms of consumption, alongside new forms of production, were central to the energies of the Industrial Revolution. While Weber emphasized ascetic self-denial as a key driving force for Western capitalism, Tarde instead reconceptualized capitalism as an economy of *desire*. For Tarde, wants and needs cannot be simplistically separated from psychological desires, as he imagined they were in explanations for human behaviour that emerged from the dominant economic theories of the time. Needs might be satisfied partly through acts of consumption, but the makeup of the choices of what to consume is profoundly influenced by the social milieu in which choices are made. The visibility of the choices of others is as significant to our choices as the requirements of the body. There are, for Tarde, needs for aesthetic or intellectual satisfaction that accompany needs for material satisfaction, and these are not just, or cannot remain, individual needs; they are shared and developed by publics or groups. Desires emerge from a *sensory* relationship with the material world, which echoes the concerns of the philosophers of aesthetics, but they are also shaped by sensory encounters with other people, which shape and explain different taste cultures, thus

> These encounters with external beings provoke so many special sensations, genuine discoveries of sight, hearing, smell, taste, and tact, which awaken certain special modes of action: gathering, the pursuit of some prey, fishing, primitive and almost instinctual inventions; and it is these more or less spontaneous elementary discoveries and inventions which by imitatively propagating themselves from the first who made them to his neighbouring individuals, and from the

latter to others, thanks to the encounters of men with one another, have led to the birth and establishment in certain countries of the desire to eat dates or figs, or of the appetite for this fish or that game, or of the predilection for some kind of pottery, or some type of tattooing or decoration.

(Tarde, 2007: 638)

Simmel, Veblen and Tarde, then, prefigure contemporary understandings of taste in important ways. They emphasize a relation between what has come to be understood, following Kant, as forms of aesthetic judgement and the sensory engagement with the material world. Moreover, they share a concern that these forms of judgement are, in the context of modern capitalism, overlain with judgements of *people* alongside judgements of things and bound up with the ongoing process of negotiating social life – with *living together* and the tensions which that evokes between the need to conform to norms of behaviour and conduct of others and the need to express and differentiate oneself. In Veblen's account of conspicuous consumption we see that the resolution of this tension through luxury and choices about leisure time integrate the subjects of the late nineteenth-century USA not into a cosy, flat egalitarian, community but into a hierarchical one, in which the capacity to express taste becomes a weapon in displaying and preserving social status. In Simmel's account of fashion and Tarde's evocation of the centrality of aesthetic desires, we also begin to see an emergent role of taste in the circulating energies of capitalism itself. All of these threads come together in the work of Pierre Bourdieu, but in the next section a final thread in the tapestry of theorizing taste will be plucked.

The problem of taste and mass society

If the theorists of the late nineteenth century can be seen from the perspective of the early twenty-first to be expressing broader anxieties about how social life is conducted under conditions of urban capitalism, the theorists of the mid- to late twentieth century might be similarly concerned with the consequences for social life that are bound up with emerging methods for the production and circulation of cultural goods. These anxieties can be coalesced into a set of debates about what became known in this period as *mass society* and *mass culture*, debates which are important in setting the scene for any contemporary theoretical approach to taste – not least because the distinction that emerges in this period between 'mass' and other forms of culture provides an abiding set

of linguistic resources through which questions of cultural taste are still articulated. The rise of the cultural industries and the version of consumer capitalism which came to dominate the USA and Western Europe in the post-war period in particular were greeted with some disquiet among commentators. The historical context is important to bear in mind here, as criticisms of mass culture which have subsequently been interpreted as a kind of academic elitism were in the context of a historical period in which the effects of mass culture in the propaganda of two brutal world wars appeared self-evident. We shall return to these questions in Chapter 4.

This twentieth-century critique itself has older intellectual roots in the tradition of Romantic art and poetry in the eighteenth century which explicitly sought to carve out a space for the contemplation of beautiful things in the context of what was assumed to be the deleterious, dehumanizing effects of the rationalizing, calculating, urbanizing imperatives of the Industrial Revolution. This movement set the scene for the separation of the man or woman of culture from 'the herd', and it marked an early example of a recurring theme in this tradition of critique of overlap between radical thinkers who were concerned with questions of human liberation and conservative thinkers who were afraid of the mob. The studied reflection of art, literature or culture was a source of self-improvement and moral renewal in conditions which were assumed by intellectuals of the period (including Karl Marx and Adam Smith) to transform men and women into not much more than cogs in the industrial machine. When in the early twentieth century this machine turned to the industrial production of culture itself, the herd is transformed into the 'mass' and the nature of intellectual anxieties is crystallized around the influence of commercially produced and circulated cultural forms – cinema, music and later television – on their audiences, also conceptualized as undifferentiated victims of processes that are beyond them. There are echoes with earlier themes here, encapsulated by Hannah Arendt's contribution to a special issue of the American Academy of the Arts' journal *Daedalus* in 1960, in which she speculates that one anxiety about 'mass society' is the extension of the term 'society' beyond the more rarefied groups which were able to 'dispose of leisure time and the wealth that goes with it' (Arendt, 1960: 278).

If, for Veblen, there was a shift in the language of taste that collapsed the beautiful with the expensive, in this later theoretical tradition we might identify a similar collapsing between the aesthetic qualities of cultural products, of whatever genre, and the mode of their production

and distribution, with popular and commercial culture becoming synonymous with diminished, and potentially damaging, characteristics. The principle progenitors of the critique of mass culture are the group of critical theorists known as the Frankfurt School, whose influential works lay out the potential consequences of the mass production of culture on the masses for whom they are produced. At the core of this critique is the assumption that products of what are identified as the culture industries are corrupt and corrupting, reproducing in the monotonous rhythms of popular music, the predictable plots of popular television drama or the tension between eroticism and repression that is evident in popular film, the exploitative relations of capitalism and contributing to the continued construction of these relations as natural and eternal. In the previous century, Veblen had imagined the leisure of the man of culture, away from productive work, enabling reflection and refinement in the development of an aesthetic sense. Under conditions of the culture industry in the context of a mass society, 'the man with leisure has to accept what the culture manufacturers offer him' (Adorno and Horkeimer, 1944: 6). The kinds of studied reflection which are the prerequisite for the disinterested Kantian judgement of beauty are rendered irrelevant by the formulaic and repetitive nature of commercial cultural forms which discourage critical thought and replace it with gratuitous amusement. Far from encouraging refinement or cultivation, these forms of culture are debasing and serve to recreate the exploitation of the workplace in the already scarce leisure time of the worker 'by occupying men's senses from the time they leave the factory in the evening to the time they clock in again the next morning with matter that bears the impress of the labour process they themselves have to sustain throughout the day' (Adorno and Horkheimer, 1944: 11).

It is a perspective which, in the age of *X Factor*, reality television and blockbuster sequels and remakes – and the persistent expressions of disappointment with these forms within critical intellectual circles – still seems to resonate today. It was certainly dominant in cultural scholarship before the advent of cultural studies implied a greater degree of agency for the mass audience. One interesting rebuttal that preceded this, and that focused precisely on the question of taste, is provided by the American sociologist Herbert Gans (1999) writing in the mid-1970s. He identifies four abiding themes of the mass-culture critique: that mass culture is of low quality precisely because it is mass produced and commercially circulated; that it is parasitic on 'high culture'; that its gratifications are 'spurious' compared with the deep satisfactions and nourishment that are acquired through the contemplation of great art

and literature; and finally that it is generally deleterious to society as a whole, encouraging passivity, and opening up its audience to the risks of propaganda and mass deception or delusion. Each of these themes, he argues, is either not based upon any substantive empirical investigation or does not tally with those forms of empirical investigation which had been undertaken at the time of his study. Instead, he suggests, the mass culture critique is 'largely a statement of aesthetic dissatisfaction with popular culture content, justified by incorrect estimate of negative effects and based on a false conception of the uses and functions of popular culture' (Gans, 1999: 44). Moreover, at its heart this story can be seen as 'historical fallacy' that shores up the position of intellectuals and exhibits 'a marked disdain for ordinary people and their aesthetic capacities' (Gans, 1999: 57).

Gans' contribution might now be read as part of a general move within the sociology of the media to roll back the anxious claims and cultural pessimism of early twentieth-century speculation about mass society and to implicate the inherent inequalities of US society, rather than the pernicious influence of the mass media, in the social problems of the USA. It also emphasizes the relative absence from all of the theorizing so far, including that of the early sociological scholars, of anything that could pass muster as substantive rigorous *empirical* engagement in the taste cultures about which it speculates, particularly the taste cultures of the 'masses'. While Gans' plausible, though impressionistic, analysis of US culture does not do much to fill this particular gap, at a similar time of his intervention, across the Atlantic, the contribution of Pierre Bourdieu was emerging to do precisely that.

Enter Bourdieu

At the time of writing this book, the Google Scholar academic search engine reveals that Bourdieu's *Distinction* has been cited over 30,000 times since its publication – in French in 1979 and then in English in 1984. While in contemporary academic cultures such metrics are taken as an unproblematic indication of success and influence, it is important to remember that one cites scholarship that one *disagrees* with as much as that which one likes, and it is arguably the continued controversy over its findings which accounts for its continued life. One humble contribution that this book aims to provide is to challenge some of the ways these controversies have ossified into positions for or against which make references to *Distinction* a kind of academic shorthand in cultural sociology and its attendant fields. As the previous discussion

has shown, Bourdieu was not the first sociological word on taste and he is unlikely to be the last if, as this book contends, taste remains an important mediating concept in social and cultural life. At the risk of adding unnecessarily to the volume of discourse that it has provoked, the 613 densely argued pages of *Distinction*, and the significant empirical work which underpins it, remains the touchstone for any scholarly discussion of taste, regardless of whether one thinks with or against it. Subsequent chapters will explore the empirical basis of work in more depth, as well as take a look at some dimensions of taste in which the insights of *Distinction* – and other work from Bourdieu's oeuvre which are relevant to the contemporary understanding of taste – are still at play. For now, though, I introduce the key elements of Bourdieu's argument before considering subsequent criticisms that help to develop a contemporary theory of taste.

The starting point for Bourdieu's examination of the social structure of taste is a critical dialogue with Kant. As the discussion above indicates, there were two elements to the Kantian version of aesthetics which a sociologist might be expected to take issue with. The first is the notion that judgements of beauty are reflective of a *sensus communis* – that is, that if an object possesses pure beauty, it is beautiful for everyone at all times and in all places. The judgement of aesthetic beauty, then, is ahistorical and universal. Such a position – speaking for all members of a social group, or even all humanity, based only on the logical deduction of one member of that group, the philosopher – might well be unsatisfying to a sociological eye. How can we know that beauty operates in this way without some empirical demonstration of it – not least because such empirical investigations of other such categories, such as time, have precisely revealed them to be far from universal? Partly, then, the engagement with Kant and indeed the concern with taste can be understood as a contribution to Bourdieu's broader theory of knowledge – an answer to the perennial ontological and epistemological questions about the kinds of things there are in the world and how we can know them. Asking people about their understanding of beauty and reflecting on the answers might indeed reveal that, far from being universal, judgements of beauty are riven by divisions and that beauty and ugliness are socially and historically located.

The second, more specific point of departure with Kant emerges from the distinction between the judgement of pure beauty as a judgement of taste and the judgement of the agreeable as a judgement of the senses. For Bourdieu, this is where claims to universality of Kant's classifications fall down, and these distinctions between types of judgement begin

to map onto the assumed capacities of those who make them. In the messy empirical reality of the real world of judging and tasting, rather than the philosopher's world of logical deduction, this move has important consequences. It contributes to the separation of judgements of those things which *please* the senses from those things which appeal to knowledge and reflection. Beginning his account with the promise that it will seek to reconnect the understanding of tastes for 'refined' objects with the understanding of tastes for food, Bourdieu suggests that such a move is a 'barbarous re-integration of aesthetic consumption into the world of ordinary consumption', which 'abolishes the opposition which has been the basis of high aesthetics since Kant, between the "taste of sense" and the "taste of reflection", and between facile pleasure, pleasure reduced to the pleasure of the senses and pure pleasure' (Bourdieu, 1984: 6). He later quotes Kant's assertion that 'we regard as coarse and low the habits of thought of those who have no feeling for beautiful nature ... and who devote themselves to the mere enjoyments of sense found in eating and drinking' (Kant quoted in Bourdieu, 1984: 489). The survival of this kind of categorization through the discourse of pure aesthetics, and mapped onto the population of the France of the 1960s, reveals different classes are differently oriented to one or other of these forms of taste. Men and women of culture appear to privilege refinement and reflection in their choices of cultural goods, whereas subordinate groups tend to privilege sensory enjoyment and indeed to actively eschew intellectual pursuits as pretentious or a waste of time. Thus the distinction between tastes of 'sense' and 'reflection' inherited from Kant acts as an 'ideological mechanism which works by describing the terms of the opposition one establishes between the social classes as stages in an evolution' (Bourdieu, 1984: 490). If challenging this Kantian separation between forms of judgement is *barbarous*, then it is important to recognize that Bourdieu is on the side of the barbarians here, holding the mores and choices of the apparently refined, disinterested and cultivated up to critical scrutiny and attempting to reveal how their judgements of beauty are transformed into judgements of other people and their tastes.

The conceptual triumvirate

Bourdieu approaches the sizeable empirical material about tastes gathered in *Distinction* drawing on the conceptual language which underpins his entire corpus, and specifically on the three concepts which represent his substantive contribution to the theoretical toolkit. The concepts are *capital*, *habitus* and *field*, and in Bourdieu's work in general they

are related to a range of substantive subject areas and techniques of empirical inquiry from education (Bourdieu and Passeron, 1979), to the production and reception of art and literature (1993, 1996), through to the French market for housing (2005). Their interpretation in relation to questions of taste, as revealed in *Distinction*, must be understood in the light of Bourdieu's abiding theoretical concern to contribute to the resolution of the perennial sociological problem of social structure and individual agency, as it was being worked out in the struggles of the French academy. The terms develop alongside this life's work and as a result they defy the hermeneutic identification of the *right* definitions – they change and evolve over time. A considerable amount of criticism of Bourdieu, as Warde (2008) and Holt (1997) point out, refers to the relative transferability of his claims in *Distinction* to other times and places. Of the many types of criticism, this seems the least reasonable. Theory can travel in time and space in a way that empirical material cannot; the empirical reality of the social world has no doubt changed since the time of Bourdieu's study but the theoretical concepts, permissively reinterpreted, might still be useful.

In *Distinction* (Bourdieu, 1984: 101) there is an identifiable formula presented – ironically perhaps in the form of an *actual* formula – which explains their relation:

$$[(\text{habitus})(\text{capital})] + \text{field} = \text{practice}$$

While the concepts themselves have been used separately in subsequent work which draws, positively or critically, on a Bourdieusian theoretical schema, keeping their *relation* in mind is central to understanding the argument of *Distinction*. A summary interpretation of this formula might be that a practice, such as a cultural choice or an inclination to like or dislike a particular cultural item, is shaped by the social space in which you are situated (field) and the combination of types of resources (capital) and inherited dispositions which you possess (habitus). Each of these terms, though, merits some fuller consideration in determining its continued utility.

The varieties of 'capital' – and cultural capital in particular – have been a permissively drawn on concept in a range of social scientific fields in the late twentieth century, and not just by Bourdieu. Fine (2001, 2010) has done a good job of deconstructing this move within social science and public policy by arguing that the prefixing of an economic concept (albeit a metaphorical one) with some kind of softening adjective – social, cultural, emotional, even erotic (Hakim, 2011) – acts as a way

of smuggling a reductive form of economic analysis, based around pro-
cesses of competition or exchange, into all forms of human action and
interaction. It is a criticism levelled at Bourdieu too, albeit that, as
Robbins (2005) points out, Bourdieu's work exhibits scepticism towards
the correct application of the terminology of the social sciences, pre-
ferring a more practical concern with the explanation of the particular
object of analysis before him. The capital metaphor emerges at an early
stage in Bourdieu's career as a researcher when, along with his colleague
Jean-Claude Passeron, he was experimenting with the discourse of social
science in their exploration of social differentiation and acculturation.
It can be interpreted, for Robbins, as a reflection of Bourdieu's desire to
establish himself as a researcher with a distinct position in the French
academic field, opting 'to present himself as a scientist rather than a
speculative philosopher' (Robbins, 2005: 22).

While Bourdieu prefaces his version of capital with the adjectives
'social', 'symbolic' and 'technical' at various places in his work, it is *cul-
tural* capital which emerges as the concept that is most taken up within
cultural sociology and beyond. In *Distinction* its primary use is as an
alternative to economic capital that explains differences between and
within classes. Overall capital volume determines which class one can
be thought to belong to, but how that volume is distributed between
economic and cultural capital determines your position in that class.
Intellectuals, for example, have high volumes of capital but greater vol-
umes of cultural than economic capital, and therefore they represent
a 'dominated fraction' of the dominant class. Subsequent studies draw
upon it as a metaphor for the kinds of advantage that accrue to those
who have the right forms of education and tastes for legitimate forms
of culture and the effects of these kinds of advantage on persistent
forms of social inequality, contributing to a general theory of the inter-
generational transmission of social advantage (cultural capital can be
bequeathed and inherited like economic capital), but also existing as an
asset that is struggled over and won.

Within Bourdieu's social theory, as Savage and Silva (2012) point out,
the concept of 'field' becomes more elaborated later in his work, denot-
ing a bounded metaphorical space of practices (e.g. cultural production
or politics) which were governed by the same rules of conduct and
struggle, and within which social actors recognized distinct interests
and goals. The establishment of a field, therefore, effectively renders
a demarcated aspect of social life that is observable for the analyst.
At the time of *Distinction* the term is used more loosely, alongside
'social space' or the 'objectively classifiable conditions of existence' as

terms to describe the methodologically constructed version of the social world which he is attempting to analyse. We'll consider this process of methodological construction in more detail in the following chapter, but in Bourdieu's theory more generally, fields can be seen to act as the conceptual container for the struggles over capital, and in *Distinction* the 'field' of French social space is the means by which the divisive nature of taste can be made visible. This is possible through the final concept of *habitus*. If field conveys the range of possible forms of action or thought open to an individual in a particular set of social conditions, habitus conveys the choices that an individual might make within that range, but also explains why some choices are more likely than others. In his discussion in *Distinction* of the space of lifestyles – and in clear dialogue with the structuralism which was the dominant analytic mode of social inquiry at the time of his intervention – habitus is described as a 'structured and structuring structure' which sits between 'objectively classifiable conditions of existence' and both the 'systems of schemes generating classifiable practices and works' and the 'systems of schemes of perception and appreciation ('taste') in generating particular life-styles' (Bourdieu, 1984: 171). Different conditions of existence generate different forms of habitus, which in turn generate different systems of generation or appreciating cultural works. Through their habitus an individual processes and places the cultural items before them via a mechanism derived from their conditions of existence and gravitates – apparently naturally – towards some items and away from others. The consequence of this is the establishment of distinct and separate taste cultures which map onto social classes. The inter-relation between capital, habitus and field mean that these relationships are not deterministic, but that the room to manoeuvre is restricted. Our habitus, which emerges through our class position, shapes our orientations or sensibilities, but also acts as a capacity or skill in judging the quality of items. It remains, perhaps, the most controversial aspect of Bourdieu's legacy.

Taste and social class

The culmination of Bourdieu's critical engagement with Kant and the application of his conceptual triumvirate of capital, habitus and field to the empirical material that he gathers results in the establishment of a clear relationship between taste and social class in the France of the 1960s and 1970s. Bourdieu's position on class emerges from the application of sociological methods – both of quantitative and qualitative types. This distinction is important because it allows him to claim both

the *objective* identification of classes and their different tastes, and some sense of how it *feels* to be in classes, as expressed through the voices of respondents and analysis of their talk about their tastes.

Arguably it is this latter, more *subjective* way of seeing class that has been the primary concern of those British sociologists who, inspired in different ways by Bourdieu, re-energized the debate about class in the 1990s and 2000s (Charlesworth, 2000, Savage et al., 1992, 2001, Skeggs, 1997, 2004), re-imagining it as a cultural as well as an economic category. Among its contributions, this work powerfully revealed the ways in which class intersected with other forms of social division, notably gender, but also emphasized the ways in which class is felt, in the body, through the day-to-day feelings of humiliation, exclusion, dislocation and out-of-placeness that characterized the everyday lives of the people in these studies. Taste is especially powerful in this process because it appears so self-evident. As Bourdieu describes, 'the ideology of taste owes its plausibility and its efficacy to the fact that, like all the ideological strategies generated in the everyday class struggle, it naturalizes real differences in the mode of acquisition of culture into differences of nature' (Bourdieu, 1984: 68).

Bourdieu's interpretation of the empirical data in *Distinction* can be summarized as one of an identified *homology* between positions within social hierarchies and cultural hierarchies. The cultural hierarchy in question is identified as one of 'legitimate culture', made up of the most revered objects and genres, middle-brow culture – 'the minor works of the major arts and the major works of the minor arts' (Bourdieu, 1984: 16) – and popular taste. Alongside the categorization of the forms or genres of culture there is also a categorization of different dispositions or orientations to culture. The principle division here is between 'tastes for freedom', associated with an aesthetic disposition with echoes of Kantian disinterestedness, which privileges form over function on the one hand and 'tastes of necessity' which are closely related to the biological needs of the body on the other. This opposition is found in different ways across different forms, but the starting point is, again, related to food – the field of 'primary tastes' which is 'organized according to the fundamental opposition with the antithesis between quantity and quality, belly and palate, matter and manners, substance and form' (Bourdieu, 1984: 177). Thus the tastes of higher social classes whose disposable incomes makes them distant from the immediate concerns of hunger or cold are able to judge food for its aesthetic qualities, while those in lower social groups are more immediately concerned with getting their fill and getting value for money. There is an echo here of

Veblen's conception of the symbolic pecuniary power of both luxury and *time*, and the ways in which those forms of culture which lend themselves to an aesthetic disposition are more accessible to those with time away from productive work to appreciate and learn their codes. As Bourdieu suggests,

> The objects endowed with the greatest distinctive power are those which most clearly attest the quality of the appropriation, and therefore the quality of their owner, because their possession requires time and capacities which, requiring a long investment of time, like pictorial or musical culture, cannot be acquired in haste or by proxy, and which therefore appear as the surest indications of the quality of the person.
>
> (Bourdieu, 1984: 281)

Around this principle division, between luxury as freedom and a taste for the necessary that reflects restricted access to resources of time and money, are more nuanced discussions which account for a greater variety of class positions. Central to each of them is the distinction between forms of cultural capital which are *inherited* and those which are gained through education. The school and university have, for Bourdieu, central roles in the reproduction of class societies, but they also have the potential to be a place where struggles over the value of capital can be fought, as they impart the codes and rules of conduct in the realm of culture. The education system, as he describes it, 'makes possible a (more or less) adequate symbolic mastery of the practical principles of taste' (Bourdieu, 1984: 67) – more or less, perhaps, because the forms of institutionalized cultural capital acquired through education, which find their most practically identifiable exchange rate in the job market, are also different from the 'practical mastery' (Bourdieu, 1984: 66) over forms of culture which comes through inherited and ultimately embodied forms of cultural capital. Knowledge of the art world, for example, gleaned from being brought up with aesthetic disposition, is different from knowledge of the art world gleaned from learning about art at school. The kinds of competence that these different modes of capital accumulation reveal are important in understanding how tastes continue to distinguish within apparently similar economic strata. Bourgeois families are able to bequeath 'self-confidence amid (relative) ignorance and casualness amid familiarity' to their 'offspring, as if it were an heirloom' (Bourdieu, 1984: 66). Such distinctions are evident in a range of examples from Bourdieu's data where adjectives to describe

interior design, relative knowledge of classical music composers and the aesthetic qualities of photographs correlate differently with social origin and educational achievement. Importantly, in complicating the homology thesis, though, it is not the most legitimate forms of culture which are most closely related to the most 'established' members of the professional and middle classes. Those who have gained their cultural capital through schooling have the most 'classical' tastes; those whose cultural capital is accumulated through the generations are also more likely to have *avant-garde* or even countercultural tastes.

These distinctions between the different markets of family and education in the attribution of various forms of cultural capital are important in explaining the variety in tastes identified between and within the middle and upper classes. The tastes of the working classes do not exhibit this nuance, though. For Bourdieu, through the operation of the habitus, working-class people are predisposed to being oriented to the cheap, the undemanding and the simple, across the range of fields. This reflects differences in income, though the apparently direct relationship between different tastes and variable incomes 'is because taste is almost always the product of economic conditions identical to those in which it functions, so that income tends to be credited with causal efficacy which it in fact only exerts in association with the habitus it has produced' (Bourdieu, 1984: 375). Partly this is a function of the lack of excess time and energy for manual workers to provide for the kinds of disinterested reflection that is required for the aesthetic disposition. In addition there is, for the working classes of Bourdieu's study, less immediate or obvious return on the investment of learning the codes and conventions of refined taste within their more restricted field of possibility.

This summary of Bourdieu's work – to be developed in relation to the various dimensions of taste encountered in subsequent chapters – hopefully suggests that it lies in dialogue with some abiding sociological dilemmas about taste, as well as providing some conceptual tools with which to resolve them. Bourdieu and *Distinction* remain divisive in cultural analysis, but the force of his account and in particular his insistence on the role of taste in cementing social division need to be reckoned with in any attempt to develop a working theory of taste for the twenty-first century.

After Bourdieu

Distinction has inspired an array of criticism, incorporating reflection on its tone (it is clearly a difficult and dense theoretical argument), its

methods and its findings. Some of this criticism might be expected for a work which seeks to explicitly challenge powerful narratives, including powerful political claims about the classlessness of contemporary societies or the notion that taste is just, and always, only a matter of personal judgement.

Placed in the broader context of Bourdieu's work on culture it can be seen as a contribution to a project of demystification of the symbolic power of acts of tasting and the ahistorical nature of cultural taste in particular. Subsequent empirical developments at least suggest that the social meaning of tastes and tasting are still in flux. The remainder of this chapter engages with a critique which raises significant questions, first about the conceptual underpinnings of Bourdieu's argument and then about the possibility of an egalitarian conception of taste.

Against Bourdieu: Rancière, the sociologist and his poor

Of increasing significance in Anglophone accounts of Bourdieu's legacy in recent years – ostensibly following the translation of his key works on the topic of aesthetics and class into English – is the French philosopher Jacques Rancière. This represents something of a lag, given that many of Rancière's works – and certainly the central issue of contention – emerged soon after Bourdieu's and reflect, as a number of scholars suggest (Deranty, 2010, Tanke, 2011) both struggles in the French academic field and a particular response to the ways in which Bourdieu's work had been taken up in policy circles in France in a cultural policy premised upon the notion of cultural inequality. Bourdieu himself was deeply sceptical about his work being taken up in this way (Dubois, 2011). Chapter 3 will explore this further, but Rancière is especially stringent in his critique of 'the blindness of policies that identify sociology's framing of the question with the advances of democracy' (Rancière, 2004: xxvii). The collapsing of a distinct Bourdieusian position with 'sociology's framing of the question' might well be interpreted as a reaction to Bourdieu's reduction of the whole of the discipline of philosophy to the 'illusion of universality' (Bourdieu, 1984: 193) that emerges from his reaction to Kant. There is more to interest us here, though, than a left-bank squabble – Rancière raises important questions about the premise of Bourdieu's argument and the subsequent analysis of his empirical material.

The first is to point out that Kant's version of aesthetics and the claim for a universally common sense of beauty is not ahistorical at all but is written at a time in history – the late eighteenth century – when

debates about relations between individuals and societies, which would later crystallize into sociological concerns, were keen political ones. The notion of universal beauty and *sensus communis* emerge, for example, a year after the beginning of the French Revolution and, as Bennett (2007) outlines, significant struggles over the establishment of Prussian democracy. This makes Kant's aesthetics a 'contemporary of a century and of populations confronted with the problem of "uniting freedom (and equality) with compulsion (rather of respect and submission from a sense of duty than of fear)"' (Rancière, quoting Kant, 2004: 197). Part of this problem included the very conceptualization of equality and inequality, and its relation to the capacities and skills of broader populations, envisaged as either the vanguard of a more democratic and liberal future or an amorphous unruly and dangerous mass – anxieties which find some resonance with the mass-culture critique of the mid-twentieth century. Questions of taste here are bound up with both the formation of people, their assumed 'qualities' and capacities and the re-formation of social structures that shape how they might live together. In Kant's conception of 'the universality of the judgment of taste he seeks the anticipation of the perceptible equality to come' (Rancière, 2004: 198). The notion of a common sense of the beautiful and the development of aesthetics, far from being a synonym for privilege as it is in Bourdieu – and in subsequent discussion within the general sociological approach to the arts – instead contains within it a progressive ideal of a common humanity and 'denies the world is split between persons of culture and those of nature' (Rancière, 2003: 198).

Following from this, Rancière rejects the notion of expressions of taste as a culmination of differently apportioned capitals or resources. The self-exclusion of the working-class habitus, for Rancière, is a contemporary iteration of abiding philosophical constructions of the nature of class division, evoking Plato's 'myth of the metals' in which social rank is essential and forever fixed. The re-creation of this hierarchy, albeit through the application of sociological methods, gives it a powerful scientific patina of inescapability – not least in the ways in which it is taken up in policy circles as encouraging and justifying a deficit model of cultural capacities – that is, that the working classes' aesthetic sense needs to be reawakened and *trained* through education. Rancière's rejection of this position can be placed in the broader context of his interpretation of the Althusserian strand of Marxism in which it is not men who make history but men reimagined as masses and mobilized through the instructions and methods of the party to make history. Such a conception robs men and women of their agency and places, respectively, the

theoretician, the cultural sociologist and then the educationalist, rather than people themselves, at the forefront of progressive struggle, reinterpreting the cultural world on behalf of those who lack the capacity to do so. As Tanke evocatively describes it, 'as long as men and women misjudge the shadows on the cave wall, they will require philosophers to guide their politics' (Tanke, 2011: 20). It is a position which cements the power of the analyst as being able to range authoritatively over 'the people' and place them in their respective categories. While one powerful story attached to Bourdieu's project is its revelation of the 'hidden' truth of the role of taste in the winning of class privilege, Rancière suggests, in the history of scholarly reflection on the poor, the claim to demystify also 'served to maintain another form of power, that of critics, scholars and intellectuals who deployed it and who, in deploying it, presupposed that the audience could not see the truth on its own' (Watts, 2010: 110).

An alternative conception of equality, as advocated by Rancière, is not as a goal achieved through equally distributed resources or capitals but as a founding *axiom*, in which the expression of aesthetics and the quest for the beautiful is potentially liberating in class struggles. He comes to this through his own empirical research on the labour archives of nineteenth-century France, inspired by a concern to explore the differences between how Marxism constructed the working classes and how working-class life has been recorded and reflected on by the working classes themselves (Rancière, 2012). These accounts include evidence of worker intellectuals, writers and autodidacts drawing on the language of aesthetics of beauty and of art to articulate their experience and also to imagine transforming it. For Bourdieu, the autodidact was a rather tragic, marginal figure, condemned to play the game of culture according to rules that someone else has written – 'defined by a reverence for culture which was induced by abrupt and early exclusion, and which led to an exalted misplaced piety, inevitably perceived by the possessors of legitimate culture as a sort of grotesque homage' (Bourdieu, 1984: 84). For Rancière, by contrast, autodidacts represent a fundamental challenge to the division 'assigning the privilege of thought to some and the tasks of production to others' (Rancière, 2004: 220). The writers explored in *Proletarian Nights* draw on and evoke a universal aesthetic language to draw attention to, articulate and challenge their own exclusion. Whereas for Bourdieu the working-class aesthete is always either wrong, or right for the wrong reasons, the existence of such working-class aesthetes for Rancière offers a fundamental challenge to the notion of a class habitus. Rather than being a means by which a form of exclusion or a lack of capacity can be demonstrated, the pursuit of the

aesthetic can be 'a suspension of the habitual sense of sense wherein new capacities can be discovered' (Tanke, 2011: 27).

One's position in relation to these struggles might well be informed by different answers to epistemological questions about how we get to know about things in the world – especially things, like taste or class, which fluctuate between the objectively identifiable and the subjectively experienced. As we shall see in the following chapter, Bourdieu also exhibits some scepticism about the limits of the methodological toolkit of the social sciences to adequately apprehend taste. One aim of sociological approaches is surely to privilege the *social* – that is, that layer of human experience which is identifiable and patterned beyond the individual. The pattern of social life viewed 'from above' via the survey might well be different from that revealed through individual biography or narrative. The existence and significance of Rancière's 'hybrid' working-class aesthetes does trouble the coherence of the relationship that Bourdieu's work reveals and seems to undermine the *a priori* assumption of *Distinction* that cultural forms of inequality might be a consequence of the differential distribution of resources and inevitably bound up with the maintenance of class privilege. It is an insight which opens up some intriguing possibilities for the study of taste in the contemporary context.

Theorizing taste today

The above discussion has teased out some recurring themes and debates from scholarship on taste across the centuries. I conclude this chapter by considering how these themes might still be relevant to the problem of taste for contemporary and future cultural analysis, and specifically for the dimensions of taste as they are laid out in the subsequent chapters of this book. The first theme to consider is the persistence of a role for taste in the very organization and operation of social life in the twenty-first century. This claim recurs across the subsequent chapters, but in setting this scene I want to highlight three elements of it. First, drawing on the imperatives underpinning analysis from Elias, Simmel and Tarde, taste remains bound up with the processes and pressures of *living together*. Those processes of training and managing the body which reflected the social structures of social life in first medieval and then modern, urban Europe generated particular modes of conduct and classification in relation to the formation of people. People constantly re-emerge to be re-formed, and the study of tastes and tasting might give some indication of the kinds of formation preferred in, or suitable

to, life in the early twenty-first century. We can perhaps see in the contemporary period when something as natural and self-evident as what and how much we eat and drink is bound up with powerful stories about the relative health (physical and moral) of Western, consumer societies and how those who are assumed to ignore injunctions to *modify* their appetites for the common good are vilified, that norms of restraint in relation to taste remain powerful. Certainly examples such as this continue to implicate taste in the second element of the story – in processes of placing oneself in, and being placed in, social hierarchies and, by extension, in experiencing and negotiating difference.

In recent years in the UK, class has re-emerged as a political issue after decades in which claims to classlessness were a feature of mainstream discourse. In the context of the deepening inequality of UK society wrought by the financial crisis of 2008, and the response to it from the coalition government, notions of classlessness are harder to sustain. The nature of class hierarchies and the ways in which they are constituted requires attention – and tastes remain implicated in these hierarchies. Class remains a cultural category as much as an economic one, and the judgement of the assumed capacities of individuals, as exhibited through their tastes and preferences, remains powerful. At the same time the role of culture in creating and sustaining social hierarchies is not settled, not least because one of the principle mechanisms through which the Bourdieusian version of cultural capital, distribution of which underpins these hierarchies, is also in flux. The significant expansion of university education, including to students from working-class backgrounds in the last 30 years, changes the distribution of that capital. In the arts and humanities, those disciplines with most at stake in the game of culture as imagined by Bourdieu, the narrative of the classifying power of culture (not least from Bourdieu and from the cultural studies tradition of cultural analysis) has been written into the reproduction of institutionalized cultural capital itself. Add to this the transformations in the cultural industries and in the emergence of new means by which culture is distributed and evaluated (to be discussed in more depth in chapters 5 and 6), and the class basis of aesthetic privilege is potentially more diffuse and certainly more difficult to manage.

A second substantive theme emerging from scholarship on taste is the relationship between the sensory and the aesthetic. Much of the weight of sociological discussion about aesthetics – of which Bourdieu is the most prominent – is bound up with a post-Kantian conception of aesthetics in which sensory experience and considered reflection are separated. This is in contrast with the original 'science' of aesthetics which

sought to understand how the material world worked to create meaningful sensations. In recent years, social theory has returned to reflecting on these more immediate sensational aspects of sensory life in what has been termed the 'affective turn' (Clough and Halley, 2007, Gregg and Seigworth, 2010), considering how the bodily or corporeal aspects of human experience can be understood and articulated. This affective turn has not drawn much (surprisingly perhaps) on the language of 'habitus', but Highmore explores the potential value in reintegrating the consideration of the experience of the body into the consideration of the beautiful, as much as it is still present in the consideration of the ugly or disgusting. If, as he suggests, 'affect gives you away' (Highmore, 2010: 118), then the signs, symbols and sensations of taste and tasting remain powerful indicators of their social meanings. Recognition of this challenges the post-Kantian aesthetic distinction between thinking and feeling, and its subsequent sociological mapping, as Rancière has outlined, onto people who *can* think and people who *just* feel. This is significant both in the forms of judgement of other people and in relation to our self-understanding. Theories of taste might do well to retain the recognition that some forms of sensation are better than others. The experience of beauty might be better than that of toothache, for example. However, at the same time, affects are not experienced outside social or cultural hierarchies. In everyday life in the twenty-first century, the shiver that a listener might feel up their spine in response to, say, a Mozart crescendo might precisely indicate recognition of the work as beautiful and might indeed be reflective of a communion between artist and listener as fellow travellers on the human journey. It might also, given the muddy relations between everyday life and actual aesthetic experience, and given sociology's identification of how the reaction, sensory or otherwise and the communication of it can be related to various forms of social identity, be socially advantageous to articulate this sensation. A twenty-first century listener feeling a similar shiver up their spine at the songs from a Disney animation, or the outcome of a reality television talent show, might, by contrast, do better to assume that they are sitting in a draught than to tell anyone about it.

Such recognition connects with the final theme, about the social meaning of the aesthetic in the specific context of the twenty-first century which might not recreate the distinction between thinking and feeling forms of judgement and thinking and feeling forms of people. The most substantive body of scholarship concerning this kind of approach to taste emerges from the cultural studies tradition. Initially concerned with giving serious scholarly attention to working-class

culture (Hoggart, 1957), and latterly with the symbolic work of subcultural forms of youth culture (Hall and Jefferson, 1975, Hebdige, 1979), this tradition has provided sustained consideration of the aesthetic practice of everyday life, as well as provided a theoretical lexicon to trouble the assumptions of the mass-culture critique. In Bourdieu's schema the effects of cultural domination effectively rule out the possibility of a working-class aesthetic sensibility. The cultural studies tradition, by contrast, recognizes the possibility of everyday forms of aesthetic work in spectacular acts of consumption, which has also generated a somewhat caricatured conception of cultural studies as an unproblematic celebrant of the popular. Certainly the insights of cultural studies increasingly find themselves *de rigueur* in the marketing industries where the assumed creative and apparently subversive energies of subcultural consumers become an idealized model for *every* consumer. Moreover, in keeping with the aesthetic 'needs' identified by Tarde and the apparently individualized forms of self-perception evident in late capitalism, consumer culture itself is arguably driven by a 'practical aesthetic imagination' (Thrift, 2010: 291), which appeals to and reflects the skills and sensibilities that a broader population can draw on in their expressions of taste. Attention to these kinds of inclusive and everyday aesthetic work might allow contemporary scholarship of taste to complicate rather than simply replicate the dominant models of the past.

2
Measuring Taste

This chapter examines the ways in which claims about tastes are established methodologically, and the various techniques of data-gathering and analysis upon which these claims are based. It does this in the light of what philosophers of social science refer to as *ontological* and *epistemological* questions. What kind of 'stuff' is taste? What constitutes tasting and how might tastes be systematically 'captured' in ways which bring them into the kinds of focus required for sustained analysis? The substantive *empirical* sociological contributions to debates about taste, to be explored below, including from Bourdieu (1984) and Richard A. Peterson (1992, 2005) and his collaborators, Peterson and Simkus (1992), Peterson and Kern (1996), and subsequent work inspired by, or critical of them, by Lahire (2008, 2011), Hennion (2001, 2007) are all based upon the application of what might be termed the conventional social science toolkit. This toolkit would include the questionnaire or survey either in some combination with, or replaced entirely by, various forms of qualitative interviewing. Empirical contributions to understanding the role of tastes have also been based on other kinds of empirical inquiry. The cultural studies tradition, privileging the meaning of experiences over generalizable patterns, tends to be based on ethnography or participant observation, for example, and there is a tradition of cultural history which has examined taste through the analysis of literary or other forms of text. All of these approaches require logistical decisions in their design and analysis, but also require assumptions to be made about the kinds of *stuff* tastes are, how they can be rendered analysable and for what ends. The chapter also considers these issues in the light of the increased interest in and scrutiny of this toolkit's role in the process of *making*, not just measuring, the social world (Law, 2009, Osborne and Rose, 1999).

So far I have argued that taste can be understood as an exemplary theoretical sociological problem because it appears to mediate between the individual, their nervous system, the social and cultural processes that place things before them to be tasted and the consequences of tasting for identities and for our relations with others. This chapter will show that taste has also been an exemplary *methodological* problem, the resolution of which depends upon the systematic identification, collation and translation of individual experiences to make meaningful claims. This evokes grand debates between the quantitative and qualitative, positivistic or interpretivist tribes in the social sciences, but it also connects with the humanities tradition. Debates about taste underpin various disciplines of artistic and literary scholarship and criticism which have the evaluation and the attribution of *good* and *bad* to cultural items as part of their *raison d'être*. The study of cultural taste also contributes to broader debates about how human behaviour can be observed and understood. In what follows, the focus is on the former set of concerns as a more manageable exercise, based upon some scrutiny of the methods used to identify and measure taste and their relation to the claims made about it. The chapter concludes with reflection inspired by the emergence of new narratives of how human behaviour in relation to taste can be known. These indicate the extent to which the problem of measuring taste remains a current concern, both for the academic social sciences, and for those institutions and industries concerned with the government and management of human behaviours in contemporary societies.

Surveying the field

The methodological landscape of cultural sociology and its adjunct disciplines has been developed through a series of controversies. These are over the value of the sociological study of culture at all (compared with the more apparently important and concrete concerns such as health, crime, work, gender or ethnicity), the best ways to conduct sociological inquiry into questions of culture empirically and, latterly, about the politics of 'big C' culture and its relation to popular culture and everyday life. Recent historical reviews of the sociological strand of this methodological landscape (Fuller, 2006, Savage, 2010, Savage and Burrows, 2007) suggest a 'golden age' of the sample survey in the immediate post-war period, in which quantitative methods predominated as the generators of knowledge about the social, ostensibly to enable the allocation of scarce national resources. This primacy has subsequently

been eroded, at least in the UK, to the extent that in the recent history of the discipline (Halsey, 2004) the qualitative interview, in its various forms, has become the dominant mode of sociological interrogation. Such a historical transformation might be accounted for by exogenous factors, such as the academic research environment in the UK and its requirements for the kinds of nimble, small-scale research projects that are better suited to the rhythms of research assessment. It also reflects endogenous factors, including the increasing critical suspicion of large-scale quantitative analysis as the powerful and impersonal allies of state or corporate power. This suspicion emerges in the later twentieth century in relation to the increased visibility of analyses which sought to give voice to the experiences of marginalized groups. Such work was strongly influenced by feminist forms of knowledge and accompanied a general radical reaction against forms of 'positivistic' social science which aped the natural sciences. Culture was a particularly ripe subject for this kind of shift, both because scholars who were interested in culture tended to have backgrounds in literary/critical studies rather than the 'hard' social sciences, and because, as Inglis intimates, in researching culture the assumption is that 'one is seeking out the presence and power of inter-subjective meaning and value. These are not quantities in people's heads, retrievable by social surveyors' (Inglis, 1993: 148). Given this general context, it is noteworthy that Bourdieu's *Distinction* remains such an enduringly influential, albeit controversial, piece of work within sociology, and cultural and media studies, given that a survey is so central to its claim-making.

The analysis of tastes through survey work brings its own problems. Any kind of survey design requires an *a priori* assumption about the categories that are being identified and measured, so the kinds of questions asked in surveys of taste require some assumptions about the kinds of things tastes *are*. It is clearly difficult in any empirical research environment not involving the attachment of sensors to tongues to judge taste as *sense*, so instead the sociological imagination tends to translate taste into questions about preferences and practices: What do people *like*? What do people *do*? This translation is, for good empirical reasons, reductive, but it creates logistical problems for survey designers. Before research participants themselves can choose between items to like or dislike in a survey encounter, for example, researchers must preselect the items for them to choose between, and no economically viable survey can be exhaustive in its construction of the cultural world which could be tasted. Add to this the complication that taste requires and entails not just preference but also questions of disposition (How do we *feel* about

the things we like or dislike?) and also about knowledge (To what extent is our preference for cultural items shaped by our experience of them?), and the construction of a questionnaire to meaningfully capture the complexity of tasting becomes a difficult task. The following sections will examine some attempts to do so, and other empirical approaches to measuring taste, beginning with some consideration of the methodological choices that underpin *Distinction*. In approaching these questions, my aim is not to wilfully criticize these attempts, all of which make substantive contributions to our understanding. Perhaps research claims are, like Bizmarck's assertions about laws and sausages, more palatable when we do not see them *made*, but here at least I attempt to show some of the logic and mechanisms behind the measurement and analysis of taste, and their consequences for assessing subsequent claims.

Bourdieu's method and reflexive critique

Given the influence of *Distinction*, it is surprising how little attention is given to the methods which underpin it. It might be, given the story outlined above about the place of the quantitative in the development of contemporary cultural analysis, that this is because of a more general ambiguity to statistical forms of knowledge among scholars in these traditions. As Lebaron (2009) points out, Bourdieu himself had a life-long commitment to the use of statistics within sociological analysis, not as an ally of but rather as a counterbalance to those forms that predominate within economics, and indeed one aim of his sociology at the time of *Distinction* was specifically to use the apparent power generated by economistic models to refute the claims of economics. As Robbins (2005) explains, the commitment to statistical forms of knowledge was also a key part of Bourdieu's attempts to distinguish himself from the theory-driven analysis which predominated in the French intellectual field, and to move towards the appearance of a systematic and objective approach to the world, albeit one that was equally sceptical of the 'positivistic' model of hypothesis-results-interpretation – the 'smug display of data and procedures which is usually regarded as the best guarantee of scienticity', as he describes it (Bourdieu, 1984: 204). At the same time, to say that *Distinction* is based around the statistical analysis of a survey is also to oversimplify. While the survey method is clearly present, it is complemented by a substantial range of other methods, making *Distinction*, as Silva et al. (2009) suggest, a mixed method social inquiry *avante la letter*. In keeping with Bourdieu's call for a reflexive sociology (Bourdieu and Wacquant, 1992), the methods of the study are also

rather thoroughly critiqued *en route* – including in ways which anticipate subsequent criticism from other scholars.

As the methodological appendix to *Distinction* reveals, the survey itself contains some 26 questions about different aspects of taste, prefaced by questions about age, marital status, place of residence, education, income and ownership of technologies. It is interesting to note, given the claim at the start of *Distinction* that its aim was to reunify conceptions of taste relating to the sensory experience of food with those expressed in relation to legitimate culture, that there is little attempt to do so within the survey. Instead, the questions are about preferred styles of furniture and interior design, preferred leisure activities, preferred singers, preferred forms of cuisine when entertaining at home and preferred genres of books, films, radio and television programmes. In addition there are some questions in which participants are invited to choose the opinion closest to their own in relation to classical music and paintings, and questions in which participants are 'tested' in relation to their participation in film, music and art. A separate section invites them to speculate about what would constitute a beautiful photograph from a list of possible subjects, including a landscape, a woman breastfeeding, a sunset and two tramps quarrelling. In addition to the research participant answering the survey, the research encounter also involved the interviewer conducting an observation about the home, its age, size and décor, and about the dress, hairstyle and speech of the participants. Some of these questions might appear rather quaint to a twenty-first century eye. Bennett (2006) suggests that the notion of prefacing a question on television preferences with 'If you watch television…' would have been unthinkable just a few years later as television viewing became a ubiquitous activity across social classes in late modern leisure time. At the very least these questions, the lists and the observation schedule remain intriguing indications of the ways in which the legitimate and popular forms of culture that were so central to Bourdieu's analysis were constructed methodologically from the cultural imaginary of the period.

Bourdieu's survey was placed in the field initially in 1963 and conducted with a sample of 692 people in the cities of Paris and Lille, and an unnamed provincial town. The same survey, slightly modified, was conducted some four years later, bringing the total number of participants to 1,217. This sample was not constructed to be precisely representative of the population of France of the period. Although there were, Bourdieu reports, equal numbers split between the metropolitan capital and the provinces, the class construction of the sample was deliberately

skewed towards the higher end. This is explained by, on the one hand, a requirement for more participants in these categories in order to facilitate meaningful statistical analysis on their replies and, on the other, from the working assumption that the responses of the *classes populaire* would be 'very uniform with regard to the object of the survey, i.e. very uniformly excluded from legitimate culture' (Bourdieu, 1984: 505). Both of these represent epistemological assumptions, but one can perhaps see at work within them the essence of Rancière's critique described in the previous chapter. The working classes are constructed *a priori* as partially excluded from a survey exercise which might be assumed to be interrogating their exclusion – and the analysis of the survey subsequently confirms that exclusion.

In his account of the survey, Bourdieu is remarkably open about its limitations as a research strategy. General questions about its 'representativeness', especially with regard to claims made within specific fields of activity (including theatre, reading and the management of personal appearance), are countered by the use of significant secondary quantitative data drawn from a range of state or commercial research. These include the 1968 French census, used to test the socioeconomic spread of the sample, and some 51 datasets from market research and opinion poll research which provide additional socioeconomic context, including a 1970 survey on incomes drawing on a sample of 45,000 households, another from the same year on household expenditure drawing on a sample of 38,000, and a 1972 survey of household expenditure based on a sample of 13,000. In addition there are more detailed data about the consumption practices in specific fields. These include data on film, theatre and festival audiences, data gathered as late as 1976 on radio and television audiences, on sport, home decoration, food, reading habits, newspapers and on personal grooming. These latter field-specific studies are based on samples ranging from 12,000 (a 1961 study of radio listening) to 450 (a 1974 study on 'Why do French women want to be thin?'). The scale and spread of this material is clearly substantial. Of equal interest, though, in relation to Bourdieu's attitude to the empirical is that the time period over which the material was collected was, given that the survey was preceded by a period of pilot interviews and ethnographies, some 15 years. The analysis itself, however, remains unremittingly *present* in its tense, describing patterns and associations as they *are,* rather than as they might have been in flux over this period.

Even this is not the end of the empirical basis of the claims. The statistical analysis of both survey and secondary material are complemented and illustrated by a series of quotes from interviews with people from

across the socioeconomic spectrum, with images and texts from literature and newspapers and from advertisements and magazines. Further illustration comes, with the anthropologist's eye, from observations of behaviour in various settings, such as the performance of greetings in a 'working-class' café, the relative gender approaches to laughter, to blowing one's nose or the performance of a Sunday meal. Among the more famous of these strategies included the use of a photograph of an old woman's hands to illicit responses about the aesthetic dispositions of participants. The reported responses range from revealing an ethical affinity with the struggles of physical labour from a Parisian manual worker ('The old girl must've worked hard!'; Bourdieu, 1984: 44) to an 'aestheticizing reference' to literary works from a Parisian engineer ('it puts me in mind of Flaubert's old servant woman'; Bourdieu, 1984: 45). While these latter forms of evidence might be less admissible to a strictly positivistic social science, they serve to emphasize the empirical-but-not-empiricist tenet of Bourdieu's cultural sociology – that his pronouncements about taste emerge not simply from an abstract theoretical model but through the interplay between theory and the real world that appeared before him, and are captured through the variety of these techniques.

In keeping with a more general intellectual commitment to being reflexive about the production of the research object, Bourdieu includes in his account several criticisms of the survey technique and its ability to adequately capture the reality of the *experience* of taste. He recognizes, for example, that survey questions are *reductive* (i.e. that they simplify the variety of experience into that prefigured by the survey designer) but also that they are *generative* (i.e. that the research encounter also involves the *creation* of social phenomena – notably of 'opinion', and in the specific case of *Distinction*, of preferences which stand for tastes). The former concern is voiced in relation to the ways in which a range of dispositions of a particular type are assumed to be captured by a few simple survey responses. Conventional statistical analysis might conceptualize these as 'indicators' which can reasonably stand for real-world relationships, but for Bourdieu they represent at best a 'series of gambles' (Bourdieu, 1984: 506). The methodological appendix to *Distinction* describes, for example, how research participants were presented with a list of adjectives which best described their friends. The precise analytic utility of this seems to be thrown into question by Bourdieu's recognition that such a list

could not be expected to yield more than an attenuated, blurred image of the deep dispositions which guide the choice of spouses,

friends or colleagues (partly because the list of adjectives, however carefully prepared, was imperfect and forced a number of respondents into the negative choice of the least unacceptable option.

(Bourdieu, 1984: 506)

The *generative* power of the survey situation is recognized by Bourdieu in relation to his discussion of what he terms 'cultural goodwill' – the tendency of people to defer to an assumption of the value of the cultural goods of which they have no knowledge, especially if those cultural goods appear to have an association with legitimate culture. In the survey situation, especially when conducted face to face with a person who, to all intents and purposes, is a representative of 'official' forms of culture, the survey becomes a 'legitimacy imposing situation' (Bourdieu, 1984: 318) with the potential for participants to second-guess the aims of the survey and to proffer what they imagine is the correct, most legitimate response. The research encounter in this conception becomes just another set piece in the game of culture, in which protagonists know both the rules and the rewards of the right moves. Such pitfalls are demonstrated with reference to opinion poll research conducted in 1969 on literary prizes which reveal that it is agricultural workers and manual workers who are *most* likely to think that prize-winning books are good and those with the highest education who are the *least* likely to. Such an inversion reflects 'the tendency of the most deprived respondents to disguise their ignorance or indifference and to pay homage to the cultural legitimacy which the interviewer possesses in their eyes' (Bourdieu, 1984: 318).

In summary, the reflexive critique of the survey method recognizes that survey answers alone cannot easily articulate what liking *means*, how it is felt in the body, or whether the choice or preference of the participant is their *actual* choice or preference or merely that which is emerging from the discursive struggle of the research encounter. Assuming that participants are telling the truth about their choices, their reasons for their choices becomes, in this light, an epistemological position that merits interrogation. In a research study which, as critics such as Rancière have observed, so much of the emphasis is on what is assumed to be *hidden* from respondents, the survey encounter seems to require a kind of acknowledged naivety in relation to the asking and answering of questions.

The tendencies of surveys to *simplify* and to *create* opinions which otherwise would not exist in relation to specific questions or topics are partly addressed by the analytic strategy of looking at variables

holistically across fields. In doing so Bourdieu draws on what were radically innovative techniques of statistical analysis. The now infamous diagrams which appear throughout *Distinction*, visually representing the relationships between tastes, preferences and various socioeconomic groups, are generated through the application of a variant of Correspondence Analysis. As with the rest of the methods outlined above, specific engagement with this strategy, which is central to the story of *Distinction*, is relatively rare, even among those scholars who have been critical of Bourdieu, at least outside France. In Anglophone social science it has been a rather marginal strategy in late twentieth century and early twenty-first century cultural analysis, allowing Bennett et al.'s (2009) study – which draws from an updated version of the methodological template of Bourdieu – to be the largest and most sustained inquiry based upon Correspondence Analysis in British sociology to be published some 30 years after *Distinction* (Figure 2.1).

According to Desrosieres (2012), Correspondence Analysis as a technique emerges from the work of the mathematician and statistician Jean-Paul Benzecri. It was attractive to Bourdieu's approach to taste for a number of reasons. First, it was a direct riposte to the variable-centred

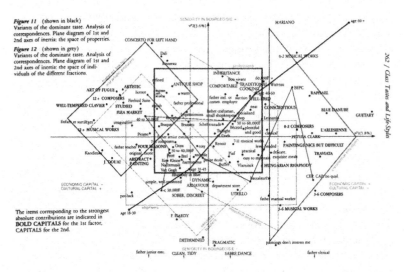

Figure 2.1 Variants of the dominant taste. Reprinted by permission of the publisher from *Distinction: A Social Critique of the Judgment of Taste* by Pierre Bourdieu, translated by Richard Nice, p. 262, Cambridge, Mass.: Harvard University Press, Copyright © 1984 by the President and Fellows of Harvard College and Routledge and Kegan Paul, Ltd

techniques more common within social sciences, especially those which were strongly influenced by economics. Such approaches, with their emphasis on identifying causal relationships and, in the case of opinion polls or market research, to do so in order to inform proposed courses of action, are undermined by their focus on small numbers of dependent and independent variables separated out from the reality of human experience. This was unsatisfying for Bourdieu, for whom, as Lebaron outlines, 'social causality amounted to the global effects of a complex structure of inter-relation, which is not reducible to the combination of the multiple "pure effects" of independent variables' (Lebaron, 2009: 12). Far from identifying causality, Correspondence Analysis was seen as descriptive and exploratory, allowing the patterns between a range of variables to be presented visually, at the same time, without imposing any underlying assumptions about their meanings. Moreover, the technique counters one of the anxieties of the critics of positivism that statistical analysis necessarily privileges aggregates over individuals and therefore denies the complexity of individual experience by fetishizing the average. Indeed Desrosières describes how, in the wake of May 1968, this multidimensional aspect 'seemed to be proof of pluralism and democracy, and not simply one-dimensional and reductive' (Desrosières, 2012). Its *visual* presentation invites interpretation rather than imposing meaning. The proximity of locations on the constructed geometric space indicates relative similarity between categories and individuals or groups, and the interpretations of the axes that divide the geometric space explain, rather than determine, the structure of that space. In Bourdieu's general schema, these axes represent the relative volume of capital, from high to low, and the composition of capital, from cultural to economic. So in Figure 2.1 the left side describes the data from those survey participants within the dominant class who have lower incomes yet the highest level of cultural competence in relation to items of legitimate culture (their incomes range from 40,000 to 50,000 francs, they visit the modern art museum, they like the *Well-Tempered Clavier*), and the right side features those with higher incomes and assets but with tastes which are less consecrated. It is an opposition between higher educational teachers and artistic producers on the left and commercial employers on the right, and it represents the key taste cleavage within the dominant class.

The ability for this technique to visually array manifold items and practices at the same time made it perfectly suited to Bourdieu's broader theoretical concern to identify tastes as part of a more holistic 'habitus', so we see tastes for music alongside knowledge of musical

works, preferences for art and income, and so on. This also allows, crucially, the meanings of items and practices to be interpreted *in relation* to one another, making the kinds of geometric space constructed through Correspondence Analysis exemplars of the 'fields' of human activity; the technique, as Bourdieu later described it, ' "thinks" in terms of relation' (Bourdieu and Wacquant, 1992: 96). In the light of subsequent critiques that Bourdieu's conception of the relationship between taste and social class is *deterministic* and inescapable, this relationality is important. Bourdieu can reasonably claim that the oppositions that he identifies between legitimate and popular forms of culture are not fixed for all times and places. The items and practices which are constructed as legitimate or popular might change over time and space, but the opposition between legitimate and popular can be predicted to remain constant provided that the structural opposition between capitals remains. It is a prediction which appears to ring broadly true with subsequent attempts to follow a Bourdieusian model of exploring tastes in the UK (Bennett et al., 2009), Finland (Kahma and Toikka, 2012) and Denmark (Prieur et al., 2008), albeit that the nature of the relationships, and the meaning and urgency of the experience of tastes, which even Correspondence Analysis analysis cannot reveal, are perhaps of a different order from those laid out in *Distinction*.

The following section will explore some alternative means of identifying cultural tastes, hierarchies and practices which followed in the wake of Bourdieu. I conclude this section by considering two critiques which have engaged directly with the relationship between research methodologies and their claims. These return us to the difficulty of identifying relationships between two variables – in this case taste and social class – which are both somewhat fuzzy and ontologically insecure. The ready presence of the empirical is a significant strength of the analysis of *Distinction*, but its construction, as subsequent scholars (Hennion, 2001, 2007, Lahire, 2008, 2011) have shown, also relies on some heroic assumptions about the kind of thing 'taste' is, the kinds of thing 'classes' are, and how the relationships between these two things can be meaningfully identified through the technologies of social science, including the statistical analysis of a survey. Interestingly, tastes for music – another ontologically insecure category – are at the heart of these critiques.

Rancière caricatures Bourdieu's approach of asking survey questions which are either about, or assume, musical knowledge (of pieces, of composers) to get at musical taste as 'a typical examination situation where, of course, students from the university get the best grades'. Such

critiques perhaps go with the survey design territory, but more damning is the charge that the sociologist 'will judge musical tastes without having anyone hear music' (Rancière, 2004: 187). Instead the survey creates an inevitable and artificial distance between the expression and experience of taste – between in our terms the *sensation* of tasting and the possibility of the immediate interpretation of its sensory affect and the articulation of a *sensibility* or disposition in relation to tasting. For all of its strengths – of co-opting the language of objective social science as part of a struggle in sympathy with those who are assumed to be excluded from 'legitimate' culture – such an approach constructs tastes as things which research participants *remember* in relation to their representation of themselves, rather than as a thing which they *experience* at least in the research encounter. This remembering is both in relation to the stories that they tell themselves about the kind of person they are and the stories that they tell researchers about the kind of person they want themselves to be seen to be. They may not like Beethoven or the novels of Jane Austen, but equally they might be keenly aware that these are the kinds of music or reading material that a person 'like them' ought to appear to like.

It is this insight that informs the observation from Antoine Hennion that it is only in the survey encounter that the articulation of taste as an abstract consequence of social determinants (nominally class) can emerge. In his work (2001, 2007), largely based upon ethnographic observation and interviews with 'amateur' music lovers, he describes a need to de-*sociologize* his participants by not asking about what they *like* or what they *know* about music but by asking them to describe what they *do* in relation to their musical practices. The logic of this is twofold. First, it is a methodological attempt to prevent the kinds of game-playing of the survey encounter in which those in the cultural know either anticipate the 'correct' answers or those outside it reproduce the assumptions of the taste and practices of people 'like them'. In the situation of the survey,

> Music lovers immediately feel guilt, suspected; they are ashamed of their pleasure, they decode and anticipate the meaning of what they say, accuse themselves of a practice that is too elitist, and over-admit the ritual nature of their rock outings or love for opera . . . Instead they put themselves in the categories they suppose are being held out for them and have only one concern: not to appear unaware of the fact that their taste is a sociological question.
>
> (Hennion, 2001: 5)

By contrast, the interview for Hennion 'frees discourse from the weight under which the sociology of taste has crushed them by denouncing these emotions as cloaking a social game of which the actors are not aware' (Hennion, 2001: 5). As important, though, is the starting point of Hennion's inquiry: that taste is not a thing which can be methodologically separated from the experience of tasting – it is a *process* that only exists in the act of tasting.

If Hennion's differing conception of what taste *is* implies a different strategy to capture it, a second critique, evident in the work of Bernard Lahire (2008, 2011), starts from a different conception of *who* does the tasting. While Bourdieu's methods – and in particular the use of Correspondence Analysis – reflect a recognition of the limits of social aggregates, the weight of the analysis remains on identifying the relation between socioeconomic *groups* or *classes* and the tastes they exhibit. In *Distinction*, more significance is attributed to the existence of relationships between things which are *the same* in hierarchies of culture (legitimate, middle-brow, popular) – that is, that *confirm* the theory of class habitus – than is to the existence of relationships which are *different*, and therefore challenge it. In Rancière's historical analysis of aesthetically informed working-class writers (2012) we get a hint of the limits of this – their very existence being a profound challenge to the contemporary iteration of the long-established scholarly and class-inflected division between workers of the hand and workers of the head. The presence of working-class likes for operatic works, or for literature, might be possible in Bourdieu's schema but they are either too statistically marginal to challenge the overall thesis or, in the case of autodidacts, rather dismissively constructed as arriviste tastes, not quite tasting 'correctly'.

These 'exceptions' become the focus of the analysis of Bernard Lahire (2008, 2011), who seeks to develop and fulfil the promise of the concept of habitus into a paradoxical 'sociology of the individual'. This is a controversial notion in the imaginary of social science where 'the individual' is often constructed as the ideological domain of economistic, psychological or psychoanalytic modes of inquiry that have been conceptualized as allies of individualism and its attendant politics. For Lahire, such an anxiety – evocatively constructed as being similar to rejecting the study of molecules in order to study planets – is limiting, and it has consequences for the kinds of claim that can be made about individual experience in social analysis. He suggests that

> intra- and inter- individual variations in phenomena are not 'error'
> or 'noise' that the sociologist should systematically eliminate with a

view to establishing general laws or general social facts (transcendent in relation to individuals). They are, rather, bound up with the macro-social structures of the societies within which individuals develop.

(Lahire, 2011: xvi)

The analysis in *Distinction* constructs commonalities of taste across different fields of culture and different classes as evidence of the differential class habitus. This transforms those individuals who appear in the analysis, in the form of interviews – such as the foreman who likes art but doesn't know artists' names (Bourdieu, 1984: 393), the baker's wife who likes television as long as it doesn't 'try to be clever' (Bourdieu, 1984: 349) – into representatives of their class whose tastes are presented to us as *typical* of the tastes of that class. This kind of employment of individual experience to exemplify the group, for Lahire, 'may become a deceptive caricature once it does not have this illustrative status, but is taken as a particular case of the real' (Lahire, 2011: 12). There is a paradox here that a statistical relationship which is initially identified in order to trouble or question individual experience is crystallized into a kind of ideal type which can then gloss the variety of individual experiences. Lahire's analysis seeks out this variety by the construction of individual taste profiles from the data of a 1997 survey of French cultural practices. He focuses on tastes for music, literature, film, television and preferred choices of cultural 'outing', defined in relation to which things were done more *frequently,* and classifying these into 'legitimate' and 'illegitimate' forms. He categorizes these individual profiles as either consonant (i.e. reflecting the kind of homology which Bourdieu's construction of the class habitus would predict) or dissonant (i.e. in which participants choose from across legitimate and illegitimate types of culture). Far from being exceptional, the 'dissonant' taste profiles that he identifies represent the *majority* – that is, it is *more* common for individuals to have a mixture of items in their taste profiles from 'legitimate' and 'illegitimate' categories. This can perhaps be partly explained by the difference in the cultural field in late 1990s France from the France of the 1960s and 1970s – and these exogenous changes to cultural production and consumption recur in the development of subsequent empirical challenges to Bourdieu, discussed below. Equally important, though, is having the individual and their tastes, in all their messy and annoying empirical complexity, as a starting point, rather than as a zoological illustration of a set of characteristics which are attributed to apparently coherent and solid classes.

Such tensions – between the individual and the social, between the objective measurement and the subjective interpretation of taste, and between the empirical research moment and the lived experience of tasting amount to a methodological conundrum, which even *Distinction* for all of its empirical weight and reflexive narrative complexity did not completely solve. The following section explores subsequent attempts to contribute to the resolution of this problem, based on the methods underlying the empirical study of taste since Bourdieu, principally in relation to what has become known as 'the cultural omnivore' thesis.

Making the cultural omnivore

The 'cultural omnivore' has become something of a shibboleth in early twenty-first-century cultural sociology. Emerging in the 1990s as a surprising finding in relation to the patterns of participation in cultural activities as revealed by survey analysis, it has spread to be arguably the most significant empirical development since Bourdieu of a social scientific theory of taste and has generated a significant number of comparable studies across Western Europe and North America. Peterson (2005) provided a useful staging point to document these but, in the ten years since this review, further studies have contributed to an impression that, at least within the specialist academic journals of empirical cultural sociology, the omnivore is omnipresent. Much of the dimensions considered by subsequent chapters, and specifically dimensions in relation to the *production* of taste, the *globalizing* of taste and the *digitalizing* of taste, are in the shadow of insights provided by these studies, and these chapters will draw on, elaborate and critique some of the substance of this work. My purpose in this section is to reflect most specifically on the methods through which omnivorousness has been identified, again with a spirit of recognizing the complexity of conducting empirical work on questions of culture. What the ongoing debate about the significance, or indeed the very *existence*, of the cultural omnivore reveals is the relation between claims about taste and the methodological processes that underpin their construction.

A working summary of the initial discovery, made by Peterson and Simkus in 1992, and based on the analysis of part of a survey conducted in 1982 on US cultural participation, is that people within higher occupational groups were no longer exclusive in their tastes in the ways in which Bourdieu's homologous vision of the relation between social and cultural hierarchy might maintain. Instead there was evidence that this group was selectively incorporating items that might previously have

been dismissed as popular or mass culture. The finding was repeated by Peterson and Kern in 1996, based on the 1992 running of the same survey data, and the debate about the scale, scope and significance of the omnivore began. Readers revisiting these initial contributions now in the light of subsequent responses to them might be surprised by the relative modesty of the claims made. These contributions are clearly *not* about the *end* of distinction through taste *per se* but about an end to simplistic notions of snobbishness which preclude the possibility of elite groups liking any kind of popular culture. These claims are also accompanied by a series of speculative explanations about the democratization of the arts by the mass media, the end of single standards of value in the art world, the role of popular culture in intergenerational politics and the possibility, established in broader surveys of global cultural values such as that by Inglehart (1990), that the spread of liberal forms of education was generating more tolerance for others among broader populations. Some of these explanations are clearly more contested than others, but none is in any way implausible with the benefit of 30 years of hindsight.

In accounting for the controversy generated by the concept – at least as measured in articles and citations – Peterson (2005) himself indicates a possible relationship with the increased interest in and infrastructure of the collection of large-scale public data on cultural participation in North America and Western Europe, which brought this kind of data more easily under the lens of curious sociologists. It is a spread which may well also reflect an increased state concern with economistic conceptions of the 'human capital' of their populations which might be revealed by these kinds of data. We might equally suggest that the shifting landscape of academic production in this period also makes the critique of an existing concept – especially one as challenging of established sociological and lay understandings of the role of taste in social and cultural life – a more cost-effective use of one's time than developing a new one.

The original studies identified omnivores in ways which were deceptively simple and specific. First, they are based solely on tastes for *music* as they are revealed through survey questions about musical preferences in relation to lists of genres that are constructed into a hierarchy of highbrow (opera and classical music) middle-brow (easy listening, Broadway musicals) and low-brow (country music, bluegrass, gospel, rock and blues). As Peterson and Kern (1996) explain, this is a reflection of the design of the particular survey, where only questions relating to tastes for music were based on such a variety of possible options. Subsequent

studies have repeated this focus on musical preferences as evidence of omnivorousness, even if they have taken different indicators of music (attendance at events rather than preference in the case of Chan and Goldthorpe (2006)), different methods of statistical analysis (e.g. recreating a directly Bourdieu-inspired Correspondence Analysis approach in the case of Savage and Gayo (2011)) or, as we'll see, more qualitative techniques (Atkinson, 2011, Bellevance, 2008, Rimmer, 2012) to explore omnivorous musical tastes. Some exceptions to this general trend of focusing on music are provided by studies which attempt a more holistic approach to culture in the round, taking in other fields, such as reading, film, preferences for visual art (Bennett et al., 2009, Ollivier, 2008, Warde et al., 2007, 2008), or those which take specific fields, such as reading (Zavisca, 2005) or comedy Friedman (2012), and explore the possibility of omnivorousness within them.

The principal survey strategy that is most common to omnivore research reproduces some of the charges laid at Bourdieu's door. Peterson (2005) himself notes some of these weaknesses in a commendably frank discussion of the problems of conducting and analysing large-scale public surveys. The very subject of these surveys – and their relation to public institutions of various kinds (e.g. the National Endowment for the Arts (NEA) in the USA and the Arts Council in the UK) – leads to the operationalization of culture in ways which reflect the priorities of these institutions with 'official' or 'legitimate' forms. Such surveys then recreate and reproduce an assumption of general *non*-participation in a population which simply doesn't do the things it is asked about. Problems of this kind can be factored into subsequent analysis of surveys, but more practical problems remain. These include the change, from 1982 to 2002, in the volume of accessible telephone numbers, the number of proxy respondents (up to 40 per cent in 2002) who filled in the survey on behalf of someone else, and the varieties of participant and indeed interview fatigue that accompanied the fact that in 1982 and 1992 the survey on cultural participation was carried out alongside a survey on the experience of crime, or that in 2002 the survey was conducted on a hot day in August. To these problems – which we might interpret as typical of the great methodological turf wars of late twentieth-century social science – are more specific critiques pertaining to the process of constructing omnivorousness as a research object.

First among these is what kind of *quantity* is omnivorousness? What is the category and how does one qualify to be in it? In its early iterations, omnivores were identified first through identifying people as *high-brows* according to whether or not they liked classical music or opera. Such

people were subsequently found to be relatively wealthier and relatively better educated, but the starting point was their *tastes*. Liking musical forms beyond the high-brow was not unusual (Peterson and Kern report that from their samples of over 11,000 participants they found only 10 exclusively high-brow respondents in 1982 and only 3 in 1992). However, to be an *omnivore* did not mean simply traversing the boundaries between high-, middle- and low-brow but the extent to which it was done. In 1982 high-brows chose 1.74 of the possible 5 low-brow genres as preferences and 1.98 of the three middle-brow genres. By 1992, all of these numbers had increased, leading to the reasonable conclusion that high-brow omnivorousness was increasing and that exclusivity (which was assumed to indicate snobbishness) was on the wane. This model of constructing the omnivore, which Warde et al. (2007) characterize as being concerned with *volume* (i.e. the relative amount of culture liked or participated in), and the relative *composition* of preferences or practices (i.e. how they relate to a constructed hierarchy of 'high', 'middle' and 'low' forms of activity) recurs, with most subsequent studies drawing on both and some focusing on one. Katz-Gerro and Sullivan (2007), for example, refer to 'voraciousness' rather than omnivorousness in relation to their study of volume and frequency of participation; Savage and Gayo (2011) also suggest that some significance might be attributed to the intensive liking and participation *within* rather than across genres in their exploration of emergent forms of cultural expertise.

A second issue concerning the construction of the omnivore relates to the place of *positive* preferences or practices, and their relative value as an indicator of the end of the *negative* judgement of snobbishness and an increase in tolerance of the tastes of others. Most studies of omnivorousness begin with likes and practices, though some (Bellevance, 2008, Ollivier, 2008, Warde et al., 2008) consider dislikes only as part of a qualitative phase. A substantial and revealing contribution to the methodological toolkit which has been less taken up by subsequent studies is Bethany Bryson's (1996) focus on the patterning of *dislikes*. This is an important contribution to an understanding of taste as part of a social struggle in which the formation of oneself is done in relation with and in judgement of others and their tastes. Again based on survey research, but this time incorporating Likert Scale questions, which allow some sense of the *intensity* of distaste to emerge, Bryson discovers that increased levels of education do tend to decrease levels of exclusivity in tastes, at least as expressed through the relative dislike of music from outside high-brow categorizations. This leads her to speculate that 'political intolerance and cultural dislike may be

two forms of the same phenomenon-based symbolic exclusion' (Bryson, 1996: 891). The intriguing corollary to this is that the identified toler-ance is itself patterned in that it embraces certain non-high-brow genres, including Latin music, jazz and blues, which might be reflective of what Bryson intriguingly calls 'multi-cultural capital', but rejects others, such as heavy metal, rap, country and gospel music. In Bryson's analysis, these last four also happen to be the forms of music that are most liked by participants with the lowest educational levels. This raises the possi-bility of a strategic exclusion at work in which judgements of tastes and distastes also stand for judgements about the people who hold them.

It also raises a final practical concern about the construction of the omnivore through relative preferences for genres of music. As Bryson has it, 'data cannot tell us what respondents have in mind when they think of each genre' (Bryson, 1996: 895). A debate within the sociology of culture and cultural studies about the solidity of genre as an indicator of taste (see Frow, 2006, Lena and Peterson, 2008) is especially apposite in the contemporary context of cultural production and distribution, which will be addressed in Chapter 5. The *practical* problem of genre is central, though, to the construction of the omnivore through survey work in at least two ways. The first, implied by Bryson and explored by Silva and Wright (2008), is that responses to survey questions about genres require equivalence between the meanings of the genre label on the part of researchers and their meaning to survey designers. Silva and Wright's example of the misinterpretation of the category *film noir* in a survey of British tastes reflects this; some participants had the rela-tive educational and cultural experiences and knowledge to interpret this genre in the way in which survey designers intended, while others interpreted it as 'old black and white movies', and still others rejected an assumption of continental sophistication in the label ('that's a bit posh – why don't you just say "black"?'). The very possibility of these interpretations raises significant questions about the solidity of genre as a category which can bear the weight required of it in the construction of the omnivore – questions which Rimmer (2012) suggests seriously undermine its usefulness to understanding musical taste in particular.

This possibility relates to the second substantive problem with the use of genre to identify omnivorousness, the constructions of hierarchies of genres which omnivores are assumed to traverse. Clearly if genres them-selves are unstable, then these hierarchies are too, but some attempt to construct them is necessary for the omnivore thesis to make any sense. In doing so, most analysts seem to follow both Bourdieu, and Peterson and Simkus, in relying on a commonsensical construction of hierarchies

of legitimacy in which classical music and opera are legitimate or high-brow and other genres are placed in relation to them according to criteria which are, at best, opaque. This kind of tacit assumption belies the possibility that genres can move up and down hierarchies over time (an insight which Peterson himself brings to bear on the 'aesthetic mobility' of jazz in the USA; 1972) or that distinctions *within* genre categories might be more significant than distinctions between them. Savage and Gayo (2011) discover the consequence of this in their analysis of classical music genre in the UK where, in the Correspondence Analysis of the associations between likes for genres and specific items within them, 'the boundaries of the classical music genre appear to exclude contemporary classical composers but actually include mainstream easy-listening music such as Frank Sinatra' (Savage and Gayo, 2011: 344). Such insights might remind us that the 'brows' as much as the genres which make them up are as much moments in the research encounter as the expressions of preference themselves, without a wholly reliable life beyond that moment.

From *quantities* to *qualities*

One response to the limitations of the survey method in interrogating tastes in general and the omnivore thesis in particular has been to either complement or replace survey questions with those of the qualitative interviewer. While such approaches necessarily lose the ability to make grand and authoritative claims about general trends, the potential advantages of this include allowing the researcher to explore in a more discursive and in-depth way the meanings of preferences and practices within more limited populations which have been identified and selected as theoretically interesting. Post-Bourdieu research on tastes for art among the urban elites of New York (Halle, 1993), or on the different strategies of symbolic boundary-drawing of the French and American upper classes (Lamont, 1992), have used this technique productively. It is also in relation to this approach that the empirical traditions of the sociology of culture intersect and overlap with those from the cultural studies tradition, wherein the more focused attention provided by smaller-scale and ethnographic work on the everyday practices of specific groups have shown how people previously assumed to be the 'masses' are engaged in complex and creative ways with the things they love, whether it be pop music, television or genre fiction. In the specific context of debates about the omnivore, the use of interviews, employed for various ends, allows some of the claims made for the omnivore to

be explored in a more immediate way by allowing participants to artic-
ulate the meaning of their tastes and practices, rather than having those
meanings assumed or read into the statistical relationships between vari-
ables. The principal methodological problem, given that the omnivore
is essentially a *quantitative* concept here, is how to identify *a priori* a
population of 'omnivores' without first doing the required kinds of
counting – that is, without tacitly assuming that omnivorousness is a
kind of objective state of a specific sector of the population or just a
synonym for the professional classes. There have been a range of possi-
ble solutions to this problem in those more recent studies which have
sought to explore omnivorousness in a qualitative way.

Warde et al. (2007, 2008) employ a mixed strategy which identifies
individual survey participants as omnivores using a scale of likes and
practices and then analyses interview transcripts in search of the mean-
ings of omnivorousness. This allows them to critique a singular vision
of the omnivore, and instead to propose a variety of *types* of omnivore,
including a *professional* whose tastes reflect their employment in the
wider cultural industries, a *dissident* whose tastes imply a self-conscious
rejection of cultural hierarchies, an apprentice whose tastes reflect
an inquisitive learning mode to cultural participation associated with
an upwardly mobile person at a specific stage of the life-course, and an
unassuming omnivore, the variety of whose tastes seems to have very lit-
tle intrinsic meaning save that of reflecting the broadened opportunity
to consume a variety of culture through contemporary media.

Similarly, Ollivier began her exploration of the varieties of openness
to culture inspired by the omnivore debate by identifying a sample of
potential interviewees from around Quebec. Having identified 41 inter-
viewees, she began the research encounter by asking participants to
indicate their levels of omnivorousness via a survey form made up of
questions about activities, musical genres and artists/entertainers from
an official survey of cultural participation. This allowed her to classify
people as *omnivores* both in relation to their relative position on these
scales (around a third of her sample scored in the upper quartiles on
two out of the three scales) or if they expressed omnivorous-sounding
attitudes to tastes such as 'I like a bit of everything' or I 'like to try
new things' (this latter formulation was, interestingly, almost universal).
Attuned to the concern that questionnaire instruments about partic-
ipation *reproduce* the phenomena that they seek, Ollivier constructs
the object of her analysis not as the identification of her participants'
preferences or practices but 'rather how they choose or feel compelled
to present themselves to the university researcher in the interview

situation' (Ollivier, 2008: 127). A qualitative analysis of these inter-view transcripts again generated a variety of ways of being open to cultural experiences. Two of these – the *humanist* and the *populist* – resonate most closely with the omnivore thesis. The former is a characteristic of more traditional high-brow respondents who recognized the pleasures of some forms of popular culture, albeit often ironically. The latter is more associated with a middle-brow sensibility, or one of cultural goodwill, in which a range of activities are engaged in but fewer from the high-brow classifications. Of equal interest, though, are the *practical* mode of openness and the *indifferent* mode. Here the former are univores by the quantitative measure, but they express a desire for self-improvement – if not through the arts and culture then through 'acquiring practical information that is useful in everyday life' (Ollivier, 2008: 139). The latter by contrast *say* that they like things and express very few dislikes but decline to name the genres and practices that they like.

Ollivier interprets this as reflecting a weak investment in cultural life, but it might also, in the light of Hennion's critique of the 'sociologizing' tendencies of research into taste outlined above, indicate a refusal of, or retreat from, the implied or perceived judgement of the interview encounter. Such examples indicate that interview encounters also have their limitations in the methodological quest to *know* taste. They might offer glimpses of the complexity that survey encounters appear to miss, but raise significant questions of their own. In the light of these identified weaknesses of the sociological toolkit, this chapter concludes with some consideration of techniques which are emerging to challenge it.

New – and neu – ways of knowing tastes?

One inspiration for the writing of this book was the experience of working on an empirical project into British tastes, published as *Culture Class Distinction* (Bennett et al., 2009). This was a mixed-method empirical inquiry into the tastes and lifestyles of the British population, which drew on a comprehensive survey of a range of cultural preferences and practices. The completion of the project took, from the time I began working on it (already some years after its principle architects had begun the process of designing and securing funding for it), about six years, including the analysis and publishing the findings. Some of these findings, which indicated the persistent relationships between demographic groups and their cultural preferences were received, at least outside of the world of academic cultural sociology, as Figure 2.2 illustrates, with

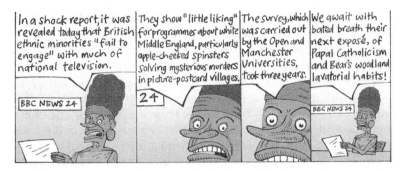

Figure 2.2 From 'Media Tarts', *The Guardian*, November 2006, reproduced with kind permission of Andrew Birch © Andrew Birch

some bemusement as representing what might be termed the sociology of the bleeding obvious. Such is the lot of empirical research.

Towards the end of this process I needed a new pair of shoes. Being unable to find the brand and style I preferred in local shops, I visited the online retailer Amazon, at this time expanding significantly beyond its original remit to sell books and into other realms of retail, including music and fashion. For me, as for many academic researchers, Amazon's vast available catalogue had become a default search engine for works which were often difficult, or at least less convenient, to get hold of quickly through traditional book retailers, but I had not, as yet, used it to buy anything other than books. Despite this, having located my desired shoes on the site, Amazon's recommendation algorithm indicated to me that customers who had bought the shoes that I wanted had also bought a list of music CDs. I already owned four of the titles on this list.

Such stories about the apparent prescience of contemporary forms of recommendation have become more banal in the years since, and the role of new technologies in reshaping tastes will be explored in more depth in Chapter 6. For now, though, this story reveals something important about the processes of knowing and measuring tastes and how they might be changing both within and beyond the realm of cultural sociology. A contrast might be made between the slow-moving production of academic knowledge whose findings, for all their insight, are difficult to translate beyond their contribution to the apparently rarefied and arcane theoretical debates and the instant and instantly useful findings of the digital age, which might themselves generate considerable sociological insight if used appropriately. What might the apparent similarities between choice of shoe and choice of music say about the

habitus of the then thirtysomething middle-class male professional from northern England, Bourdieu might ask?

This Amazon experience is an exemplar of a broader set of developing methodological issues which have questions of taste at their heart. The journalist Chris Anderson outlines the possible consequences of these kinds of digitally generated data for established ways of knowing the social world in his speculative assertions about 'the end of theory' in the light of the possibilities afforded by large amounts of transactional information married with algorithmic tools for predictive analysis. 'Forget taxonomy, ontology, and psychology,' he declares. 'Who knows *why* people do what they do? The point is they do it, and we can track and measure it with unprecedented fidelity. With enough data, the numbers speak for themselves' (Anderson, 2008). The story is also emblematic of what has been termed the crisis in empirical sociology (Savage and Burrows, 2007) in which the sociology's brief post-war period as the key discipline for knowing social life has been usurped by other more apparently innovative ones. The concern with preserving a 'critical edge' to cultural analysis in the sociological toolkit has, according to this story, allowed the cutting methodological edge to move away from the social scientific bit of the academy and into a commercial world that is increasingly oriented around the reflexive forms of strategic activity that characterize what Nigel Thrift (2005) has referred to as 'knowing capitalism'. While academia might satisfy itself with being more critical or nuanced in its engagement with its research questions, data about tastes and preferences are routinely gathered elsewhere, as part of the everyday commercial operations of companies seeking to gain market advantage, and being permissive and creative in their methods to do so. These forms of data self-consciously aim to tell commercial organizations what people – reimagined as consumers – like to do and what kinds of meaning they generate from their practices.

Savage and Burrows emphasize the forms of data generated by commercial credit-management organizations such as MOSAIC, which combine geodemographic data with data about lifestyles, or the kinds of 'transactional' data about *actual* consumer preferences that emerge from contemporary shopping technologies such as the TESCO clubcard loyalty scheme. This multilayered aspect, linking choices to places and to the people who live in them, is also important to the ACORN consumer classification system operated by the information services and technology company CACI. The ACORN system draws on a significant range of public and commercial data about neighbourhoods, postcodes and the households that make them up to create finely grained pictures of the

UK population. There are 6 broad categories divided into 18 subgroups and a further 62 segments, each relating to identifiable types of neighbourhood and searchable by postcode, allowing access to data about the most common family type, relative income, place of birth, relative level of reception of benefits and, in keeping with the concerns of contemporary marketeers, the extent to which residents engage in social media and with online forms of marketing. As one might expect from research designed as a resource primarily for commercial organizations, descriptions of these social categories use preferred brands or stores as tacit cultural signifiers (e.g. John Lewis versus Poundland). They also reveal that households in the 'large house luxury type' within the 'lavish lifestyles' group of the 'affluent achievers' category 'read the *Financial Times* and broadsheet newspapers', and that here, 'typical leisure interests might be golf, culture, wine and antiques' (ACORN, 2014: 14). Moreover, households in the 'fading owner occupied housing' type from the 'modest means' group of the 'financially stretched' category engage in 'a range of leisure interests amongst which bingo, angling, rugby league and gambling might feature slightly more highly', while 'In addition to *The Star, Daily Mirror*, or *The Sun* some will read celebrity, TV, women's or travel magazines. It will not be unusual to see *Sky* dishes along these streets' (ACORN, 2014: 68). This is a complex, empirically generated classed imaginary which would not look entirely out of place within *Distinction* itself.

These kinds of data potentially represent, for Savage (2010), a kind of endpoint to the development of a longer social scientific imagination, providing a level of holistic detail that not even the most sophisticated Correspondence Analysis diagram has yet achieved. While sociological methods have tended to oscillate between the individual and the social, such forms of data have the potential to allow the individual, in the case of transactional data, and the household or postcode, in the case of geodemographic data, to be grasped *together* at the same time with the broader social context of which they are a part. As the sociologist Richard Webber, one principal academic architect of the MOSAIC system, suggests, the scale and reach of these forms of data represent a significant improvement on conventional social scientific methods, 'where self-reporting and lower sample sizes make the salience of people's responses uncertain' (Webber, 2009: 177). Questions of taste are central to these developments, with 'word of mouse' acts of 'liking' and 'recommending' emerging as both a consumer guide for individuals looking to satisfy their needs and desires according to their tastes and, at the same time, for accumulated data generated by these acts of liking

and recommending to be a significant research resource for advertisers and marketeers in developing new products and services to meet those tastes. We'll revisit the implications of these new methods in Chapter 6.

These empirical questions – about tastes as choices or preferences – seem some way from the grand philosophical questions about the role of tastes in the formation of people and as expressions of social relationships which underpinned the theoretical reflection in the previous chapter. A further challenge to the exclusive authority of the social sciences to elaborate on these questions comes from another highly visible form of contemporary knowing that has emerged from the natural sciences and, specifically, from the neurosciences and their application in commercial contexts. The growth and development of the techniques of neuroscience can be seen precisely in the context of a longer tradition of philosophical inquiry into the very meaning of being human with tastes, as part of human desire, identity and the formation of personhood being bound up with this story. The concern with tastes in this emerging tradition seems to be based either on the exploration of the experience of *art* as part of a general concern with questions of perception, or on the identification of universal patterns of brain activity in relation to forms of consumer preference which can then feed into the development of marketing and product development. Responses to these kinds of development within the social sciences and humanities, as Rose and Abi-Rached's cultural history of neuroscience explores (2013), have been characterized by the kinds of defensive wholesale rejection or territorialism that is typical of previous skirmishes in the wars between the arts and sciences, or between the positivist natural sciences and the critical social sciences, or between accounts which privilege external structures and histories in their knowledge-making and those psy-disciplines which privilege the internal world.

There has also been an enthusiastic embrace of neurological explanations for the experience of art on the part of some artists or humanities scholars as if these developments reveal the definitive proof that they were right all along about the specific magical stuff of their concern. As the neuroscientist Raymond Tallis (2011) points out, this is somewhat ironic given the insistence of critical humanities scholars, at least since the 1960s, of the inter-relations between the natural sciences and various forms of power structure. There is, of course, a clear conceptual link between the identification of a neural basis for the appreciation of beauty and Kant's concern with aesthetics as the very science of perception, and the logical assumption underlying such a move might be that, as with other material aspects of our humanity, 'our aesthetic

preferences were forged in the 80,000 generations of the Pleistocene era rather than the mere 500 generations since the first societies' (Tallis, 2011: 61). There is also a move within social theoretical perspectives more broadly, hinted at in the discussion in the previous chapter about the theoretical explanations of affect and the senses, to emphasize and examine the *embodied* nature of human experience. Experience needs a body to capture it – and bodies and brains have responses, including sensory responses, which can be identified and measured. Such questions perhaps provide the basis for scholars within cognitive psychological and physiological disciplines to turn their attention to understanding the experience of art, (e.g. Tröndle and Tschacher, 2012), but they also provide a logic for scholars in art history to add the methods of neuroscience to their analyses (Onians, 2007, Starr, 2013). The appreciation of the qualities of literary texts and music has also been a focus of interest for neuroscience that has also been embraced by humanities scholars and critics, again as if the addition of a neurological explanation for these forms gives them credibility or authority which they somehow lack otherwise. Rose and Abi-Rached, for example, report the novelist A.S. Byatt's gleeful comments about the 'discovery' that experimental subjects' neurons remain active for longer at the sound of Shakespeare's sonnets, thus supposedly indicating some intrinsic 'hard-wired' superiority of Shakespeare, as if centuries of legitimation had not established this superiority in any case.

The second concern, that brain activity can help us to understand tastes, desires and motivations in the contexts of marketing and product development, has become a staple of the news cycle. In recent months while I have been writing this book, studies have claimed to reveal the identified brain activity of viewers of television and film as being predictive of the likely future popularity of those products (Costandi, 2014), and also that 'deep brain stimulation' has been responsible for the development of obsessive tastes for the singer Johnny Cash (Woolf, 2014). Perhaps this appetite for and fascination with the neurological aspects of preferences explains its crystallization into the disciplines of neuromarketing or consumer neuroscience, which a special edition of the *Journal of Consumer Behaviour* proclaims ought to be considered as a 'scientific sub-discipline in its own right' (Senior and Lee, 2008: 264). Researchers in this field attempt to draw on the forms of medical and psychiatric expertise which have been dedicated to identifying neural explanations for pathological forms of consumption, such as addiction or compulsive forms of eating or gambling, and apply them to more everyday choices. McClure et al. (2004), for example, use brain-imaging

technologies to reveal the relative activation of the hippocampus and the right dorsolateral prefontal cortex when self-identified Coke drinkers are told that they are about to get a drink of Coke. Berns and Moore (2012) use an intriguing approach of scanning the brains of adolescent music listeners during the playback of 15-second clips of 20 newly released songs from a range of genres and combining this with both asking participants to rate their preferred songs and collecting data on the relative subsequent success of the songs as provided through indicators such as downloads and sales. They select music as an especially appropriate 'product' to be tested in this way both because of the ready presence of metrics of success and because the act of listening is a direct sensory experience, rather than one that is filtered through the traditional approaches of knowing consumers, the sample survey or the focus group. Their intriguing finding is that subjective song ratings did not correlate with subsequent commercial popularity, but that activity in the brain – and particularly the ventral stratium, which has, we are told, been identified by previous research in neuroeconomics with predicting future purchasing decisions – did. Berns and Moore explain the logic of their experimental approach and its relation to other methods of identifying preference in the following way:

> Asking an individual how much they like something requires several cognitive operations, including the initial processing of the stimulus, referencing similar items with which the individual has experience, projection of future utility, all of which may be subject to framing effects of the experiment. In contrast, brain responses in reward-related regions are likely to reflect sub-conscious processes and may yield measurements that are less subject to cognitive strategies. This would be especially true during the consumption of music, which occurred during the listening phase of our experiment. Thus, while the act of rating something requires metacognition, the brain response during the consumption of the good does not, and the latter may prove superior to rating approaches.
>
> (Berns and Moore, 2012: 159)

Of course, such findings – as with all of the empirical findings outlined above, can be subject to critical scrutiny. In this case, in addition to the critiques of the solidity of genre outlined in relation to the omnivore debate, we might ask to what extent the advantage of the direct sensory experience of music is ameliorated by that experience taking place in a scanner, rather than in the more familiar spaces of teenage music

listening. We might also ask how solid the indicators of success are, given that neither purchasing nor downloading are the same experience as *tasting* or even *liking* – points to which we will return in Chapter 5.

Much of the more reasoned critical response to the rise of neuroexplanations, such as those from Tallis, and Rose and Abi-Rached, accept the possibility that the technical developments in neuroscience can add to our understanding of the human condition. They also point out the heroic assumptions that are required to equate causal relationships between the kinds of activity identified on brain scans with actual behaviour in the real world, and critique the rush to identify neurological solutions for all forms of human experience or problems as a form of neuromania. The data from brain scans, which so frequently accompany the popular media reporting of neuroscientific stories, are not pictures of brains but, as Rose and Abi-Rached explain, translations of quantitative data about molecular activity projected onto an image of the average brain, with the colours that represent relative levels of activity imposed upon it. Much as the survey of cultural taste constructs its object and then defines its absence in relation to the brain scan, 'as the process disappears into the product, the illusion of transparency is crucial to the effects of truth' (Rose and Abi-Rached, 2013: 79).

Such criticisms are the lot of anyone attempting to do empirical work on human behaviour. What is intriguing here is that these new forms of neuroknowing aesthetics or preferences, somewhat paradoxically, *remove* the human as a potentially untrustworthy and ultimately unnecessary piece of this process of knowledge production. This may be a similar assumption that underpins the 'the hidden' world of culture with which Rancière critiqued Bourdieu's method. In assessing the relative utility of these new and 'neu' methods in understanding taste, though, there is a significant difference between on the one hand recognizing, as Bourdieu and subsequent empirical scholars of taste in the sociological/cultural studies tradition did, that the expression of preference is a fragile and contradictory element of a complex research interaction and, on the other hand, assuming that people don't have conscious access to their own desires and wants.

These points are extensions of what we identified in relation to earlier approaches as ontological and epistemological assumptions about the kinds of things people are, and how their thoughts and motivations can be accessed, which are overlain with stark ethical assumptions about people and their capacities. They are also assumptions about what tastes are, as elements of choices or motivations under various degrees of conscious or personal control. In reflecting on all of them I have attempted

in this chapter to direct the reader to the relation between claims made and the processes of the production of evidence that underpins those claims, and I ask the reader, in assessing the claims made in the subsequent chapters about other dimensions of taste, to keep this approach – sceptical of the empirical but also attuned to its difficulties – in mind. In the light of the new and 'neu' methods, it may be that the traditional methods of social sciences – the survey, the interview – are feeling their age and that new forms of data, including neurological data, can contribute to our understanding of the phenomenon of taste, either as an embodied sensory phenomenon or, in the case of the digital data which accompanies new taste practices, by allowing us to reimagine the processes by which tastes come to be formed. There is also some value in retaining the flawed and complex *human* part of the problem of the measurement of taste that more established methods allow. If, in Hennion's memorable phrase, 'one does not like wine or music as though one has tripped over a rock' (Hennion, 2007: 108), it is unlikely if one does these things as though one is attached to sensors or clicking an icon of an upraised thumb on a website. In keeping with the assertions of the previous chapter, which implied a role for a holistic understanding of the place of taste in perennial questions of how we come to live together, Hennion's conception of the *process* of tasting is as a 'collective technique whose analysis helps us to understand the way we make ourselves to become sensitized to things, to ourselves, to situations and to moments, while simultaneously controlling how those feelings might be shared and discussed with others' (Hennion, 2007: 98), which is useful here in reminding us of the potential political and ethical motivations for the empirical study of tastes. Taste in this sense is not something that reveals hidden social determinants, however well established, nor cognitive processes which are beyond conscious understanding. Rather, it is a set of active responses to these determinants and the world that produces them.

3
Governing Tastes

The focus of this chapter is on the role that strategies of government play in giving shape to taste, with a particular focus on questions of *policy*. The chapter will argue that relations between taste and the political context in which tastes are contained are something of a hidden dimension and one with both a significant history and a revealing present in the British experience of cultural policy. Three aspects of this dimension can help to introduce this discussion. The first is the relationships between tastes for specific cultural objects and practices and forms of national *identity*. Indeed, one might argue that the construction of national identity only emerges alongside the cultural representations through which it is expressed – notably print cultures or 'literatures' (Anderson, 2006, Casanova, 2007). Such relationships place considerable emphasis on managing what might be identified as *national* culture in a context of global cultural flows which, depending on one's point of view, either swamp and dilute national cultural forms or generate optimistic post-national cosmopolitan taste cultures. The former anxiety has been an abiding one for cultural and media studies, and was very much present in post-war Europe as jazz, milk-bars and streamlined aesthetics in design became the battlegrounds for struggles between established and emergent forms of taste culture. While these anxieties, in Hebdige's (1998) account of the *cartography* of post-war British taste, were felt at the level of the grumbling of cultural elites and critics across the political spectrum, elsewhere in Europe explicit policies of cultural protectionism were designed to guard against the swamping of national cultures, specifically from US-generated mass cultures. This was a taste position bound up with political, cultural and strategic struggles of this period, and this geographical element of the mass culture critique will

be returned to in the following chapter in relation to the possibility of *global* taste cultures.

While the abiding ideological struggles of post-war propaganda might feel less immediate in the contemporary landscape, a more recent and interesting policy response to the question of national tastes has emerged in debates about multiculturalism in Europe. It is found in the attempts to create and circulate national *canons* of cultural artefacts, and to claim, for various ends, that tastes for, knowledge of and orientations towards these artefacts can be indicative of national cultural traits or even *values*. In the UK's recent history such interventions range from former prime minister John Major's wistful evocation of George Orwell's cricket and warm beer version of Englishness in the mid-1990s, Tony Blair's more apparently inclusive 'Cool Britannia' celebration of the UK's commercial creative industries and, most recently, in the inclusion of questions about Jane Austen, Chaucer and Gilbert and Sullivan as part of the UK's national citizenship test for potential immigrants.[1] Elsewhere in Europe, responses have included attempts to create, through broad consultation, national cultural 'canons' in response to the apparent crises in national identity wrought by the flows of people and things that accompany globalization. The Danish example, *Kulturkanon*, published in 2007, attempted ambitiously to indicate an official version of what constituted Danish culture in the fields of the visual arts, music, architecture, film, literature, design and children's culture. This canon included such diverse items as the Lego block, Hans Christian Andersen and, much to his dismay (Falconer, 2010), the avant-garde film director Lars Von Trier's *The Idiots*. Knowing and, presumably, *liking* such items is, by implication, a route to an appreciation of 'Danish values' for non-Danes (and potential Danes), as well as a resource for Danes through which their 'Danish-ness' can be judged in the context of the confusing and destabilizing processes of global cultural and economic flows. Notwithstanding the effectiveness of such initiatives (which have also been attempted in the Netherlands and Latvia), or indeed whether such canon-making is desirable, they provide interesting evidence for an abiding critique of taste as a matter of personal and individual choice. In such contexts, tastes are more than social; they are *political*, and bound up with the kinds of people that are assumed or desired to inhabit national territories. Such policies construct taste as, partially at least, the business of the state.

A second aspect, less urgent perhaps but similarly expressive of this relationship between taste and government, is revealed by examples of how questions of taste intervene in the performance of national

politics – in ways which recognize that personal tastes are also social signals which have significant political resonance. Tastes for music demonstrate this tendency nicely, with the pre-campaign establishment of a candidate's 'personality' increasingly likely, in the contemporary period, to include a question of the type 'What is on your iPod?' The singer Ian Bostridge's (2011) collection of essays, memoir and reportage bemoans this development as itself emblematic of what he describes as an illusory 'bad conscience of a triumphant Western bourgeoisie' (Bostridge, 2011: 65), in which politicians fall over themselves to declare their musical tastes as a badge of their democratic credentials. Such efforts are a subtle recognition that classical music, which is Bostridge's stock in trade, no longer carries the authority it once did. The associations between certain types of taste or practice and the possibility of 'elitist' exclusion are more tacitly recognized here as political figures attempt to establish themselves as men/women 'of the people'. Such interventions have the potential to backfire. Barthes' famous essay on 'Wine and Milk', for example, reports the reaction in France to President Rene Coty being photographed with beer – rather than the wine which represents the earthy, moral life-blood of a nation. It was, Barthes suggests, 'as intolerable as having a bachelor king' for the French Republic because, he continues, wine is 'part of the reason of the state' (Barthes, 1993: 60). The widespread ridicule that attached, in 2006, to the then chancellor and soon-to-be prime minister Gordon Brown's apparent enthusiasm for the emerging Sheffield-based rock band *Arctic Monkeys* became, in the subsequent 2010 electoral campaign, yet more evidence of his lack of a common touch and inauthenticity.[2] The response to the man who replaced him, David Cameron, who expressed enthusiasm for alternative, even anti-Thatcherite, rock bands, such as *Radiohead* and *The Smiths*, was similarly sceptical. Such taste claims might have indicated, or been designed to indicate, Cameron as a 'modern' Conservative, attune with contemporary popular culture – and even, given his own background, to establish some 'anti-establishment' credentials. In the latter case, though, *The Smiths*' guitarist Johnny Marr's outrage at the notion of a fan of his band emerging from the ranks of the Tory establishment might indicate that, while Cameron likes *The Smiths*, they do not like him. Such examples might be sorry indictments of the 'fluff' of contemporary political life, but they also indicate the extent to which personal likes and dislikes are implicated in powerful narratives about *character* and the qualities of people which have, or are at least are assumed to have, substantial political influence in contemporary democracies.

These relationships between taste, politics and policy underpin our discussion in this chapter and feed into the final aspect. If, as Chapter 1 outlined, conceptions of taste revealed by historical philosophical, sociological and theoretical accounts are bound up with the formation of modern personhood, in the contexts of cultural policy these processes coalesce with the role of the modern state in producing and managing its citizens. How, then, do cultural policies and the forms of evidence and assumptions which inform these policies give shape to contemporary tastes? What is the role of *taste* in the performance of contemporary forms of government, as represented through the priorities of cultural policy? In answering these questions, the policy problem of *reading taste* is chosen as an area which has received relatively little critical comment as part of contemporary cultural policy debates, compared with, for example, the subsidized arts or museum sector. This is perhaps partly due to the position of such tastes on the 'boundary' between cultural policy and more general policies in relation to education and training – a boundary which follows closely the topology of *skill* and *sensibility*. The historical anxieties about reading and literacy, though, exemplify and are archetypal of a number of current policy debates, specifically around what has been characterized as a 'deficit model' of cultural participation. Here the *problem* of cultural participation is identified through observation of the tastes and practices of marginal groups, and geared towards their incorporation and training into what is constructed, ostensibly by cultural policy-makers, as *better* tastes and practices – with the qualities that make such practices *better* defined as aesthetic, moral and economically useful. Here, then, my aim is to reflect on the kinds of evidence corralled into debates about reading and the kinds of problem which evidence-based policies are assumed to address in the light of the multidimensional nature of contemporary tastes.

Theory, state and policy

It is noteworthy in making these connections with the broader sociological understanding of taste that, in cultural policy analysis, Bourdieu's models, as outlined in Chapter 1, have been useful in revealing the persistent and enduring relationships between taste, class and cultural consumption (1984), and in shedding light on the tensions between culture and commerce in cultural production (1993, 1996). The former source is arguably the more influential in policy-making circles, with its insights into the relationships between taste and social class being partially integrated into policy narratives, by way of a broad acceptance of a

relationship between social class and cultural participation. As Chapter 1 discussed, it was the relative ease of the translation of the assumptions of citizens and their apparent capacities into the policy priorities of the powerful that is at the route of Rancière's objection to Bourdieu. The implications of these relationships might not be, as we shall see, recognized or taken up in quite the ways Bourdieu intended, but the notion that certain sectors of society feel out of place or uncomfortable in art galleries or museums, for example, would be uncontroversial to contemporary actors in the field of cultural policy.

Ahearne (2004) points out that Bourdieu's emphasis on the value of a critical theoretical distance from the state belies the partial origins of his empirical and intellectual project in state-sponsored research. *The Love of Art* (Bourdieu, 1990), for example, emerges from an instrumental research project commissioned by the French Ministry of Cultural Affairs. While the findings of this research, about the relative levels of participation of the whole population of France of the 1960s in the 'highest' forms of publically funded culture, would be relatively uncontroversial or even unsurprising to contemporary surveyors of cultural practices, his conclusions and proposed solutions were controversial. If tastes for such arts derive from inherited dispositions, and if the ability to appreciate their codes are not innate and universal, then a project to *democratize* culture should, Bourdieu argued, attempt to teach these dispositions and abilities more broadly. As Dubois points out, such a set of recommendations, focusing on *education* policy rather than *cultural* policy *per se*, fell foul of the French Ministry of Cultural Affairs' attempts to construct itself as a standalone agency within government. Moreover, policy actors within the ministry retained a profound commitment to what Bourdieu would critique as culture's charismatic ideology – its magical abilities to confer meanings and values by its mere presence. Dubois outlines how French cultural policy-makers spoke of culture as 'the substitute for religion that would preserve a sense of community and of spiritual values in the midst of a secularized, materialist society' (Dubois, 2011: 500). A commitment – such as that suggested by Bourdieu – to the desacralization of culture as a route to a more genuine democratic cultural policy was unlikely, then, to be received with much enthusiasm. These intergovernmental struggles reveal that, inasmuch as the formation of the French Ministry of Cultural Affairs marked a key moment when taste became a concern of modern government in Europe, the question of which arm of government would take a lead in its management or regulation was far from settled.

The project of identifying and managing tastes which the French Cultural Ministry embarked on with Bourdieu, though, has more contemporary resonance in the field of cultural policy, where *instrumental* policies based around a conception of what culture (or perhaps more specifically 'the arts') can do have formed the discursive frame for debates within cultural policy studies of the UK, the USA and Europe for a quarter of a century or more (see Matarasso, 1997 for the foundational account of this relationship in the British context, and Belfiore and Bennett, 2008, Merli, 2002 for the critique). This emphasis in cultural policy, particularly intensive in the UK since the general election victory of the New Labour government in 1997, for all its apparent novelty is a continuation of the kinds of managerial struggle over resources and prestige within government such as those outlined by Dubois in France. Together with rather persistent nineteenth-century visions of culture and its role in shaping individuals, these struggles suggest that taste is not simply a benign add-on to the workings of government in such areas as law and order, health or the economy. Instead it is better understood as being central to the *practice* of government in the creation and shaping of particular types of subjectivity within its citizens. Taste, here, crudely reimagined as choices relating to the best use of leisure time, is one element of a broader conceptualization of behaviour and conduct – of *sensibility* understood as a tacit preferred orientation to the cultural world and to other people within it. Bennett (1995, 1998), for example, outlines the relationship between the establishment of the 'museum', in the Foucaldian (Foucault, 1973) tradition of the institutions, both physical and cultural of the modern state, and the establishment of correct forms of conduct among and between visitors to a museum, of silence, reverence, awe before the assembled objects. Producing the person here becomes, through the practices of the state and its cultural institutions, part of a process of managing and regulating citizens. This historical dimension is also important in considering what is at stake in contemporary cultural policy debates in Western societies, and the ways in which policy-makers conceptualize and solve these problems of management and regulation in more apparently benign, democratic and inclusive contexts, albeit that these contexts still 'require' particular types of people, such as citizens, consumers or flexible workers. Bourdieu's theoretical tools provide both the means to identify which cultural tastes and activities get recognized and labelled as 'worthy', and an outline of the field of policy on which battles between intrinsic and instrumental approaches to policy in the formation of these kinds of people are played out.

Bourdieu remains useful for a second reason here, as Chapter 5, which focuses on the relations between the cultural industries and the *production* of tastes, will outline. For Bourdieu, the *field* of cultural production, as part of the more general field of power, is organized around two poles. The first *autonomous* pole attracts agents that are committed to the production of art for its own sake, and goals of producers and consumers relate to the accumulation and redistribution of cultural capital, as determined or defined by the critical appreciation of cultural elites. We might label this the *intrinsic* pole in the contemporary policy imagination. For agents that are close to the opposite, 'heteronomous' pole, success is more easily *quantified*, measured by commercial success, ticket sales, print runs or positions on bestseller lists, which translate cultural capital into a more immediately visible economic capital. In the context of the concerns of cultural policy, it is this latter pole that is relevant to the consideration of how culture is put to work by government in the field of power, and how processes of measurement and quantification, in relation to social impacts and outcomes, represent an extension of forms of *heteronomization*. In the British context in particular, the identification and measurement of such outcomes become the aims which cultural organizations adopt to justify and lobby for public funding. In the shifting cultural imaginary of tastes, though, a heteronomizing influence is more economically useful, as tastes are implicated, as we shall see, in debates about *skill* in a flexible economy and even debates about national competitiveness in a global economy. There is, within the policy imagination, the conception that doing more of certain types of activity will generate various forms of measurable *capital* at both the individual and the national level. Critical attention to the basis of the judgements about which types of activity are valuable and for what purposes returns us to the question of taste.

It is important to recognize here, though, that the distinction between heteronomization and autonomy is complex. Although in his later work on the media (Bourdieu, 1998b) heteronomy became short-hand for the pernicious influence of the market on culture and also on politics, Bourdieu recognizes that a commitment to *autonomy* on behalf of cultural producers is also part of the *illusio* of the game of culture, preserving what counts as worthy for those who are able to define it as such. It is here that we can see the relevance of Bourdieu to the 'backlash' against impact and measurement within the arts community. While the weight of recent critical commentary on issues of instrumentality posits that it represents a threat to the perceived *intrinsic* value of culture, Gibson's reassessment (2008) reminds us that such

a perspective also hands over 'rationales for culture's management to those who believe that cultural funding and management needs no justification and should not be "accounted" for because certain people "just know" what is worthy' (Gibson, 2008: 250). In other words, it represents a return to the charismatic ideology of culture which spreads its goodness magically without any need for that to be demonstrable or accountable to those upon whom its magic works. The valorization of 'autonomous' forms of cultural production by critics of instrumental policies denies the extent to which the commitment to autonomy on behalf of cultural producers is itself complicit in the position of those producers as agents in the field of power – that is, in the masking of the relationship between specific tastes and abilities manifest in the volume of accumulated cultural capital and their associated positions, particularly class positions, in social space. It is a distinction between the assumption of value on the part of those in the cultural know and the attempt to quantify value on the part of those concerned with either economic profits or social and political impacts. This emphasis places considerable importance not simply on whether or not culture has an impact – the terms in which the instrumentality debate has largely been framed – but the ways in which such impacts are identified and measured. The next section will outline the specific problems which have been identified, in pinning down a role for the state in questions of literacy, literature and tastes for reading. These include the establishment of a relationship between reading, literacy and literary taste, and an agenda geared towards equipping a population with the requisite competences for work in a changing economy. As this plays out, as we shall see, the distinctions between *skill* and *sensibility* begin to collapse.

Identifying the policy problem

In reflecting on the contemporary cultural policy milieu, George Yudice (2003) refers to the *expediency* of culture in the policy imaginary, evident in the systems through which the myriad of managers and administrators within the various agencies involved in policies of cultural production mediate between artists, funding bodies and communities. He suggests, 'like their counterparts in the university and the business world, they must produce and distribute the producers of art and culture, who in turn deliver communities or consumers' (Yudice, 2003: 12). Such a conception of cultural policy, in particular the idea of policy-makers 'producing' and 'delivering', emphasizes the role of research and evidence in this operation. Miller and Rose characterize the operation

of political power in the contemporary state as exercised 'through a multitude of agencies and techniques, some of which are only loosely associated with the executives and bureaucracies of the formal organs of state' (Miller and Rose, 1990: 1). In order to successfully complete its operations, contemporary government makes its claims based on particular kinds of evidence as a means of garnering support for and measuring the value of its various initiatives. Thus

> The events and phenomena to which government is to be applied must be rendered into information – written reports, drawings, pictures, numbers, charts, graphs, statistics.... This form enables the pertinent features of the domain to literally be *re-presented* in the place where decisions are to be made about them.
>
> (Miller and Rose, 1990: 7)

In such a light, processes of measurement are bound up with the process of *creating* the problems of government, shaping and marking the discursive terrain upon which government practices can operate. We have seen in Chapter 2 the complexities involved in the measurement of cultural taste and participation – complexities which, when critical attention is paid to them, might seriously undermine the solidity of statistical relationships between taste and social class in sociological analyses. Such uncertainties are all well and good in the context of sociological debate. They are less useful to government where legitimacy rests, rhetorically at least, upon the robustness of the categories upon which policies can be seen to act. For the purposes of this chapter, this process of representation, through the identification and measurement of impact and outcome, can be interpreted as a form of heteronomous influence in maintaining the position of the field of cultural production in the field of power. Here we consider this impetus using an analysis of recent policy initiatives, research and campaigns focused on reading tastes from the USA and the UK.

Reading and the participation in literary cultures has been given a distinct status in accounts of cultural life, being bound up, in the cultural imaginary of post-Gutenberg Western Europe at least, with powerful narratives about the development of Enlightenment projects of self and political forms of liberation. McLuhan (1962) adds another important aspect to an appreciation of literacy, given the role of print culture in training the *senses*. For McLuhan the rise of print culture instigates a process through which the senses become separated from one another, and trained to bracket out the experience of the world as a whole from specific media of communication, requiring concentration, attention

and *skill* to make print *sensible*. The rapid rise of print culture in the realms of administration in the context of the modern state quickly elides the requirements of education with the training of the senses in the concept of *literacy*. Reading, then, also has a pivotal place in the development of cultural policy. One recurrent characteristic of this status is a vision of reading and literary culture as somehow under threat from the pernicious influence of other forms of culture, audiovisual, electronic or digital, with this threat being symptomatic of more general societal crisis. These conceptions have a long and contradictory history. In the sixteenth century the publisher Robert Copland notably prefaced his edition of the poems of William Neville, *The Castell of Pleasure*, with the lament 'bokes be not set by, their time is passed. I gesse', and he complained about the role of that age's parenting by suggesting that 'men let theyr children use all such harlotry, that byenge of bokes they utterly deny' (quoted in Williams, 2001: 178). Such complaints, based on a conception of books as *special* kinds of object and of reading as a *special* kind of cultural activity, have a modern-day ring to them. In such a light it is noteworthy that, as Graff (1979) points out in his history of literacy, it was not until the mid-nineteenth century that the political and economic elites of Western societies finally came down entirely positively on the side of mass participation in print culture. This was achieved through educational programmes aiming towards universal literacy – an innovation that also belied the extent to which the working classes of the period had already taken responsibility for their own literacy education (Rose 2001, Vincent, 1981). Prior to this period, political opinion had been divided about the subversive possibilities of a literate poor and its effects on social order (Bratlinger, 1998, Carey, 1992). Arming citizens with the technical skills to read, it was argued, raised the possibility that they would be drawn to read the wrong things, or to read them in ways which were not sanctioned or socially useful.

Ultimately, though, literacy and its general spread throughout a population was a mark of *progress*. More than that, in the nineteenth century it was the primary aim of progressive politics, 'the final milestone on the road to Utopia' (Disch quoted in Graff, 1979: 6). At the end of the nineteenth and early in the twentieth century, literacy, synonymous with education, was the central route to social stability, but at the same time literacy removed from a clear moral appreciation of its appropriate uses was also considered to be potentially subversive:

> Literacy, the medium for training, consequently, was rarely seen as an end in itself. More often its possession or absence was assumed to represent either a symbol or a symptom of the progress in moral training

or an index of what remained to be accomplished through the educational systems embracing all the children of the community.
(Graff, 1979: 23)

The key finding of Graff's work is that, while the relationship between literacy and forms of progress and development is claimed by governments and other agencies, it is not one that is consistently observable. In the context of his historical study, he argues that while 'illiteracy could be depressing, occupationally or economically... literacy proved of remarkably limited value in the pursuit of higher status or greater rewards' (Graff, 1979: 198). Such a finding remains controversial in the contemporary context, but the question of the *causality* of the link is still valid when an industry of benevolently inspired educational scholars, campaigners and non-governmental organizations continue to seek to establish relationships between literacy and various social problems. We will consider examples of this below, but to echo debates from Chapter 2 about the inter-relationships between our knowledge of tastes and practices and their *measurement*, this type of research largely draws on quantitative indicators of reading activity (e.g. the number of books in the home) or qualitative accounts of, typically, children's experiences of, attitudes to and preferences for reading, and relates them to a range of variables that can be summarized as indicative of social exclusion. The relationship in the policy imagination is clear though, with distant echoes of Graff's construction of nineteenth-century literacy campaigners. Despite levels of literacy themselves expanding, a deficit model of literacy – that is, a belief that people, or certain people at least, are not or are no longer reading – emerges as the prominent policy concern.

This paradox perhaps explains why it is a characteristic of policy discussions in this area that the categories of *literacy* (i.e. the technical skills of reading and writing and their relative importance to processes of active citizenship, or indeed active and enabled personhood in contemporary societies) and the *literary* (i.e. a specific orientation towards particular aspects of print culture) are run together in the policy imagination. In our terms the *skill* is elided with the *sensibility*. Critical historical researchers in literacy, such as Graff, and analysts of more contemporary literacy programmes or practices in the USA (Fernandez, 2001, and especially Stuckey, 1991), argue vigorously that literacy, far from being a neutral and benign means of education or enlightenment, is caught up in historical struggles about the moral conduct of 'the masses' and about the useful requirements of the modern workplace.

To illustrate this we might consider the inflation in the requirements of an individual to achieve the classification 'literate' from the 'signature literacy' of seventeenth- and eighteenth-century Europe, to a form of functional literacy which enables the kinds of interpretation of written and symbolic materials required by a complex economy. In the contemporary context, 'even the ability to read is no longer taken to be adequate literacy. In the twenty-first century minimal standards for literacy insist on the ability to make inferences, to carry out complex comparisons, and even to think critically and creatively' (Fernandez, 2001: 5). At the same time, and perhaps more contentiously still, a further shift can be identified towards the kinds of *cultural* literacy based on the minimum level of knowledge of a nation's cultural output, envisioned by American writers such as Hirsch (1987) and Bloom (1994), and made manifest in the kinds of canon-making initiative outlined at the start of this chapter. Such transformations illustrate the extent to which literacy is a form of *capital* whose value decreases and increases largely on the terms of powerful agents in the field of cultural production – including policy-makers.

Alongside this shifting definition of literacy is a shifting definition of what literacy is *for*. Historians such as David Vincent (1981) and Jonathan Rose (2001) remind us of the place of autodidacticism in the quest for an urbanized, industrialized working population to escape from its categorization as a 'mass' through the mastery of the cultural tools of educated elites. In the contemporary context the value of reading maintains echoes of these struggles over who has access to information, and of romantic narratives of self-discovery and fulfilment. At the same time, though, the contemporary cultural imaginary of literacy is also bound up with dominant ideological understandings of the *value* of all cultural practices within the field of power, and is not therefore entirely neutral or benign. This kind of *expediency* of literature represents another continuation with the past. The public library service, for example, as Patrick Joyce has pointed out, was founded in the mid-nineteenth century with a desire to create citizens as a central motive (Joyce, 2003). Policies surrounding literacy continue to be linked with this educative project, reimagined for contemporary conditions, which are, Stevenson points out, more complex:

> If, during the industrial period, factory labour required a kind of mute repetitiveness, and democracy the development of symbolic capacities beyond the need from the body to labour, then this is no longer the case in the modern economy. The modern knowledge economy

requires the reproduction of workers who are flexible and mobile, but above all with good linguistic, affective and communication skills.

(Stevenson, 2010: 346)

The category of the *literary* is arguably even more contested, as definitions of what counts as literature are embedded in claims to expertise and aesthetic forms of value which underpin institutional and objectified forms of cultural capital. Such debates are a staple of literature departments in universities as scholars attempt to broaden the canon to include various types of genre fiction (sci-fi, crime, romance) and various categories of author. In its manifestation in policy terms, the question in relation to literary tastes has historically combined a paternalistic concern with governing how leisure time is spent with recognition that the products of writers, as with other artists, are an assumed social good. The state's primary role here is in the consecration, via the education system, of legitimate forms of reading material, tastes for which can be cashed in as cultural capital. Although the notion of the literary canon has been thoroughly deconstructed through the various movements of cultural and literary theory of the latter part of the twentieth century, and the struggles for literary recognition of women and people of colour (Corse and Westerveldt, 2002, Guillory, 1993), it retains a pull for policy-makers in the identification of literature as a concern of government. This concern with protecting the literary is not simply confined to the institutions of education but also crystallizes around questions of the autonomy of literary work from both the patronage of the state and the pressures of the market (Sapiro, 2003). Examples might include legislation on the price protection of books, abandoned in the UK in 1994, or the continuation of Arts Council support for small independent presses framed through a rhetorical commitment to the social value of a 'marketplace of ideas'. It is this rhetorical commitment to the apparently unique capacities of the products of the literary industry to contribute to the culture of a nation which informs the continued position of literary activity within more general cultural hierarchies, as they come under the remit of policy. This notion of a *useful* literature is currently manifest in at least three ways.

First, it is present in the distinctive forms of contribution that tastes for reading and literary production is assumed to make to both the social *and* economic policy goals of the UK. The Arts Council's (2007) restatement of its priorities for literature in the UK until 2011 included both. In it the council pledged support for independent forms of publishing in the light of conglomeration and consolidation in the publishing

industry (a firm commitment to the autonomous pole in protecting literature from the market), and placed the production of and engagement with literature as central to its general goals of 'audience development' and social outreach work. Drawing on evidence on the role of literature in prisons, health and education, it argued that, 'Literature can have a powerful effect on our lives. It can help us explore the world and understand ourselves and others' (Arts Council England, 2007: 4). The characteristics of the 'specialness' of literature among the arts are also claimed by the English professor and critic John Carey, who, in his polemical attempt to prick notions of utility in the world of the arts (Carey, 2006), makes an exception of literature by virtue of what he describes as its 'thought-content', its unique tendency, ability or essential quality that leads to readers being 'forced continually to assess and discriminate between alternative personalities, opinions and world views' (Carey, 2006: 259). This ability is socially useful, he argues, in a number of ways in the late-modern age, in ways which participation in the visual arts or the performing arts, and certainly the participation in non-literary popular cultural pursuits associated with electronic and now digital media, are not and could not be.

Second, literature's ability to contribute to the broader articulation of integrative *national* values also has some contemporary provenance. Pascale Casanova has argued that,

> Because language is at once an affair of the state and the material out of which literature is made, literary resources are inevitably concentrated, at least initially, within the boundaries of the nation itself. Thus it is that language and literature jointly provide political foundations for a nation and, in the process, enoble each other.
>
> (Casanova, 2007: 34)

In such a vision, certain literary works are the terms upon which inclusion in a national community can be claimed. This symbolic or ceremonial element to literary practice is revealed by Priscilla Parkhurst Clarke, who begins her study of literary France with reference to the symbolic position of the graves of consecrated writers, Voltaire, Rousseau and Victor Hugo, in prominent national monuments. Their physical position here as much as their work – and much less their contemporary readership and any judgement on whether readers actually *like* such works – sustains a sense of inter-relationship between literature and nation. The position of these kinds of public writer, for Parkhurst Clarke, reflects an assumed ability 'to articulate a sense of country that both comprehends

and transcends politics' (Parkhurst Clark, 1987: 4). Thus, participating in literary cultures can be socially and politically useful as a means of integrating diverse populations. This again has been a key tenet of the impacts that cultural policy might have in New Labour discourse since 1997, where the promotion of values of an inclusive Britishness took place in the light of the various national anxieties wrought by the changing internal and external political and economic structures of the UK.

In the light of both of these strands of the 'contribution that literature can make', recent policy initiatives have focused on the perceived value of reading *together* in a continuation of a Putnam-style (2000), 'social capital' inspired thesis which posits cultural participation as a corrective to the assumed isolating effects of a range of aspects of late modernity and notwithstanding the central contribution of print culture itself – 'the technology of individualism' (McLuhan, 1962: 158) in McLuhan's terms – to these effects. Such an approach finds its most recent policy incarnation in publicly organized mass-reading events in which a particular region, city or nation is encouraged to read identified titles. Fuller and Rehberg-Sedo (2013) provide a full exploration of this phenomenon and its complexities. Such initiatives, with their links across numerous institutions within the book industry, have come to exemplify the beliefs of policy-makers that culture can do civic work and contribute to the social good.

Reading tastes are, then, significantly loaded in policy terms. The tactics and orientations involved in contemporary policy campaigns to influence tastes for reading reflect the role of policy both in changing the shape of the contemporary literary field and in the repositioning of tastes for reading within the broader field of cultural production. The following section explores this in relation to the concerns about reading tastes which emerge from contemporary policy research and initiatives.

Evidence for reading tastes

A key problem of cultural policy research, identified, for example, by Selwood (2006) and Belfiore and Bennett (2008), is the weight that relatively weak forms of evidence are required to carry in order to sustain substantive policy justifications. This is a problem that results partly from the inherent complexity of identifying and measuring cultural activity and its impacts. The distinction between forms of critical, objective research and advocacy in the realm of cultural policy has been

reflected on by Belfiore and Bennett (2009) in their consideration of the difficulties in precisely identifying what constitutes 'the arts', or even what precisely constitutes a specific artform such as 'the novel'. This ontological fuzziness can be identified in the narratives emerging from the range of evidence conducted in reading tastes, literacy and the literary, and their relation to both grand policy narratives connected with education and the economy, and what might appear to be more mundane and contested choices over how individuals choose to spend their leisure time. This section will examine the discourses that emerge from some recent national and international research associated with policy initiatives which explicitly attempt to identify and offer solutions to the problem of tastes for reading.

A key point to emphasize here, though, is that the existence of this problem is empirically far from clearly demonstrable. The 'deficit' model of participation in reading activities, which frames policy debates in the literary field, might receive little empirical support from recent sociological work on the spread of reading as a form of leisure practice. In her review of the available quantitative evidence relating to reading across the world, Griswold (2008) maintains that, while mass participation in *book* cultures represented a relatively brief moment in late nineteenth-/early twentieth-century life in the USA, Europe and Japan that preceded the rise and spread of electronic forms of communication, reading maintains a central place in the daily lives of the vast majority of people. Rates of 90 per cent or more participation are identifiable in recent survey evidence of daily reading activities if newspapers, magazines and online forms of reading are taken into account. The technical skill of *literacy* has reached near universal levels in the global North, and reading is a rather mundane or taken-for-granted part of the infrastructure of everyday life. This has been accompanied by what Griswold terms the rise of 'the reading class', characterized by the intensive participation of the economically and educationally successful in *literary* culture. A similar finding emerges from Bennett et al.'s (2009) account of taste in contemporary Britain where, alongside the intensive participation of higher occupational classes in book cultures, there is a tacit acceptance across social classes and ethnicities of the *value* of reading as a means of arming oneself and especially one's children with the requirements of modern life. If, then, reading is a cultural practice that the state is required to persuade people to engage in, its benefits are far less controversial than those of visiting the theatres, museums or art galleries which policy research and the instrumental/intrinsic debate about culture has tended to be organized around.

However, the belief that certain people are not reading, or not reading enough, or not reading the right things remains central to contemporary literacy initiatives. This begins to shift the debate away from questions of *skill* and towards questions of *sensibility*. Twenty-first century policy research has complicated a concern with the identification and improvement of the technical skills of literacy by focusing more on literary practices, attempting to uncover not whether or not people read, but whether or not they read 'voluntarily' or 'for pleasure'. The series of reports produced in the USA by the NEA (2004, 2006, 2009) have been especially influential in shaping this idea, and their galvanizing of social and political concerns has allowed them to become a model for the framing of policy debates in this area internationally, including in the UK. The story that emerges from these reports begins with *Reading at Risk*, published in 2004. An analysis of the US Census Bureau's 2002 survey of cultural participation among adults, this research begins with the statement that explicitly weaves together these concerns with broader questions of citizenship, suggesting that

> If literacy is the baseline for participation in social life, then reading – and reading of literary work in particular – is essential to a sound and healthy understanding of, and participation in, a democratic society.
>
> (NEA, 2004: 1)

In the context of contemporary American life, this assertion is met with evidence that literary reading (defined as respondents answering positively to questions about reading any novels, short stories, plays or poetry in the previous 12 months) had declined in relation to a range of variables. A 10 per cent decline overall is the headline figure, though this is a fall from a relatively healthy figure of 57 per cent of American adults engaged in reading literature in 1982. Given the specificity of the definition and its exclusion of non-fiction books and other forms of reading practice, this might equally be interpreted as a remarkably high figure given the many other leisure practices that were available to Americans at the end of the twentieth century. The report also recognizes, but does not celebrate, the fact that the number of books sold in the USA in the previous 25 years had tripled, or that the proportion of people participating in literary cultures was higher than identified leisure activities, including sport. How much reading and of what kinds of material, we might ask, in the light of these kinds of assertions would be *enough* for the kinds of civic engagement which the NEA describes to flourish? The implication of this kind of data is that reading, knowing about and

having a feeling for certain types of book and certain types of literature – namely, national canonical novels, plays and poems – has been, and to some extent continues to be, indicative and constitutive of particular forms of national population, regardless of the extent to which this knowledge reaches numerically across the population of a particular bounded national space. This is in a way that the knowledge of other cultural forms – most specifically popular mediated cultural forms – is not. In his recent redrawing of literary culture as a multidimensional, multimedia phenomenon, Collins (2010) critiques the NEA's findings for failing to recognize the porous nature of the category of the literary, its detachment from the object of the book and its diffusion across television and film cultures. Similarly, Carter, discussing the various roles of cultural institutions in forming national cultures in Australia, suggests that 'we have scarcely begun to talk about literature as a form of public-commercial-aesthetic institution comparable to cinema, television or popular music' (Carter, 1999: 141). Acknowledging the suspicion of the concept of 'the nation' within critical literary studies and the tendency, within the Australian context at least, for those texts defined as nationally canonical to be taught in ways which critically deconstruct their relation to the nation – or their nationalism – 'can we', he asks, 'take seriously the idea of literature having a role in forming good citizens?' (Carter, 1999: 139). Is it desirable or sustainable to continue to think of literature as a public good, in the ways which appear to hold sway in contemporary policy narratives, without also giving similar thought to how other forms of narrative culture, including those which have traditionally been cast as literatures 'other' – notably film, television and increasingly digital cultures – might have these same roles. Doing so, or not, might be more a question of taste than of empirical substance.

The visibility of the NEA report and its generation of considerable media comment nationally and internationally provided the logic for a second report, *To Read or Not to Read*. This drew on a later version of the same survey, supplemented with additional data from the Organisation for Economic Co-operation and Development (OECD) and the US Department of Education, but placed its focus more on the specific impact on young people. These figures are reported in the context of concerns from US employers about the importance of reading comprehension and writing in English as skills for American high-school graduates. While both of these reports, in their more detailed analysis, are entirely open about the lack of a definitive causal relationship between these variables, the headline trends remain eye-catching and fit with long-established narratives about books and various forms of

social problem. The final report, *Reading on the Rise*, from 2009 (intriguingly subtitled *A New Chapter in American Literacy*) more optimistically reported a reversal in the trend of decline, and identified significant rises in engagement in literary practices, especially among the young in the most recent survey of cultural participation. While again stopping short of attributing a causal influence in this data, the implication of this report is that the years of investment in community and educational initiatives to support the formation of literary tastes have *worked*. The evidence acts as a powerful heteronomizing force in the field of power, placing numerical values and the powerful patina of objective evidence on more deep-seated intergenerational concerns about cultural decline. Moreover, it serves to reassert the values and assumptions which underpin a deficit model, and confirms the role of policy-makers in resolving this problem.

These reports have had a global impact, being cited by UK researchers from within the literary professions as a *crie de couer*, along with other substantive quantitative research, generated at the suprastate level. The OECD's *Reading for Change* document, for example, makes the case for the importance of literacy in shaping the skills agenda, offering international comparative data which allow the identification of reading as a leisure practice to be implicated in debates about global competitiveness, and the growth of 'human capital, linked to both the social and economic fate of individuals and nations'[3] (OECD, 2002: 12). The report specifically identifies the voluntary uptake of reading 'for pleasure' but outside the contexts of formal educational curricula as a key marker of 'success', and identifies, through the sophisticated quantitative analysis of large-scale surveys of the reading practices of 15-year-olds across the OECD, the encouragement of *reading for pleasure* as the key policy route to international competitiveness. The task of literary professionals – librarians and educators of various kinds – in this context is not to teach the technical *skill* of reading but to inculcate a 'habit' or taste for reading in young people. Young people mustn't just learn to read; they must learn to *like* it. There are two substantive points of interest here. First, the corralling of statistical evidence in support of narratives of decline heteronomizes literary practices – that is, they are no longer to be appreciated on their own terms but for the meeting of specific goals, in this case the goal of the globally competitive knowledge economy. Second, the identification of reading for pleasure, as opposed to the ability to read, as the key determining factor opens up a space for industry and policy advocates for print literacy to continue to press their case, even as the forms of literacy required by the global skills economy – for example,

the complex digital forms of literacy embedded in various online cultures, whether though social media, collaborative production, sharing and playing – escape their immediate sphere of influence. Such stories about the relations between reading practices and more general economic success recur. In 2014 a report produced by the charity Save the Children in collaboration with the Confederation of British Industry (Save the Children, 2014) and significant groups within education, and with supporters from across the literary, entertainment and sporting worlds, claimed that poor reading could cost the UK £32 billion in lost growth over the coming decade (Wintour, 2014). This broadbased coalition of interest groups – with echoes of the road-to-Utopia narratives attached by Graff to the campaigners of the nineteenth century – conceptualizes tackling inequalities in reading as a route to addressing more entrenched forms of structural inequality, starting from the germination of a *love* of reading alongside the technical skill of reading in schoolchildren. Similar points emerged in the case of the National Year of Reading (NYR) initiative in the UK. This was launched in 2007 towards the end of the New Labour years, which exemplified and firmly embedded the place of evidence in the cultural policy imaginary. Coordinated by the Department for Children, Schools and Families, in liaison with a similar range of agencies, charities and institutions connected to literacy and community education, this initiative attempted to encourage reading for pleasure among targeted groups. The campaign existed as a focal point for a range of organizations with interests in the 'the reading sector'; as an organizing umbrella for a range of events; as a focus for generating and publicizing reading events within schools and libraries; as an advocacy campaign for organizations with specific interests in literacy; and as a means to bring together elements of the publishing industry, state agencies and literacy charities to generate research on reading to inform future strategies for developing 'a nation of readers' (Thomson, 2008: 32) and 'transform our reading culture' (Thomson, 2008: 5).

A key organizing principle of the NYR was that 'all forms of reading count'. This is a distinction that is made between books and other forms of reading, based upon the assumption – as indicated by some quoted market research – that *books* are perceived by some of the key target groups (especially teenage boys) as unattractive or unappealing compared with other forms of reading (e.g. celebrity gossip magazines or tabloid sports reporting). It is also a distinction made between popular forms of reading and 'classic' literature. It is notable that the only occurrence of the word 'literature' within the 130-page evaluation report

(Thomson, 2008) on the NYR is as part of a disavowal of what are assumed to be the pernicious and exclusionary influence of hierarchies of culture. There is, though, some ambiguity about this. In research undertaken on behalf of the campaign by a marketing agency in partnership with a publisher, for example, it is the view of *books* among target groups compared with their views of other types of reading (tabloid news) and other activities (television, the Internet, computer games) which is the source of concern. The distinction is made between 'reading' and 'reading better', but the terms of that improvement are opaque. There is some nimble tightrope walking here between the recognition of the value of literature, and the value of literary taste and the need to be *inclusive* in a policy context in which asserting that value might be seen as a tacit judgement about the tastes and practices of its target groups.

In keeping with Miller and Rose's vision of the diffuse, evidence-oriented bureaucracy of the contemporary cultural agency, the NYR had a range of institutional partnerships, including the National Literacy Trust, the Reading Agency, the National Institute of Adult Continuing Education, the Museum, Libraries and Archives Council, ContinYou (a charity drawing down public grants and lottery funds to provide community education), Booktrust, Campaign for Learning, Volunteer Reading Help, National Youth Agency, Arts Council England and the Centre for Literacy in Primary Education. In addition there were contributions from a 'partnership marketing agency' and four separate commercial research agencies providing both project evaluation and original empirical work to inform future reading priorities. The publishers Harper Collins, and Mills and Boon were directly involved in this research work. The NYR also operated partnerships with local authorities, libraries (an increase in library membership is reported as a key achievement of the campaign) and the media (by placing the campaign in the news cycle, the production and dissemination of an advertisement featuring reading celebrities, and using newspapers – notably tabloids – as a key means of distributing campaign literature to what was assumed to be its key constituency). Target groups were identified as 'white C2DE[4] groups', Bangladeshi and Pakistani children, newly arrived Eastern Europeans, dyslexic children and visually impaired children, 'looked after' children and adults seeking skills for life. These groups might have different problems that improving literacy might solve, from integrating into society by improving language skills in the case of migrants to, in the case of young people, developing the important skills required to be, first, socialized into a print-oriented society and, subsequently, successful in education and employment. There is a

tacit acceptance here that differing tastes for reading exist between social groups, largely defined by ethnicity, gender or age rather than, at least explicitly, structural class differences. The initiative, while not claiming to offer a definitive account of the state of reading in the UK, did generate a range of forms of research on reading practices. These included research with young people which identified the lack of connection with book culture (including a relatively intense dislike for *Harry Potter*, even though this publishing phenomenon was claimed at the launch of the campaign to exemplify a new enthusiasm for reading among the young). Other research was conducted with the publisher HarperCollins on C2DE families, based on an analysis of marketing data, and with Asian women conducted with the publisher of romantic novels, Mills and Boon. This research was largely based on *book* culture, and the bulk of the events were based around writers visiting schools and libraries. The success of the campaign was evaluated according to the volume of particular forms of output or impact, in the manner of a public relations campaign, though its evaluation report also records identifiable and measurable successes, such as the recruitment of 2.3 million new members for the library service.

More nuanced research emerged from the National Literacy Trust, an advocacy organization for the literacy and education sector. A report produced in association with the NYR campaign (Dugdale and Clarke, 2008) points out that people with 'poor literacy' are more likely to live in a non-working household, more likely to live in overcrowded housing and less likely to vote. Moreover, those with 'improved literacy' are less likely to be on state benefits, more likely to own their own home, more likely to use a PC in their work and more likely to become involved in the democratic process. This final assertion is based on a figure of 16 per cent of men who *improved* their literacy skills (though the terms of this improvement are not clearly defined) between the ages of 21 and 34 'having contact with the government', compared with 0 per cent of those whose literacy remained poor (Dugdale and Clarke, 2008: 7). These statistics are drawn from the secondary analysis of the National Child Development Study and the British Cohort Study and while, again, there is a partial disavowal of causal relationships in these accounts, the statistical evidence is allowed to speak for itself as part of advocating for the value of literacy and tastes for reading in tackling social exclusion. The outline of the engaged, PC-using, employed and *literate* citizen is clearly and deliberately sketched by this evidence.

In the UK in particular, the identification of both the groups upon whom literacy policies can act, and for whom literary taste can be

socially and economically beneficial, fits with a broader project within the field of power that recasts social division into more benign questions of inclusion and exclusion, and individual skills and capacities. As Levitas (2005) has clearly illustrated, these were fluid, even nebulous, concepts in New Labour's social policy discourse in particular, standing variously for the economically or culturally disadvantaged but also for the morally suspect, with each strand being interchangeable in various policy contexts. In debates about literacy and reading, though, social exclusion serves as the means of identifying and quantifying the targets for and measurable effect of policy-related initiatives. There is a notable fuzziness of the categories of reading, literacy and the literary across these kinds of research, but the fuzziness of these definitions of what literature, reading and literacy *are* stands in marked contrast with the clarity of what tastes for the right kinds of reading are assumed to *do* for individuals, for particular groups or for society as a whole. The research involved in the identification and measurement of these problems and effects is often recognized as limited and partial, but the claims that are made for the measurements are all-encompassing.

In the field of cultural production, as Chapter 5 will show, quantification and measurement, revealed through price, the length of a print run or a position on a bestseller list, are the means by which the value of things can be translated from the less readily recognizable cultural form of capital to more easily transferrable economic capital. In the field of policy *production* we might similarly interpret the identification of the assumed social impacts of policies geared towards the value of specific tastes and practices in these terms. While strongly politically committed to the revelatory power of the empirical in the social sciences, Bourdieu's concerns about doing state-sponsored research were with the possibility of it providing alibis for previously decided policy initiatives, rather than informing a genuine platform for action in the political field. It is a concern which finds some succour in the 'evidence-based' policy narratives of the New Labour period, and some critical application of it might reveal the role of tastes and cultural practices as a part of, rather than a solution to, the social, political and economic fissures within complex societies.

The kinds of research and interpretation of research in relation to literary tastes serve a number of purposes in the dimension of governing taste. First, they serve to create or to cement problems upon which policy can act, as part of the functioning of the modern state. Evidence is crucial to a democratically accountable cultural policy, but there is an absence of critical or methodological reflection in much of the research

cited in relation to literary tastes. This allows headline-grabbing research about decline to fuel the advocacy work of various organizations in the field of policy production, rather than provide solutions to specific social problems. Finally, this kind of indicator-led policy research positions literary *taste*, not simply literacy, within a skills agenda for the knowledge economy. This shifts the cultural imaginary around the value of literary tastes away from the kinds of notion of self-reflection and critical intellectual engagement which, for example, accompanied the working-class self-education movements of the nineteenth century. Instead, these tastes are shifted towards the needs of the economic field, requiring specific kinds of flexible worker. The deployment of evidence of this kind can be interpreted as a process of translation of ephemeral notions of cultural tastes into quantifiable and measurable values, translating cultural capital into the kinds of social capital which are presumed to be valuable to civic participation and something more akin to an OECD definition of *human* capital. While the technical skill of literacy has historically been part of struggles in the field of power, the shift towards enjoyment and *sensibility* alongside *skill* operates as a means of corralling organizations and professionals within the reading sector into this contemporary educative project. Taste remains, this chapter has attempted to demonstrate, the business of the state implicated in the processes of forming and managing its citizens. The next chapter will explore a threat to the extent to which tastes can be used to establish clear relations between *nations* and their inhabitants, wrought by the global forces which shape contemporary cultural consumption and production.

4
Globalizing Tastes

This chapter extends the conceptual reach of our discussion of taste to incorporate a direct engagement with the global. In keeping with the general aim of the book to examine debates about tastes in a number of dimensions which are often kept separate and distinct, it explores how questions of taste have been, and continue to be, shaped by processes of what has come to be termed 'globalization'. This a concept which generated manifold forms of heat and light upon its emergence into the sociological and social scientific imagination in the late twentieth century and has become, as Bauman describes it, something of a 'shibboleth' (Bauman, 1998: 1), invoked to account for and explain a range of phenomena, from new forms of economic organization and transaction, to new forms of war and new forms of culinary experience. Such a short-hand is always likely to lose the nuance of specific detailed inquiry. It is, of course, beyond the scope of this chapter and book to do justice to the complexities of these debates, but it is notable from the perspective of the early twenty-first century, as the global-*ness* of the social world continues to be lived with and experienced through various everyday mechanisms and representations that aspects of these debates concerned with the 'reality' or 'inventedness' of globalization – what Giddens (2002) pejoratively characterizes as between 'sceptics' and 'radicals' – are more settled. It would certainly be difficult to argue that the contemporary nations of the global North are *not* intensely interconnected in various ways, both with each other and with the nations of the global South. Such connections might be extensions and intensifications of earlier connections, but they are readily manifest in political, economic and cultural life, albeit that some forms of interconnection – relating to national and international politics and governance, the movements of the shadowy and all-powerful finance markets, and

the flows, forced or voluntary, of people in and beyond their nations of origin – are not equally accessible and legible to everyone at all times. What is of interest to the argument of this book, though, and what underpins the rationale for this chapter, is that tastes are also shaped by the movement of things and people across national and cultural boundaries. The *manifestations* of globalization, such as the ready availability of a range of Asian food (Thai, Vietnamese, Chinese, Korean, Indian, Japanese) in the Midlands UK city where I live, the ready access to music and film from around the world (or at least from beyond the UK) through my broadband connection, and the presence of international authors, be it Nordic crimewriters or Latin American self-help gurus on bestseller lists and on the shelves of city-centre bookshops are precisely the *stuff* of debates about taste. This makes taste and tasting a field where the apparently abstract and inaccessibly complex processes of globalization can be identified empirically and, perhaps more importantly, experienced and lived with, making the possibility of *global* taste cultures an important consideration in understanding the contemporary social and political relations of tastes and tasting. There are good critical reasons too to be sceptical about the meaning and significance of these manifestations and their implications for our understanding of taste. In keeping with the rest of the book, our understanding of this global dimension of taste is likely to be enhanced by considering continuities as well as changes.

There are, in particular, four strands from previous chapters that this chapter can be read in the light of. First, as we discussed in Chapter 1, taste can be understood as mediating between the individual and the social, between the sensory experience of the physical world and the ways in which the social world is organized – politically and economically. Thinking about taste sociologically and sensorily entails considering how the material and institutional aspects of the social world are felt in the body – and subsequently understood to be good or bad, useful or valuable. Even the sensory experience of taste is not, in this light, socially neutral, and nor are the specific spatial locations of the nervous systems of the bodies of individuals who taste disconnected from the complex processes which place things before them to be tasted. Sidney Mintz's (1986) study of the history of sugar and the accompanying taste for sweetness demonstrates this and its relation to the global nicely. The production and circulation of sugar was bound up with the imperial exploitation of the resources – natural and human – of the colonized world. The arrival of sugar in the courts of the colonial powers of Europe made sweetness an exotic and refined luxury taste, and an

expression of technological and military superiority. The increased and more efficient production and circulation of sugar – enabled, of course, in part by the exploitation of the human resources of the colonies – made sugar more abundant throughout the strata of the imperial powers, and consequently a taste for sweetness became, paradoxically, less refined and more associated with lower social orders. The sensation on the tongue here is filtered through a significant set of institutional, political, economic, cultural and geographic layers before its shared, social meaning can be established. As Alex Rhys-Jones' ethnographic account of the smells and tastes of a multicultural urban market in the twenty-first century demonstrates (2013), contemporary *sensory* experience of the presence of the global in the immediate, local world is a useful indication of how relationships between nations, regions and cultures are currently played out and lived with as part of daily life.

Following from this, while taste has been predominantly understood in sociology in particular, following Bourdieu (1984) and Veblen (1899), as related most closely to questions of competition in social life, it is also bound up with, following Simmel (1997a, 1997b) and Tarde (1903), how we live together and respond to one another. Taste also acts as a means of orienting ourselves and managing our conduct in relation to others. As Elias's (1994) account of the civilizing processes of the development of more intensive forms of space-sharing in late medieval and early modern Europe revealed, living together requires the establishment of shared norms and values about the 'correct' or preferable forms of conduct, which provide a foundation for the moral judgement of good or bad taste, extending sensory notions of disgust into the establishment of social rules of etiquette. In this light we might ask whether there are equivalent norms and values which might be learned in a context in which the push and pull of migration and the increasingly embedded infrastructure of distance-collapsing electronic and digital technologies in everyday life enable the space we inhabit to be extended and reimagined as *global*. Tastes for the exotic and the distant have always held social meanings, but what might these meanings be when, in the global North and in the global cities of the rest of the world, the distant is so readily brought home and the exotic has become so familiar? To what extent are tastes for the exotic and distant implicated in our contemporary experiences of living together in a multicultural or global space?

A third strand connects these problems with the general methodological problem of *knowing* tastes outlined in Chapter 2, and specifically the problem of the empirical identification of the social patterning of tastes,

exemplified by Bourdieu's *Distinction*. One of the more subtle but significant results of the developments of globalization is the challenge to what has been described as the 'container model' of the social sciences (Beck, 2004, Chernilo, 2006), in which societies have been equated with the nations where research activities are located. The sociological extrapolation from the empirical reality of one specific nation to stand for the experiences of all nations has always been problematic, but the global flows of people and things evident in the early twenty-first century mean that the walls of the containers of social life are more porous. *Distinction*, with its specific temporal and geographical location in the France of the 1960s and 1970s, might well exemplify this methodological nationalism, and some interesting work has been done to critique the transferability of Bourdieu's schema to other places – notably to the USA in Lamont's exploration of the different bases for social division evident in the USA and France (Lamont, 1992). In a later defence of the general methodological approach in *Distinction*, Bourdieu makes clear that surface differences between specific items in the game of culture in specific nations (i.e. whether French intellectuals like Japanese food, or whether Japanese intellectuals like French food) are trivial superficialities compared with the deep, organizing, structural tensions between capitals in specific national fields (Bourdieu, 1998a), which, he suggests, are likely to be universal. The things that are tasted in different nations might be different, but their relations to one another, and to the characteristics of the people tasting them, are likely to be the same.

It is also interesting in this light to point out that, for all its French*ness*, Bourdieu's survey still made reference to items and individuals with origins outside the borders of the French nation state, which reflected the high cultural imaginary associated with mainland Europe, the particular colonial histories of France and the flows of the dominant cultural industries. Bourdieu's thesis then had a geographical and spatial dimension, even if it is one which is largely unacknowledged, and any contemporary attempt to empirically identify tastes in the context of globalization is likely to face the difficulty of constructing a 'container' big enough to encompass the global dimensions of tastes and tasting. Indeed, more recent explicit attempts to construct 'comparative' studies usually draw on equivalent surveys of cultural participation established *within* nations to compare relative measures of preference *between* nations (e.g. Chan, 2010, Katz-Gerro, 2002, Virtanen, 2007). Such approaches can be revealing empirical exercises, but they fall foul of what Purhonen and Wright (2013) describe as problems of measurement and translation. Survey instruments, with their requirements to be

legible *within* populations, are more likely to be skewed towards national cultural forms and, more importantly perhaps, reflect the national *meanings* of cultural forms, such that comparing the same survey items in two different national contexts requires analysts to make heroic assumptions about, for example, shared histories or shared positions in the uneven global circulation of genres, cultural goods or cultural practices. These kinds of surface manifestation can say relatively little about the role of tastes in a global social space in the same way as they might in a national social space. The notion of a *global* taste culture is far from an empirically established reality, but the possibility of it forms an important part of the imaginary of social and economic life, and contemporary scholarship.

In a similar vein, the final strand connects with the relations identified in Chapter 3 between taste and nation, and the policy imperative to inculcate various forms of taste as part of a longer historical project to 'form' citizens. The historical projects to construct national forms of art, literature, food and music have been central to defining nations and marking their presence on the global stage. How might this governmental project cope with the intense, multifaceted, chaotic flows of people and things of the early twenty-first century version of the globalized world in which nations move from being 'imagined communities' (Anderson, 2006) to 'fictions' (Ohmae, 1995). What kinds of people might be produced in these kinds of context by *globalized* systems for the production and circulation of taste cultures? The chapter considers this question more closely in the light of claims for new kinds of postnational, cosmopolitan forms of subjectivity – claims which are bound up with questions of taste. I preface this with an outline of some anxieties and possibilities which are implicated in how global taste cultures have been imagined.

Imagining a 'global taste culture'?

As Chapter 3 outlined, there has been a significant historical relationship between 'taste' cultures and national cultures. It is a relationship which has contemporary manifestations in such initiatives as the Danish *KulturKanon*, or the inclusion of items of literary culture on contemporary tests for citizenship. The imaginary of *national* tastes here can be seen to reflect and indicate a nation's 'official' view of itself; can represent a nation to an audience beyond its borders, for symbolic, political or economic ends; and can be implicated in the national governmental project to form citizens. This project has a history which is

implicated in interesting ways in notions of cultural hierarchy in which narratives of 'civilizing the masses' equate certain tastes and practices with correct forms of conduct. The possibility of global taste cultures, wrought by the intense flows of people and things evident in the early twenty-first century, might complicate all three of these relationships, troubling the coherence of such national self-narratives. These complications emerge alongside the story of globalization's political economic and cultural influences and its assumed effect on reshaping – and even undermining – national identities and cultures.

Central to this story are the globalizing forces of the cultural industries, and their role – intensifying in the post-Second World War twentieth century – in producing and distributing the things which can be tasted, with the result that narratives about Coca-Cola, McDonald's and Hollywood become shorthand for a geographical variant of the mass-culture critique that I discussed in Chapter 1. As Tomlinson (1991) outlines, this is one of a number of powerful 'discourses' of *cultural imperialism* which developed in the post-Second World War period, specifically eliding the popular cultural products of the expanding US cultural industries with the rise of the USA to be the dominant political, economic and strategic power in this period, and making debates about globalization synonymous with Americanization. Such elisions are not entirely inaccurate, at least at the level of rhetoric. In 1923, Will Hays, president of the Motion Picture Producers and Distributors Association, associated the growing US film industry, for example, with a project to 'sell America to the world' (Maltby, 2004: 1) in a way which explicitly imagined film as part of international missionary work on behalf of capitalism's US variant and its associated values and styles of life. Moreover, in the immediate post-war period, US economic aid to Europe and elsewhere was premised upon the settling of terms of trade requiring the opening up of international markets to US goods. This initiative helped to serve the strategic propaganda requirements of the Cold War regarding the supremacy of Western consumerism and its lifestyles, but also allowed US cultural production to expand beyond its own saturated domestic market and around the globe. In the field of 'cultural trade', this expansion was met with some resistance as countries with their own relatively developed cultural industries sought to protect them from being overwhelmed by powerful competition from the USA (Singh, 2011). These 'cultural exceptions' remain key symbolic battlegrounds (in France, Korea and elsewhere) given the continued dominance of the USA as a superpower of cultural production, but the urgency of these debates may also have dissipated in the contemporary

period with the rise of powerful cultural producers from outside the USA and Europe.

The associated implications of a single dominant generator of globally circulated cultural products shaped debate within media scholarship in the latter half of the twentieth century and were the subject of both micro- and macrolevel debates. The latter might include the MacBride report (UNESCO, 1980) about the relationships between the global infrastructure of media and communication, citizenship and the inequalities of global power, or the more recent attempts by the United Nations Educational, Scientific and Cultural Organization (UNESCO) to identify and preserve, through policy levers, the *intangible* forms of cultural practices which are assumed to be under threat from the globalizing tendencies of contemporary culture. The former might also include the seminal piece of popular cultural criticism *How to Read Donald Duck* (Dorfman and Mattelart, 1975) about the role of Disney comics as a cultural arm of the imperialist strategies of the American state in the Latin America of the 1970s, promoting, through its commercial popular culture, a compulsive consumerism of value to the interests of US corporate capital as well as constructing the global South and its residents as ripe for commercial and political exploitation.

Such examples indicate precisely how tastes for both high and popular culture, and the means of their circulation, are significantly politically loaded in global terms. As with the mass-culture critique, though, there remain a number of elisions in this narrative of how culture and cultural taste have become *global*. Such elisions include an assumption of relationships between all of the products of the US culture industries and a version of 'American culture' constructed as simplistically aesthetically diminished. US culture in this discourse is almost always and inevitably a crudely constructed version of popular and commercial culture – a conception which, of course, belies the place of the USA in the rise and spread of various *avant-garde* forms of modernist 'high art' (the poetry of Pound, the art of Pollock), but also denies the possibility of the new commercial cultural forms which might define the 'American century' – jazz music or film or the comic book – themselves developing any form of aesthetic complexity or attaining the status of *art*, as opposed to *just* being entertainment, and therefore not meriting a place in the taste profiles of serious people. There is also a crude elision between the commercial interests of the US cultural industries and the global military and strategic interests of the American state which, while perhaps demonstrable in specific instances, cannot be generalized across the vast range of output – much of which might equally be considered,

or at least read, as subversive, satirical or directly critical of the policy priorities of specific administrations. Finally, and perhaps most significantly for our concern about the social role of tastes, there is in this caricature of US cultural imperialism a tacit judgement not only of the aesthetic qualities of the items being circulated by these industries, but an accompanying judgement of the people who consume them – or at least those who *like* them – as either unwitting victims or enthusiastic accomplices in the spread of US hegemony.

This latter point reflects the significant anxiety evident in post-war Europe about the rise to dominance of US cultural products. Hebdige (1988) considers these anxieties in his analysis of the emergence of a 'cartography' of tastes in mid-twentieth century Britain in which distinctions between US culture and European culture become, in the imaginary of the cultural criticism of the period, mapped onto distinctions between high and low, good and bad, 'modern' and 'traditional', and complex and simple. These positions emerge as remarkably uniform across the political spectrum in Hebdige's account, being variously espoused by more recognizably conservative cultural figures such as the novelist Evelyn Waugh and the poet T.S. Eliot, and more social democratic voices such as George Orwell and Richard Hoggart. The former group invoked narratives of aesthetic decline in relation to established canons of music or literature, while the latter spoke of the perils of consumerism and its especially pernicious influence on *authentic* forms of working-class culture. This surprising level of uniformity of critical perspective in the British case can be accounted for in Hebdige's analysis by the broader processes of social change which these new tastes – whether for hairstyles, streamlining in the design of cars, or new forms of music such as jazz or rock and roll, with their hints of intergenerational tension and social disorder – were seen to exemplify. Anxieties about the rise and spread of US popular culture here are bound up in the immediate post-war period with such factors as the humiliation of the continued US military presence in the UK, the dependence on US financial aid in the process of recovery from the war and, as the century progressed, with the UK's more general decline as an imperial power in its own right. Together with the challenge to established modes of national governance wrought by the post-war election of the Labour government, this period of flux allowed questions of taste to become emblematic of broader anxieties among cultural elites about the social and cultural order. At the same time, popular sentiment towards US popular culture, exemplified by large audiences for Hollywood films or US popular music, constructed it as glamorous, exciting, exotic and

modern in a way which suggested some appetite for a break with the monopoly of the British state and cultural establishment over the symbolic life of the nation's population. Here the enthusiastic embrace of US popular culture by the youth of the UK and Europe in the post-war period can be partly interpreted as an aesthetic manifestation of broader discomfort with the established, traditional conservative cultural order.

Such tensions and anxieties were similarly spread across Europe, and similar critiques of US culture as a deleterious influence on national cultures, on the morals of the young and as emblematic of new forms of consumerist materialism are evident elsewhere – for example, in Italy (Scarpellini, 2011) and Finland (Alasuutari, 2001). France maintained an especially powerful anxiety about the threats of the swamping of national culture, no doubt also a partial response to its own war experience of invasion, occupation and resistance, and the various challenges to its own view of itself from changing relations with its own colonial resources. This ambivalence towards US popular culture is reflected in *Distinction*, where, for example, more 'cultured' groups – the professions and secondary schoolteachers – were, in response to Bourdieu's question about preferred films, more likely to have seen and expressed a preference for the films produced by France's European neighbours (the *avant-garde* Spanish director Luis Bunuel's *Exterminating Angel*, or the Italian films *Rocco and His Brothers* (dir. Luchio Visconti) or *Divorce Italian Style*) over blockbusters such as the epic war movie *The Longest Day* (starring John Wayne and Robert Mitchum) or what *Le Monde* is reported as describing as 'an excellent example of box-office moviemaking', *55 Days at Peking* (Bourdieu, 1984: 271). These latter two US films were more popular in Bourdieu's study with industrial and commercial employers – the fraction of the middle class relatively lacking in cultural capital. The status of *55 Days at Peking* is especially revealing, as Hill (2007) describes, of the incoherence of the logic of cultural hierarchies in the context of global cultural flows. Directed by Nicholas Ray, it was representative of the kind of 'auteur' filmmaking which was leading critics and filmmakers – and French critics and filmmakers in particular – to recast Hollywood filmmaking as the height of the cinematic arts rather than as trash polluting a sacred national culture. Such critics might exemplify the cultural intermediaries – to be discussed in more depth in the next chapter – who Bourdieu identifies as significant in bringing new tastes into the realm of the legitimate, often in direct intergenerational challenge to established cultural orders.

Despite the powerful post-war narratives equating US culture with a diminished culture, the travel and transformation of cultural items

through time and space suggest a more complex narrative at play in the formation of contemporary global taste cultures than simply that of imperialist homogenization. The global infrastructure of cultural distribution is also a global infrastructure of *tasting*, and these flows are less unidirectional in the early twenty-first century than they once were. Alternative powerhouses in cultural production (South Asian film industries, Latin American telenovelas, Japanese animation, Korean pop music) generate their own flows of commercial culture, albeit through modes of production which often match and model those from the USA (Thussu, 2007). 'Hollywood' itself – the exemplar of the globalizing tendencies of the cultural industries – might be better understood not as an imperialist centre with an identifiable geographical origin but rather, as Teo (2010) implies, as a mode of production, circulation and distribution now with multiple centres in Los Angeles, Seoul, Hong Kong, Mumbai and elsewhere. As Miller et al. (2005) reveal, the commercial production of the blockbuster movies which continue to dominate global box-office success is also less geographically or nationally specific, with the financing and production of films being an increasingly international affair as the Los Angeles-based US industry becomes parasitic on international talent, international markets, international settings and the favourable tax regimes that chase 'American' filmmaking around the globe.

There are echoes here of the debates in Chapter 1 in relation to the mass-culture critique. Scholars of the cultural studies tradition identified a complexity in processes of cultural consumption which challenged simplistic associations between cultural and social hierarchies and revealed how tastes for items of popular culture – such as in relation to youth subcultures – could both demand and require aesthetic forms of judgement but also could be used to negotiate and critique abiding social and class relations. In a similar way we might see, in the context of global flows of cultural items and their influence on the formation of global taste cultures, that local, nationally located forms of consuming the items of global culture might complicate and generate more nuanced narratives of belonging and identity characterized not by homogeneity but by *hybridity* (Pieterse, 2009), the creative mixing of cultural tastes and practices to produce both new tastes and also new regimes of meaning, judgement and value. There are classic examples of this phenomenon in the cultural studies canon, principally organized around small-scale ethnographic work which attempts to reveal how local audiences for global cultural products use these products in their identity work. This tradition of work is closest to an anthropological

view of culture – and indeed as a key figure in this perspective, Daniel Miller explains – is partly a response to a broader anxiety among anthropologists of the 1970s and 1980s that 'real' or 'authentic' cultures were being transformed by the inexorable rise of global culture, exemplified by a circulating anecdote about a nomadic people suspending their annual migration in order to watch a season finale of *Dallas* (Miller, 1994). Turning an anthropological eye to the symbolic meaning of cultural practice here allows the multi-layered complexities of the experience of global culture to be revealed. Miller's study of the reception of the US daytime soap *The Young and the Restless* in Trinidad, for example, reveals the extent to which this apparently 'exotic' and foreign show is indigenized and adapted such that it becomes a more immediately engaging dramatization of the tensions of Trinidadian society than that produced by national broadcasters with their concern to represent the small island nation on a global scale. Because of its close geographical links with the USA, the presence of US military on Trinidad in the immediate post-war period, the migratory movements of Trinis to the US and Canada looking for work, and the ready presence of US culture in Trinidad, the Caribbean region might be viewed as conceptualized as a passive victim of 'Americanization'. In fact, Trini audiences respond to the resources provided by the infrastructures of global communication over which they have little immediate control in far more creative ways, taking up the products arrayed before them to be tasted, and reworking them as symbolic resources in their understanding of their own lives and their relations with one another.

The cultural studies perspective on the global television audience similarly reveals how popular cultural tastes are implicated in negotiations with, rather than simple acceptance of, the products of global culture. This includes, in the classic discussions of the audience for the US television drama *Dallas* among viewers in Holland (Ang, 1985) or Israel (Liebes and Katz, 1990), revelations that part of the pleasures of *liking* such programmes included critiquing them and the materialist values they were perceived to represent. Clearly the presence of the *Young and the Restless* in Trinidad or *Dallas* in Europe or Israel (or their subsequent equivalent global television phenomenon such as *Friends* or *Sex and the City*) indicates an uneven power relationship between a core of global cultural *production* and a more dispersed periphery. The nature of this relationship might be changing with the rise of alternative sites of television production and also through the intercultural adaptation of stories, models and formats from one national culture to another (e.g. the transfer of Danish drama to the USA, such as *The Killing*, or the many

international versions of reality television and talent shows). There is an analogy to be made here with the discussion of the global taste for sugar that introduced this chapter. Just as sugar was propelled along the routes of established colonial power relationships, so the products of the cultural industries are circulated through the existing infrastructure of cultural distribution, and these have become more global in their scope and reach through a combination of the agglomeration of large cultural producers across international markets and the despatialized technologies of cultural circulation. There is considerable uncertainty in this process, however, and, as in the case of sugar, enough unintended consequence in the process of travel to challenge the notion of global culture as *homogenizing* tastes in any simplistic way.

At the very least the flows from centre to periphery are not always predictable. Lietchy's (2003) study of the emergence of tastes for global television and pop music genres in Nepal suggests this. Here a state-funded project to cement a national identity in the face of the political power and influence of neighbouring India is undermined, as the cost of producing television that viewers want to watch becomes prohibitive. This, coupled with the pressures from local and transnational advertisers, leads the Nepali state broadcaster to rely on cheaper foreign imports to fill its schedule – making *The A-Team*, *The Smurfs* and *Knight Rider* popular features of Nepali culture despite the best efforts of patrician Nepali elites. While this story of cultural dependence on the products of the 'centre' is not unfamiliar in the global South, the case of popular music in Nepal is more nuanced. Here, 'pirating' cultures, and especially pirating enabled by portable audio cassette tapes in the 1970s as a technology which enabled easy reproducibility and which was physically robust enough to survive the journey to Nepal intact, had a significant effect on the development of Nepali pop music cultures. The coterminous arrival of the cassette tape and disco music made that genre – so closely associated in the Western cultural memory with a specific time and place (the downtown Manhattan of the mid-1970s) – an addition to Nepali culture, to complement the ready presence of the rock music that had attached to the countercultural flows of people along the hippie trail of the 1960s. The increased efficiency of the modes of pirating and circulating cassette tapes made Nepal an unlikely outpost on the expansion of Western popular music that also escaped the intellectual property regimes of the cultural industries more generally. At the same time, as Lietchy describes it, the popular culture of Nepal is both implicated in the flows of the global cultural industries and also 'unmistakably Nepali, in that local historical and cultural contingencies form

the ground from which a particular contemporary experience emerges' (Lietchy, 2003: 205).

Tastes for commercial music seem especially globally mobile in this regard, reflecting, as Regev (2013) has explored, a specific infrastructure of production which has collapsed into an increasingly universal aesthetic in such forms as 'pop-rock' and its associated genres. Music circulates globally through people and through technologies, but it is also made, and made meaningful, *locally.* As Gilroy has powerfully argued in relation to the circulation of African cultural forms and practices, throughout the diaspora of *The Black Atlantic* (Gilroy, 1993), the movement of people changes their music, but also changes the music cultures of the places that they move through and to. Global musical forms and genres are not simply handed down or out from a cultural core to be accepted on the periphery. Instead they are part of processes of negotiation – of belonging and identity for and between migrant and indigenous cultures. In the case of pop-rock in Regev's construction, there is an Anglo-American point of origin in the immediate post-war period which established the norms of this infrastructure. These include the formula of the drums, bass and guitar, or the centrality of the technologies of the recording studio. The adoption and adaptation of these forms and practices, and their accompanying taste cultures, are always, though, in relation to local, national tensions and issues. Work on the global spread of punk rock or hip-hop, for example – again, genres with specific geographical points of origin in the London and New York of the late 1970s – indicates this. In these places such genres might have had specific meanings in relation to specific cultural or political tensions, but as they spread – punk rock to Indonesia (Baulch, 2002) or hip-hop to Japan (Condry, 2001) – they are not spreading as simplistic harbingers of Western values which dilute or threaten pure local national cultures, but as symbolic resources through which local populations and local cultural producers can explore and negotiate their own identities in relation to the tensions within the societies in which they live. Such processes of hybridization and indigenization of 'global' cultural products, with multiple sources of origin, might better reflect a coming norm of global culture. They certainly represent a more complex – but also more hopeful and less anxious – 'cartography of tastes' than the one that dominated reflection on this topic in the latter part of the twentieth century. Global taste cultures are, in this story, shaped by flows of people and things, rather than *determined* by the techniques and technologies of the global cultural industries, and they are certainly less clearly associated with these industries as proxies for political economic

or strategic forms of domination. The following section will consider one potential consequence of this in exploring a powerful and optimistic narrative about the relations between these kinds of taste culture and the kinds of people who exist in the globalized world.

Cosmopolitan taste cultures

This chapter began with the claim that understanding taste is one means of exploring the lived reality of life in a globalized world, and that the abstract processes of globalization could be made visible through considering how tastes for things from beyond our immediate local, national or cultural context are acquired and made meaningful. This was a global version of claims from earlier chapters that tastes are implicated in both the formation of people and the establishment of the means to live together. While the empirical problem of knowing global tastes is difficult to resolve, the previous section sketched out some elements which might make up a global infrastructure of tasting, relating to those changing cultural industries which are global in reach, but also the processes of push and pull which move people and their culture around the globe and mould their tastes. This section will build on this by considering a concept which has come to exemplify more hopeful theoretical accounts of the cultural consequences of globalization and hybridization as they are outlined above, and come not only to describe a kind of post-national form of subjectivity but also to include a glimpse of the ways of living together in a global world. The concept of *cosmopolitanism* has a long history, part of which includes contributions from Kant on the imagination of a post-national community of nations as a teleological endpoint of human progress to secure global peace. This is interesting in the light of the relations between cosmopolitanism and questions of taste, given Kant's place in the history of that idea, as sketched out in Chapter 1. Just as, for Kant, according to Rancière's defence of him, the aesthetic notions of beauty were an appeal to a universal dimension of human experience at a time in history when that idea was emerging as a potential political reality, so cosmopolitanism has a kind of rhetorical, ethical force behind it as a future state of being for human societies and governments, at a time when the presence of the global within the national is increasingly hard to police or ignore. Built into this history are some abiding ambiguities about why and for whom cosmopolitanism is a good thing, and the consequences of its emergence. The process of civilizing populations within nations, for example, was, as Chaney (2002) indicates, undertaken by cultural

elites who were already, paradoxically, looking beyond the parameters of their nation in identifying and selecting the kinds of things which could count or be presented as culture. Cosmopolitanism here becomes an elite position, reflective of inequalities of cultural resources within nations and characterized by a sense of authoritative performance of knowledge and styles which non-cosmopolitans, local, parochial or provincial populations, lack. A character in the epistolary fiction of the writer and humourist Thomas Hood, for example, points out this tension in the mid-nineteenth century when he observes, in discussing a perception of the relative levels of animal cruelty in England and the Netherlands, 'I don't set up for being a cosmopolite, which to my mind signifies being polite to every country except your own' (Hood, 1852: 42). At the same time, though, Chaney contends that the growth of a global cultural *avant-garde* also allowed cosmopolitanism – like romanticism – to emerge as a way of life for artists and thinkers which precisely challenged the rationalization of social life in the interests of global capital. Its contemporary incorporation into the default taste position of the creative class (Florida, 2002), in which the international contemporary art museum becomes another non-place (Auge, 1995) for free-floating elites, might mean that this aspect of cosmopolitanism is tainted in understanding contemporary taste cultures. Other forms, labelled 'ordinary' (Lamont and Askartova, 2002) or 'banal' (Beck, 2004) though, contain the possibility that cosmopolitan taste cultures can still be revealing.

The term re-emerged with particular energy as a priority for discussion in sociology and the social sciences in the early twenty-first century, an adjunct of the intensive interest in the processes of globalization and in the broader reimagining of social, political and governmental modes of international relations of this period. Like globalization, debates about cosmopolitanism are political and bound up with institutions of government, notably nation states, and their transformation. However, they are also *cultural*, and manifest in values and practices. If taste is bound up with the production of people – that is, their shaping in the context of particular regimes of social norms and strategies of governance – then historically the kinds of people who were made by learning the right kinds of taste were citizens of nations and the 'system of nation-states and national identities involved antagonism towards the "stranger", especially those strangers deemed to have a different colour, creed or culture' (Szerynski and Urry, 2002: 462). While the early bloody history of the twenty-first century suggests that the promise of this new subjectivity has not been universally fulfilled, the prolonged contact with other

cultures and the increasing presence of the global within parameters which were once exclusively local and national suggests that the kinds of citizen that are produced in the contemporary 'post-national' global system are also different. Part of this difference is premised upon *tastes* for the culture of the 'other', and *how* one encounters that culture – what Stuart Hall (1996) would describe as the 'roots' and 'routes' of the circulation of cultures – becomes important.

One key theorist in this debate, Ulrich Beck (2000, 2004), distinguishes between a normative philosophical ideal of cosmopolitanism and the lived experience of the global world which he characterized as 'banal cosmopolitanism'. The former has been the substantive stuff of theoretical debate, while the latter has, perhaps as a consequence of the difficulties of finding a realistic global 'container' for analysis, been more assumed than proven. He also distinguishes between a state of being cosmopolitan – which may be a conscious choice bound up with individual narratives of self-identity and therefore might not be equally accessible to all – and a process of cosmoplitaniz*ation*. The latter can be understood as a 'compulsory choice or a side-effect of unconscious decisions' (Beck, 2004: 134), which may be traumatic, such as the refugee fleeing oppression or disaster, or more unreflexive, such as the development of preferences for those forms of culture which appear before one through the infrastructure of the global cultural industries. While this latter form is less dramatic, it is this which, for Beck, heralds new ways of being when he suggests that, 'without my knowing or explicitly willing it, my existence, my body, my "own life" become part of another world, of foreign cultures, regions and histories' (Beck, 2004: 134). Tastes are significant here to the possibility of empirically identifying and observing these processes, and Beck identifies the relative presence of cultural commodities from beyond a nation's borders, such as the relative levels of local and foreign productions at cinemas, or as part of national broadcasting schedules or the 'transnationalization of the book trade' (Beck 2000: 97) as potential indicators of the process of cosmoplitanization. Rather than the presence of such items representing a shock to established national cultures, it is the very banality of their appearance that is most revealing of a change in the texture of global taste culture, for what seems likely to be a growing fraction of the populations of the global North, at least.

In their attempt to map and navigate the field of recent scholarship on this topic, Kendall et al. (2009) identify three tenets of contemporary cosmopolitanism, all of which can similarly be related to questions of taste. The first tenet is of 'corporeal and virtual mobility' (Kendall

et al., 2009: 110). Cosmopolitans are able, and keen, to move around the world – having tastes for international travel and for using the infrastructure of contemporary communications to bring the world home through their consuming practices. Second, they possess the cultural skills to know how to 'handle' the exotic or the foreign, how to feel comfortable in its presence and enjoy, even seek out things, which are new or even challenging. Finally, they are ethically committed to values of openness and tolerance, exhibiting 'a genuine commitment to living and thinking beyond the local or nation and...more likely to act in cosmopolitan ways that are ethically directed' (Kendall et al., 2009: 121). As such, cosmopolitanism is a *sensibility* which might resonate precisely with the imperatives of contemporary consumer capitalism, with its drives for the novel and the experiential as inevitably in exciting contrast with the local and the familiar. We might see a perfect evocation of this kind of figure in the image of the 'transculturalist' as evoked by the journalist, cultural entrepreneur and magazine publisher Claude Gruzintsky,

> Transculturalists lead lives some may consider unusual. They often think, consume, date, or marry outside of their race, religion, or nationality. They travel on a whim to a faraway lands, dress unconventionally and codify their own styles. They live in areas their parents were once barred from and take jobs previously considered outside of their leagues. They are comfortable listening to, creating, and criticizing music outside of their original cultures and often display high levels of creativity in various progressive disciplines. Some call transculturalists heretics; many call them the future.
>
> (Grunitzky, 2004: 26)

This kind of conceptualization of an idealized contemporary, young, mobile, open and tolerant figure as a kind of vanguard of a coming society typifies some of the rhetoric of contemporary cosmopolitan taste, but it also points to some of the ambiguities, complexities and contradictions contained within the concept. Clearly access to the resources to achieve this kind of lifestyle, notwithstanding the rise of cheap air travel, is not open to everyone. Nor are the forms of mobility that are required to make this kind of orientation open to all. Cosmopolitanism might resonate with what Calhoun (2003) has termed the 'frequent-flyer' model of the global business elite, but it is less accessible, for example, to the migrants and refugees of the global South who are attempting to cross the highly guarded borders of the global North. This

leads us to a second ambiguity. The valorization of mobility and travel also reimagines the immediate and local environment of 'origin' as a thing to be got away from or risen above. The corollary to the tenet of openness for Kendall et al. is that 'the reflexive cosmopolitan feels little or no ethical and political commitment to local and national contexts and in fact is likely to show an irony, almost bordering on suspicion, toward their own myths and discourses' (Kendall et al., 2009: 129). This is perhaps a contemporary manifestation of the older dynamic that is so neatly summarized by Thomas Hood. It also points to the relations between the concept of the cosmopolitan and another contemporary figure that is significant to understanding contemporary patterns of taste – 'the omnivore'. In his review of the global spread of the concept, Peterson (2005) reveals, interestingly, that 'cosmopolitan' was one candidate for the label for this empirical phenomenon. As explored in Chapter 2, the openness and tolerance of the omnivore is read off from the empirical identification of tastes for a range of items across cultural hierarchies, among higher educated and more affluent US cultural consumers, with omnivorousness replacing snobbishness as the sensibility of the cultured middle classes. Subsequent studies have pointed out the limits of these forms of openness. Warde et al. (2008) indicate that some items are beyond the pale of omnivorous taste (reality television and electronic pop music). Bryson (1996) indicates the complex role of ethnicity in shaping the tolerance of US cultural consumers, with some genres of music (Latin, jazz and blues) underpinning a form of multicultural capital which excludes, for example, hip-hop or gospel music. These limitations are similarly relevant to any consideration of cosmopolitanism as an emerging disposition or sensibility. It might be one which adds a spatial, geographic and ethnic dimension to established forms of cultural hierarchy. The valorization of the cosmopolitan sensibility might also, as Skeggs (2004: 159) has pointed out, construct it as another label which acts to universalize middle-class experience, to affect an 'entitled, embodied subjectivity', which 'relies on the requisite cultural resources (time, access, knowledge) for generating the requisite dispositions'.

Those studies which have attempted to specifically focus on exploring the relative tastes for global forms of culture in general and the possibility of a cosmopolitan sensibility appear to bear this out, while also revealing some subtle developments in the empirical manifestations of global culture. Savage et al. (2010) consider the UK case, and examine the spread and intensity of likes and dislikes for cultural items from beyond the UK with a particular focus on the white British population.

A number of things of interest emerge from this study. First, given the discussion in the previous section, is the relative *lack* of anxiety attached to those items which emerge from the USA. Far from being a source of disquiet or inherently diminished 'mass culture', US culture – and US television and film most especially – had been somewhat gentrified, at least in comparison with homegrown cultural forms in the UK. The latter were more likely to be dismissed as parochial, especially among the younger, more educated groups, while the latter were a source of some fascination and, in the case of the global television shows of recent years – *The West Wing*, *The Sopranos*, etc. – embraced as markers of quality. This is in contrast, in the UK experience, to a general lack of excitement and fascination with European cultural forms. The traditional source of high cultural authority in the years of the Victorian grand tour is more readily dismissed as stuffy, obtuse or old-fashioned in the symbolic imaginary of contemporary Britons. This, coupled with the marginal presence of preferences for cultural items from beyond the global North, suggests both a marginal shift in attitudes to global culture, which effectively restates national and imperial historical relationships but also implies that even those that are most likely to become cosmopolitan are not, at least as yet, very cosmopolitan at all.

These tensions between the *local* and the *global* in the formation of cosmopolitanism are also inherent in Wright et al.'s (2013) comparative account of tastes for global culture in the UK and Finland. Again, debates about cultural imperialism are less urgent among these participants, although a different symbolic geography pertains here – perhaps informed by the need to acquire foreign-language skills in order to access the plenitude of global culture in Finland, but also reflecting the different collective history of Finland and its different cultural and strategic alliances with Nordic and Northern European contexts. Alasuutari (2001) outlines the place of Finland in relation to the forces of globalization and their assumed consequences for Finnish national identity, including a challenge to its internal ethnic and cultural homogeneity wrought by the deregulation of national broadcasting, the rise of migrant populations and the emergence of both post-national forms of collective identity and the strengthening of ethnic identities. Here, in a cultural context where the national maintains an emotional pull, there was a clearer sense that younger, more educated groups in Finland felt at ease with a variety of global forms of culture. Familiarity with the forms of international cuisine which were available in metropolitan centres in Finland was enabled, for these groups, by the ready experience of global travel, whether for work or as part of quests for 'real'

and authentic experiences abroad. Similarly, foreign television and film were readily accessed and much preferred to their national counterparts, which were as likely to be dismissed as dull or parochial. More educated and elite older groups who were able to access the global through their professional and linguistic expertise were also able to appropriate aspects of the national, particularly its cuisine, as 'exotic' as part of a confident reclamation of the national space in the light of an awareness of a coming global cosmopolitan culture. At the same time there was, among groups with less education, a suspicion of the global, particularly of 'ethnic' cuisines. The spread of cosmopolitanism as a form of disposition might here be marked by, and contribute to, the reproduction of the inequalities of cultural capital, with those who are less invested in the game of a global taste culture being less likely to see the value in tastes for the foreign or the exotic.

These empirical examples suggest that the spread of a global cosmopolitan taste culture is uneven, marked both by the varied global circulation of people and things, and also by the persistent internal divisions within nations. The historically identified process of tastes contributing to the formation of a national identity here might be reimagined as part of a process of marking in/out groups, with tastes for particular forms being broader indicators of belonging. Distinctions between local, national and global forms of culture, and the appeal of tastes for these kinds of culture, reflect different geographic and spatial imaginaries of the most useful group to belong to – global, national or local – within national spaces. The valorization of certain forms of national culture – canonical works of literature, or art or iconic national dishes – goes alongside the possibility that these forms might be rejected, especially by outward-looking sophisticated elites within national spaces. Hage, taking a distinctly Bourdieusian approach to the formation of what he identifies as 'practical nationality', suggests that, for minority ethnic groups within national spaces (be they migrant or, in the case of the Australia of his interest, marginalized indigenous groups), 'it is *national* belonging that constitutes the symbolic capital of the field. That is, the aim of accumulating national capital is precisely to convert it into national belonging; to have your accumulated national capital recognized as legitimately national by the dominant cultural grouping within the field' (Hage, 2000: 53). Negotiating belonging here is not simply a process of conforming to a coherent and dominant culture. Cosmopolitan taste also reveals the fissures *within* national fields, including in relation to tastes for the foreign or the exotic, such that belonging is not simply to one's nation but also perhaps to the different

geographical and spatial horizons of one's class position in which the local is part of a territory to be defended from global flows which seem outside one's immediate control. Cvetacinin and Popescu's (2011) study of the patterns of taste in Serbia reveal the potential significance of this. Here, traditional internal distinctions between high and low culture in judgements of taste are given a particular dimension such that divisions within the cultural practices of Serbia can be understood through reference to local and global forms of culture. The latter, which is more closely associated with professional elites, relates to tastes for the products of global commercial culture, while the former relates to 'traditional' and folk practices, including modern variations of them such as the genre turbo-folk music. In the specific setting of Serbian society, post-socialist and recovering from the profound and violent divisions of the early 1990s Balkan conflict, and the later international military and sanctions response to the dispute over Kosovo, these divisions are particularly loaded. The more traditional national distinctions between people of different educational experiences, people from rural or urban backgrounds, or people from different geographical regions are joined by an additional division between 'cosmopolitans' and 'patriots'. In this context, tastes for global culture are far from banal in the pejorative sense. They reveal the extent to which the everyday life of tasting is bound up with very real struggles over the meaning of national spaces and the places of people and their nations in the global world, and the different responses to those struggles within nations.

A world of tasting

This chapter has set out to explore how tastes are implicated in, and visible manifestations of, processes of globalization. We can see in relation to both of the competing stories about the emergence of global taste culture – from the homogenizing anxieties about cultural imperialism to the more nuanced stories about hybridity – that tastes can be exemplary indicators of these processes, as well as, in the case of the uneven emergence of cosmopolitan ways of being, indicators of their consequences. The global dimension of taste indicates other characteristics of taste considered so far too. It is associated with questions of choice and preference and, as such, perhaps especially in relation to the notion of cosmopolitanism outlined above, it resonates with powerful narratives about the self in contemporary consumer capitalism, as a thing which is enriched through diverse experiences. It is not reducible to these consumer choices, though – tastes for the global are also reflective of broader

social relationships, within and between nations and indicative of more complex ethical and political processes than the simple satisfaction of consumer wants or desires. These are both at the level of individual orientation and also reflective of the processes of cultural production and distribution in the infrastructure of tasting, which is, in terms of popular commercial culture at least, globalized. Contemporary analyses of taste need to take account of these global flows, and come up with new frameworks and 'containers' through which to observe them, so that the spatial, geographical, cultural and national divisions in taste culture can be better understood in relation to, and alongside, the traditional hierarchies of 'high' and 'low'.

Sensation, sensibility and *skill* are also implicated in the global dimension of taste as people navigate between the diversity on offer, either embracing or being repelled by the smells, sounds and tastes of the global world as threat or site of self-discovery. The spatial and geographical aspects of global taste culture and its overwhelming scale, its sensory overload, require particular skills to navigate. Knowing what to embrace or dismiss about forms of culture from beyond one's nation, and how to embrace or dismiss them, resonates with the established conception of taste, both as a proxy in social struggles and as a resource through which to perform and negotiate our lives together. What empirical evidence there is in relation to the banal experience of global culture suggests that access to these skills and sensibilities is not as universal as hopeful accounts of cosmopolitanism might suggest, but that perhaps they are in the process of becoming more so along with an ethical and aesthetic orientation to the world which contains the germ of a universalist aspiration and critique that is evident in the abilities of tasters to adopt and adapt their tastes in relation to changed relationships with one another. The development of these skills and sensibilities is in the context of a global infrastructure of taste in which judgements of what is good or bad have been wrestled from national cultural elites, but perhaps not yet re-embedded in a global equivalent. This notion of the flux and possibilities of a changing infrastructural architecture of taste is also at play in our final two dimensions.

5
Producing Tastes

This chapter sets out to explore how tastes are produced. As such it builds on the approach outlined in earlier chapters which emphasizes the extent to which our experience and understanding of tastes do not emerge naturally from a sensory engagement with the world but are shaped by various social and cultural processes. Many of these processes might already be interpreted as processes of *production*, and we can identify aspects of the dimensions discussed in earlier chapters which are also *generative* of tastes in some sense. In Chapter 2, for example, we discussed the relations, identified in recent social scientific critiques of research technologies, between the gathering of information on a phenomenon and the processes of bringing that phenomenon into being to be known. In Chapter 3 we identified a role for the state, both historically and in the contemporary context, in *forming* its citizens, partly based on a process of forming their tastes. In Chapter 4 we considered the flows of people and things around the world, and how these flows are shaped by various forces, including the techniques and technologies of the global cultural industries. This last example connects most clearly with the specific concern of this chapter, which focuses on these industries and explores the ways in which their operation and organization can be seen to shape the tastes of their audience. A starting assumption for exploring this dimension is that sociological accounts of tastes – and indeed accounts which emerge from the various applied forms of social and market research concerned with tastes – focus the weight of their analysis on processes of *consumption*. In the latter case this reflects a starting assumption that people – understood as *consumers* with all of the imaginaries attached to that label – are the problem to be solved and that understanding the patterns of their tastes, interpreted as 'choices', 'behaviours' and 'preferences', is a route

to more efficiently meeting, or commercially exploiting, their demands and desires. While there is, in foundational theoretical and empirical accounts in the field, some recognition of the inter-relations between production and consumption, these seem to fall away in contemporary accounts of the social patterns of taste. Attention to the processes of cultural production and the techniques and technologies of the circulation and distribution of cultural forms might complicate some assertions that are made about the significance of changing social patterns of cultural consumption.

A focus on 'industrial' production also tends to collapse important distinctions, which this book attempts to preserve, between *taste* as a complex social, sensory, aesthetic and affective phenomenon and choice or preference as a rational, economic one. The cultural realm has already been marked out by economists (notably Cowen, 1998 and Throsby, 2001) as a somewhat different sphere of economic life and, therefore, a more complex sphere of *choosing* than that which might emerge, for example, by taking price as an indicator of a market-generated notion of quality, or indeed taking purchasing as an indicator of liking. Different rules might apply to cultural goods, and we need not look too hard for examples where processes of consumption in the realm of cultural taste complicate such economistic assumptions. Given the experiential nature of cultural forms, such as a trip to the cinema, the theatre or a live music event, the commitment to buy precedes the process of judgement – and one still pays the price for films or plays or performances whether one subsequently *likes* them or not. In these kinds of case the process of *liking* might be established before the process of *buying*, through engagement with the kinds of institution and technologies outlined below – be it from listening to trusted reviewers or reflecting on one's existing knowledge of one's preference for a performer, actor, director or writer in coming to a decision to purchase. Equally, though, the process of buying, and the subsequent experience of a performance, might well be the moment when *dis*taste is established, albeit that producers might take one's commitment to purchasing a ticket as an indicator of *preference* in assessing the relative success of a product, through sales or box-office receipts. The number of people who buy a cinema ticket is relatively easy to measure, while the number of people who walk out before the end of a film, or grumble about plot or performance on the way home, is more ephemeral, but both are important in establishing a more holistic view of taste. In a similar way we might reflect that the price we pay for cultural goods cannot be understood as a reflection of relative quality, or even as an indication of

the operation of market forces of supply and demand. While retailers within the cultural industries might compete on price at the level of individual units or in relation to specific forms of promotion, the unit price of a cinema ticket, CD, DVD or MP3 file is not related in any clear way either to the relative aesthetic characteristics of the different units to which purchase brings access or to the relative scarcity or popularity of these units within a marketplace that is governed by supply and demand. We will return to these issues in the next chapter, where we will consider the digital modes of cultural circulation which might, at least rhetorically, require some re-examination of this apparent distinctiveness. Recent work in what has come to be characterized as the *cultural economy* tradition (Amin and Thrift, 2004, Du Gay and Pryke, 2002) has helped to establish the limitations of reductive forms of thinking about all economic activity as somehow outside cultural norms and values, and subject to immutable laws of rationality. This work uses a broader lens not so much to consider the distinctiveness of issues pertaining to culture in relation to the principles of economics but to understand the economy as itself a *cultural* phenomenon, shaped by values, assumptions and practices. This work has some overlaps, in its genealogy, with the perspectives discussed in this chapter, but here the specific case of production within the cultural and creative industries is considered as an aid to our investigation into the shape of contemporary tastes.

This chapter proceeds by first outlining some relevant scholarly accounts of the processes of cultural production, including considering the place of production in understanding tastes in the work of Pierre Bourdieu, Richard A. Peterson and others in what has been characterized as the 'production of culture perspective'. Here our concern is with the *work* of cultural production and its role in shaping cultural taste. It continues by considering in more detail what can be identified as industry-based *strategies* of evaluation which act, often at the same time, as indicators of 'quality' in the variegated and diverse market for cultural goods, and as indicators of tastes more widely. It reflects, in turn, on the historical and contemporary role of critics or reviewers, the role of cultural prizes, and it concludes with a consideration of 'list culture' (Wright, 2012). These three strategies and the practices that are associated with them are outlined as reflecting the significant mediating structures between processes of production and consumption, which are important to understanding the creation and circulation of tastes for cultural goods.

Producing culture: 'The Lovely Consensus'

In his 2013 Reith Lectures, the artist Grayson Perry recounted the story of the sale of his pot, *The Lovely Consensus*. Perry's work, as both artist and commentator, playfully teases the established modes of the contemporary artworld perhaps most effectively in relation to questions of class, heteronormative forms of identity and – the subject of his lectures – notions of good and bad taste, albeit that he does these things, as a Turner Prize-winning, cross-dressing fellow of the Royal Academy, as something of an *insider* to this world. *The Lovely Consensus* is a pot upon which are painted the names of significant figures in the success of his career, including those of art critics, dealers, gallery owners and prominent collectors. Such figures, Perry acknowledges, form a 'validation chorus', without which the individual artist's works would never appear before the world to be either liked or disliked. The work of the members of this chorus, between the process of creation and the moment of consumption – in this case whether it be the viewer in a gallery or the collector at a sale or auction – is crucial to, and constitutive of, the position of the artists and their works in both cultural hierarchies of high and low culture (a distinction of particular significance to Perry, given his abiding concerns with the differential statuses afforded to conceptual forms of contemporary art and the less consecrated 'craft' work of pottery) and in the more general regimes of taste through which artworks can come to be known, liked and loved, or not (Figure 5.1).

The punchline to Perry's story about this work is that the collector Dakis Joannou saw his name on the pot and subsequently bought it, via a telephone call, while looking at it in the Tate Gallery (Perry, 2014). It is an intriguing story about the mechanics of the artworld, which themselves are rarely revealed (see Thornton, 2009, for a similar light-shedding exercise). For our purposes, this example illustrates two important contributions from scholarly accounts of cultural production. The first, expressed by Bourdieu (1993, 1996), is that the powerful figure of the individual creative genius which underpins the narrative of art in Western societies, and is central to the cult of culture which Bourdieu's work attempts to expose, is a myth. In order to acquire the status of an artist at all, much less the status of one who can exhibit in national galleries and subsequently be collected by wealthy connoisseurs, one needs, alongside the technical and aesthetic expertise to produce art, an *a priori* audience of significant figures in strategic

Figure 5.1 The Lovely Consensus by Grayson Perry, 2003, glazed ceramic, 60 × 41 cm, 23⁵/⁸ × 16¹/⁸ inches. Courtesy the Dakis Joannou Collection, Athens, the artist and Victoria Miro, London. © Grayson Perry

positions, choosing, accrediting and enabling its production. For Perry's validation chorus, we might substitute Bourdieu's 'universe of celebrants and believers' (1996: 169) who legitimize and give value to the works of artists and place works, first within the field of culture to be tasted at all and, second, in particular points in that field which reflect the

relative types of capital, be it cultural, symbolic or economic, associated with specific genres or styles of work. This links to the second important contribution – the recognition that such processes involve *work* and workers to inhabit these positions, and workers whom, in the pursuit of their own personal and professional goals, as well as their own aesthetic choices and cultural enthusiasms, might in subtle and not so subtle ways shape the parameters of creative production. Bourdieu has, again, instigated a tradition of research into these workers, identifying in *Distinction* the figure of the 'cultural intermediary', a strategically significant figure in the field of cultural production, engaged in the manifold roles that are required by the 'presentation and representation of symbolic goods and services' (Bourdieu, 1984: 359). Both the scale and the reach of these industries, and the volume and breadth of research into them, have grown significantly since the France of the 1960s, as the creative industries become recognized as both drivers of economic success on a regional and national scale and as suitable venues for careers for graduates emerging from, in Western Europe, North America and the rapidly expanding economic powerhouses of Asia, an expanded university sector. Perhaps it is this relative historical novelty, and an accompanying confluence of youth cultures and new technologies, which have allowed cultural intermediaries to embody hopes for new forms of work and new forms of dispositions to work, which have become influential outside the restricted realm of the industries themselves – with Florida's *Rise of the Creative Class* (2002) exemplifying and cementing this assumed significance. Studies have identified and critiqued cultural intermediaries in the fields of advertising (McFall, 2002), branding (Moor, 2008), book retail (Wright, 2005), fashion retail (Pettinger, 2004) and others (Smith Maguire and Matthews, 2014). In an important contribution to this debate, Negus (2002) also points out the limitations of a focus on particular kinds of worker and particular kinds of work within the broader field of cultural production, at the expense of, for example, accountants or IT technicians, or logistics workers. These less heralded workers also provide vital support infrastructure for cultural production but lack the 'symbolic' element in their day-to-day work – and it might be that these forms of work are growing in significance as the reorienting of the cultural industries towards 'frictionless' (i.e. labourless) forms of production and circulation change the requirements of mediation. Equally we might ask whether other forms of mediation – provided, for example, by the institutions and practices of cultural education – are not as significant in shaping our understanding of, and tastes for, cultural forms within specific times and places.

In the more restricted original definition, cultural intermediaries are not neutral parts of processes of cultural production. Rather, as part of the 'dominated fraction of the dominant class' (Bourdieu, 1984: 438), they are strategically significant – not just as agents of consecration but also when engaged in processes of struggle over the terms of consecration. As well as making things legitimate, they are also involved in processes of choosing what gets to be considered for consecration as good, bad, current, fashionable, passé or indeed kitsch, through a variety of strategies. These strategies can be distant from, and potentially even in conflict with, strategies of consecration of existing legitimate culture, such as the canon-making of academic scholarship, and they might include notions of *cool* (Frank, 1997, McGuigan, 2009), and the identification and exploitation of the internal hierarchies of taste subcultures. This gives the process of cultural mediation an intergenerational element, as new and emerging actors in the field of cultural production use their expertise and enthusiasm for new and emerging forms or artists to challenge, refine and perhaps, ultimately, *replace* established forms or artists as exemplifying legitimate culture and its 'opposite', popular or commercial culture.

This debate about cultural intermediaries can be understood as part of a more general concern within the sociology of culture named by Richard A. Peterson (1976) as the 'production of culture' perspective. Influential contributions to this debate similarly identify the significance of workers within the cultural industries, or, as a key figure, Howard Becker (1982), terms them, within 'Artworlds', who might have roles as support workers or gatekeepers (Hirsch, 1972). Here, workers in specific positions within the organizational structures of the cultural industries take on a formal selecting role in the process of cultural production. The embodied expertise of these decision-makers, as much as rational or immediately transparent forms of discrimination, becomes the key arbiter in decisions about what gets commissioned, published, signed or promoted, and the forms of knowledge which underpin these decisions become tacit, taken-for-granted modes of professional conduct. A good example might be provided by Radway's account of the US Book of the Month Club (Radway, 1997), a mail order-based book enterprise. Here, in making judgements about which books to select for distribution to its customers, this organization largely eschewed questions of aesthetic or literary merit and instead focused attention on identifying notions of *readability*, based on a working conception of what a 'book club' book might be. The editorial panels made judgements and selections based on this conception in combination with an

empirically identified sense of the kinds of book that had been successful in the past. In a similar field, Fuller and Rehberg Sedo (2013) discuss the figure of the television producer Amanda Ross who, for a time, rejoiced in the title of the most powerful woman in UK publishing by virtue of her role as editor of the book club segment on the noughties daytime chat show *Richard and Judy* – itself a UK variant of the similarly organized *Oprah's Book Club*. Here the criteria for selecting a title to be featured on the programme involved a complex intersection between readability, assumed resonance with the audience and translatability into the talk-show format, largely achieved through the possibility of the title generating a colourful celebrity-led package through which its plot, characters and qualities could be explored. Success in this endeavour, for a time, guaranteed publishers unprecedented levels of exposure to a popular audience and subsequent bestseller status for its titles. The quest for this kind of success seems likely to have influenced the behaviours of publishers in selecting between titles to publish and promote, and might be imagined to influence the choices of writers themselves in producing character- and plot-driven work for an assumed popular audience.

In these kinds of instance, workers in these strategic gatekeeping and mediating roles are more readily cast as taste*makers*. Their practices remain relatively hidden, except perhaps, as in the case of Ross, when their success makes them the object of broader curiosity within the cultural field itself, or, paradoxically, where their decisions might be interpreted as being spectacularly wrong. In this latter instance we might consider the stories of record labels that turned down the Beatles or Madonna (in the former case the 1962 verdict of Decca records that has passed into historical folklore was that 'guitar groups are on the way out'), the publishers who passed on the *Harry Potter* books or the BBC commissioning editor who passed on the early scripts of *Fawlty Towers*. The drama and legendary status of these kinds of example emerge from the subsequent successes of these artists or works, as if these successes were somehow a reflection of some inevitable and intrinsic aesthetic or artistic quality of the pieces or artists concerned, and not the result of a subsequent process of identification, selection and promotion resulting from a *different* decision from a worker in a similar gatekeeping role.

By bringing these kinds of process under scrutiny, the production of culture perspective also broadens the influence from workers in these roles, individually and collectively, and shifts the focus of understanding towards those institutional and professional norms and values which act to inform and constrain decision-making, and towards technological

change and the potential that this has for shaping the modes of production and circulation of culture. In this sense, in its earliest iterations, Peterson's vision of the production of culture emerges from an ambition to apply the more general insights into processes of social or cultural change previously identified in the fields of science, through the concept of the paradigm as a collective form of working knowledge (Kuhn, 2012). From this perspective, scientific knowledge and especially scientific discovery does not emerge from the cumulative practices of scientists working on problems, but it is shaped and constrained by tacit assumptions of scientists in relation to the dominant theories of their time. Periods of change, such as from Newtonian to Einsteinian modes of understanding physics, are both rare and traumatic for the scientific community as old certainties and institutions, and individuals invested in them, fall away and new ones emerge to replace them. In a similar way, the production of culture perspective is most effective in providing the explanatory tools to comprehend process of change within cultural forms, changes which again trouble the conception of individual artists or cultural producers as bold innovators and implicates them in processes of institutional and industrial regulation. Peterson constructs the distinction between these kinds of change as exogenous (i.e. outside the cultural field itself but ultimately shaping it) or endogenous (i.e. from within the cultural field, emerging more clearly from the practices of artists or the institutional organization of cultural production). Such influences might be related to the structural organization of cultural production itself, such as in the shift from a model of courtly patronage for artists in renaissance Europe to a more market-oriented model in the nineteenth century. Influences can also be identifiable at the level of genres within artistic forms, within the very emergence of forms themselves, and indeed in the development of the careers and works of individual artists. Peterson and Anand's (2004) review of work in this tradition draws on the insight of De Nora (1995) in discussing the development of the career of Beethoven and the significance of the invention of the pianoforte. Its design and sound were, apparently, more forgiving of, or responsive to, Beethoven's own less delicate and more emotional style of playing than the harpsichord. Moreover, the range of tones and sounds available through the pianoforte allowed for more complex forms of composing for the orchestra. The emergence of this technology, and Beethoven's ability to exploit it, allows the historical figure whom we now revere as emblematic of a consecrated and legitimated artist to emerge from his origins as a 'provincial musician on the streets of Vienna' (Peterson and Anand, 2004: 314).

In the mid-twentieth century, a range of technological and cultural developments sparked what we now recognize as the cultural industries into life, and also sparked the accompanying 'mass culture' critique that we examined in Chapter 1. These changes are perhaps most telling in revealing the industrial and infrastructural architecture of genres and forms which now appear self-evident and eternal. The role of electronic recording and amplification, for example, was essential to the development of popular musical vocal performance, with the rise to popularity of 'crooners' such as Bing Crosby or Frank Sinatra in the early twentieth century helping to shape a market and taste for this genre which challenged and partially supplanted the previously dominant position of singers in the operatic tradition. The recording and storage of music in specific 'technical media' (Thompson, 1995) allowed for its distribution and commercial exploitation, and, through accompanying developments, for its *broadcast* through radio, into the homes and workplaces of its audience. Peterson's account of the subsequent relative decline of the crooner in what has become known as (to echo both the language of paradigms and the labelling practices of musical industry intermediaries themselves) 'the rock era' explains this process as reflecting not simply a shift in tastes but a shift in the organizational mode of the music industry, in which a few large firms that were competing for an audience imagined as a mass began to be displaced by smaller firms who were more able to respond to the developing *niche* tastes of younger audiences. The subsequent history of the music industry in this era might suggest that monopolization and conglomeration reestablished themselves, but this model of churn in the development of cultural industries, and the relation between these models and the cultural forms and genres which emerge from them, remains significant to understanding the institutional architecture of contemporary taste. This is perhaps especially true in the contemporary context where modes of production and circulation of cultural forms are again in flux. The next chapter will consider these changes in relation to the digitalization of tastes.

More recent contributions in this tradition move us closer to a direct understanding of the relation between the kinds of structural, technological and social change implicit in the production of culture and the formation of tastes. In particular this work has provided important conceptual tools for exploring the *careers* of forms or genres and their movements up and down hierarchies of legitimate and popular or commercial culture. Paul Di Maggio's (1982) work on the 'brahims' of Boston is especially influential here in explaining and exploring the processes

through which cultural entrepreneurs from within the educated middle classes of the nineteenth-century US city sought to put boundaries around their preferred forms of entertainment and exclude the mass urban audience, including by marking the spaces, forms and ways of presenting entertainment. These moves are bound up with the kinds of struggle for status, recognition and distinction described above in relation to cultural intermediaries, but can also be reflective of wider social and technological changes, including anxieties about what a mass audience is and what it is to be part of one. Baumann (2007), for example, describes the career of film as a legitimate *art*. This history includes an early period when the nickelodeon theatres were associated with the working classes, and in which both the subjects of these entertainments and the venues for them (especially the dark, packed, enclosed spaces in which films were exhibited) were considered salacious, shallow or morally suspect. While in the early days of film there may have been some crossover between the technical skills of film exhibitionists and *avant-garde* forms of artistic representation, especially in Europe, the rise of film as a global cultural form in the pre-war period was largely premised upon a Hollywood-based studio production system aimed at producing entertainment for what was assumed to be a mass audience. The persistent association of this audience with the entertainment choices of the working class was a brake on the possibility of film being more widely legitimized and consecrated as an artform.

For Baumann, the emergence of the notion of film as *art* intensified in the post-war period, and most especially in the 1960s. Here what Peterson would characterize as *exogenous* factors changed the nature of the audience for film. The demographic changes of this period include the coming of age of the baby-boom generation and a general expansion of levels of education which made the 'mass' audience younger and more 'sophisticated', as well as more affluent. Technological changes included the cementing of television of a popular and alternative leisure pursuit for the mass audience which somewhat paradoxically *shrank* the audience for film. Other changes were closer to the field of cultural production itself, including the intergenerational shifts within the art world – analogous here, perhaps, to Kuhnian paradigm shifts – in which established aesthetic hierarchies were being challenged. The young and educated products of post-war affluence that underpinned the pop art movement brought the products of mass culture, including film, under the lens of artistic and aesthetic consideration. Within the field of film itself this period is also one in which the practices of the filmworld began to echo those of other artworlds through, for

example, the institutionalization of a calendar of festival events, prizes and the further establishment of the notion of the director as film's driving creative force. Both of these processes can be seen as responses to a shrinking audience too. The first helped to strategically distinguish the products of the industry from its principle rival: television. The second reflected a desire for experimentation and innovation in the light of the failing models of imitation and reproduction which had characterized the relative commercial decline of the studio system. Finally, and perhaps linked to this, this period of consecration is also characterized by the further establishment of an academic and critical discourse about film as 'art', including from beyond the USA in the *Cahiers Du Cinema* journal and the schools of European critical thought, which valorized popular film directors such as John Ford and Alfred Hitchcock, and prepared the ground for film's more general acceptance as an aesthetic form that could be struggled over and talked of in the same terms as the products of the visual or literary arts. These historical intersections between industry, technology and the social and demographic changes in US society reshaped the ways in which films were produced, but also shaped the range of things that film as a cultural form could mean, and the range of things that could be said about it, altering its position in cultural hierarchies and regimes of taste.

 A final contribution from this perspective considers the role of the *consumers* of cultural forms to our understanding of the process of producing tastes. Our discussion of the dimension of *measurement* in Chapter 2 outlined the significance of genre to the understanding of taste, reflecting on the difficulty of using genres in methodological strategies for exploring tastes because of their relative lack of solidity. This is a practical problem for researchers, but also a practical problem for cultural producers for whom genre works as an organizing lens through which decisions about the kinds of work to invest in or promote is inevitably refracted. Equally for cultural consumers the genre labels provide import signals about the characteristics of cultural goods and about their broader social meanings. In the work of Jennifer Lena, for example, building upon an important collaboration with Peterson (Lena and Peterson, 2008), genres are not simply adjectives to describe the nature of cultural forms – they are *institutions* which act in shaping or sorting the cultural world into categories through which it can be made meaningful. Producers and consumers of culture are 'genre stakeholders' (Lena, 2012: 15) who sometimes have competing interests in producing, maintaining, policing or subverting genre conventions, and it is often consumers rather than producers who have the strongest

claims to knowledge about, and the most investment in, the authentic characteristics of a genre. In the context of tastes for popular music, this is most often reflected in the forms of subcultural activity that are associated with fans of specific artists or genres that are able to identify and pronounce upon the *real* hip-hop or heavy metal, and equally identify and dismiss the *fake* as well as place items in increasingly fine-grained subgenres. These kinds of strategy of evaluation are closely followed, even *reproduced*, by industry forms of genre-making.

Importantly, though, in Lena's account, processes of classification are part of a process of framing genres and their audiences – placing them in relation to other things and to the people who like or do them. Rap music, for example, might be considered differently in the hierarchy of musical taste if it is *political* in its subject matter, or if it is identified as 'underground' or *avant-garde*, than if it is commercially successful or, in relation to the history of this genre in particular, if its lyrical content is conceived to reflect shallow materialism or is labelled misogynistic. These strategies of labelling are partly judgements of taste, but they are not aesthetic judgements about the qualities of the texts or products themselves so much as social and even moral judgements, of approval or disapproval, about the people who listen to or produce the music. Genre here can perhaps be understood as another element of a productive and generative infrastructure of taste, the history of which falls away in the processes of production and consumption in a similar way to how it does in the design and interpretation of surveys of taste. These relations between the dimensions of producing and measuring taste recur in the next section, which considers other examples of the productive infrastructure of tastes.

Strategies of evaluation

Questions of taste are always questions of judgement and interpretation, with pronouncements about good or bad taste, or the relative position of things or people in regimes of taste reflecting an endpoint of these processes of judgement and interpretation. This section characterizes these processes as *strategies* of evaluation, and it identifies three distinct strategies which are employed in the processes of producing taste. These strategies can be interpreted as part of a more general sociological concern with the rise of the notion of evaluation and the accompanying attribution of worth – one which, as Lamont (2012) summarizes, can be found in a range of contexts. Not the least of these, of course, is academic research where the worth of works – including the one before

you – is judged through a range of modes of evaluation, at least some of which (its subsequent citation or review in prestigious journals or by prestigious scholars in a field) are really only rather tangential to judgements about whether readers liked or disliked it or whether students or researchers found it useful. Strategies of evaluation are central to a range of forms of social life, including in attributing worth in the spheres of health or education, and the intensification of these strategies reflects the cementing of neoliberal forms of governance, organized through technologies of measurement and ranking. Lamont proposes a 'sociology of valuation and evaluation' which can address how these conditions attribute value and worth to people and things, but can also provide the basis for alternative modes for this attribution. The study of taste, with its focus on the inter-relations between aesthetic and moral forms of value, might well remain important to such a project. The more general study of processes of evaluation might well benefit from a consideration of how such processes play out in the specific field of cultural production. Here the attribution of value might appear benign if interpreted as, for example, the provision of information to a consumer to inform the expression of a preference or choice, but might also result in the ossification of the sum of evaluations into cultural hierarchies which are exclusionary or divisive. In approaching these discussions, though, it is also worth being reminded of John Frow's (1995) reflections of the relative rarity of a sociological concern with evaluation in relation to culture, where judgements of the qualities of things are too easily interpreted as proxies for judgements of the qualities of people. Such a move misses the *pleasures* of evaluation, and that having one's tastes affirmed or challenged by evaluative frameworks – be they expert, academic or peer-to-peer in their origin – might be an enjoyable part of the game of culture. Subsequent sections explore these strategies, attempting to keep both the risks and the pleasure of evaluation in mind and beginning with a consideration of the role of the critic or reviewer.

Critics and reviewers

Critics or reviewers – with the distinction between these two labels being significant in ways which will emerge below – represent a relatively identifiable, bounded and concrete aspect of the infrastructure of tasting, exemplifying the mediating role between producer and consumer. In *Distinction*, Bourdieu describes the role of critics as one among three apparently autonomous and distinct spaces in the field of cultural production. He identifies the 'perfect' correspondence between the space of critics, the space of producers and the space of the audience. This

correspondence accounts for the fact that, as he describes it, 'every actor can experience his encounter with the object of his preference as a miracle of predestination' (Bourdieu, 1984: 234). The place of the critic in the infrastructure of taste is so mundane and everyday, in other words, that it falls away from our immediate apprehension at the moment of choosing, so that it looks and feels like we are making discoveries in the cultural realm, as opposed to selecting between the things which are placed before us by, among other social processes, the mechanisms of the cultural industries. The specific role of the newspaper critic is mentioned here too in relation to an account of Jean-Jacques Gautier – the literary critic of *Le Figaro* who is described as the paper's ideal reader. A critic, Bourdieu suggests, 'can only influence his [sic] readers in so far as they grant him this power because they are structurally attuned to him in their view of the social world, their tastes and their whole habitus' (Bourdieu, 1984: 240).

There has been subsequent analysis of the role of critics in the institutions of the art world and how it might have changed over the periods of the historical development of the cultural industries. A useful insight into this narrative perspective is provided by the work of Wesley Shrum (1991, 1996), who accompanies his empirical analysis of the persistence of cultural hierarchy, based upon analysis of the reviews of performances at the Edinburgh Festival in the mid-1990s, with some attempt to trace the genealogy of contemporary criticism. Critics and reviewers here are assigned specific mediating roles in both moving audiences that attend the festival in the city between shows, and also reporting from the festival to the wider culture – and the distinction between critic and reviewer is significant. As Shrum points out, the terms are used interchangeably – it is 'critics who write reviews' (Shrum, 1996: 44) – but equally the scale and ambition of each role in the field of tasting might be different. *Reviews* are shorter, more informational and evaluative, answering questions such as 'What kind of thing is this?'; 'Where is it available?'; 'What is it similar to or different from?'; and 'What is it about?'. The products of *criticism*, by contrast, are longer and more reflective, and are concerned with the place of a work in a tradition or genre, or in the career of an artist or movement, or more generally in relation to the cultural concerns and tensions of the day. The former might be more readily recognized as part of a guide for consumers, while the latter is part of critical dialogue with an informed audience, with critics acting as *guardians* as much as mediators, apparently distinct from the grubby processes of cultural promotion. The boundaries between these two categories are somewhat fuzzy but still worth attempting to identify.

Shrum's work (1991) is also useful for charting the development of the modes and purposes of criticism alongside the development of the specific forms or genres which are being reviewed, evaluated or critiqued. He identifies a first phase as 'interactional' criticism, emerging from the UK's theatre culture of the seventeenth century where rival playwrights and significant men might sit, on the basis of an increased admission price, on the stage itself. This put them in a position in which they were visible to the audience, allowing their reactions to be assessed *alongside* the performance but also allowing them to comment directly on the performance as it was ongoing. In this sense, criticism is not simply about mediation but also a kind of extension of the performance in a way we might imagine that reading reviews of new and emerging cultural items is not simply about evaluating them but also part of the *pleasure* of cultural consumption itself. This visual presence of the expert critic might have another contemporary iteration in the television talent show judge where editing allows movement between the performances to be judged and the individuals accredited with the authority to judge. This makes the pleasure of the experience of watching not simply evaluating the performance but predicting the judgement of experts on the basis of their facial expressions. This creates the possibility for – in the much heralded example of the launch of the career of the popular Scottish singer Susan Boyle on the television show *Britain's Got Talent* – the invented drama of confounded expectation.

Shrum's second phase is 'promotional', and this relates to the emergence of the newspaper as a commodity, but also as a site for the containment and routinization of reviewing practices as part of the increasing institutionalization of the arts. This phase is noted by a shift in the tone of criticism from strategic forms of abuse or one-upmanship to still strategic mutual support and celebration on behalf of a community of artists, with reviews becoming more explicitly promotional. The final phase of modern criticism is when critics take on evaluative roles in 'ways not necessarily to the liking of performers' (Shrum, 1991: 350). A bounded and professionalized field of criticism (accompanying the rise of a more bounded and professionalized field of journalism) depends on the expression of more objective forms of authority and expertise which reflects a role for critics in educating their audience about the terms of judgement and recommendation, and identifying and selecting between items according to norms of quality. An analogy with journalism is perhaps apposite in understanding the overlaps between the modern and promotional phases, especially in relation to claims of objectivity. Some aspects of the contemporary critical landscape – the

film promotion 'junket', for example – requires a symbiotic relationship between reviewers and producers such that the informational aspects of broadcast or print media content about a film are effectively co-opted into its marketing strategy through access to the actors or directors involved. Producers also need good reviews, as the objective authority of the critic becomes a promotional tool in itself. Newspaper critics, as journalists, have the power to give attention to and select a few from a range of possible items to bring before their audience for them to choose between. Such decisions might themselves be based on the practices of the industry (circulating review copies of books, review screenings of films, 'press-night' performances of shows) but also be based upon the tacit professional judgements of the tastes of the audience. The mismatch between these assumed and actual tastes might undermine the authority of an individual critic or even a publication. In his account of the rise of the film-school generation of 1970s American film directors, for example, Peter Biskind (1998) recounts the screenwriter and director Paul Schrader's early career with the underground LA Free Press. Schrader reviewed *Easy Rider* and described this sacred cow of the counterculture as a cliché-ridden propaganda piece precisely designed to appeal to its imagined audience and to confirm their prejudices, 'like every other gutless piece of Hollywood marshmallow liberalism'. He was fired soon afterwards.

A more recent contribution to the sociology of reviews is provided by the work of Grant Blank (2007), which helpfully moves the debate on from a focus on the bounded field of artworks and towards the increasing embeddedness of strategies of evaluation in other fields, focusing on restaurant reviews – a more obvious sphere, perhaps for considering questions of taste – but also reviews for specialist forms of software. Blank emphasizes in analysing these examples the ways in which reviews are constructed as representing objective sources of credibility, emerging from the perceived competence of either individual reviewers or the reputations of the publications in which the reviews appear. Like Shrum, Blank reminds us that reviews and reviewers are the products of institutions with memories, cultures and priorities of their own. He identifies two useful *frames* through which reviews can be read. In the first, *connoiseurial* reviews, the skills, sensibility and training of the reviewer are significant, and critics in this tradition can become authorities in their own right within the fields in which they operate. We might think of figures such as Kenneth Tynan or John Lahr in relation to theatre, Pauline Kael or Roger Ebert in relation to film, Greil Marcus or Nick Kent in relation to rock music – figures who muddy the line between

criticism as an arm of consecration in an academic sense and reviewing as a promotional strategy of the cultural industries. Reviews in this frame tend to be textual in nature, to supply context and to interpret the aesthetic, canonical or even broader social significance in order to persuade the reader or viewer to see, read, visit, experience – if not explicitly *buy* – the thing under review.

In the second frame – labelled *procedural* – reviews gain their credibility through the processes through which the objects under review are scrutinized. The identification of the qualities of these objects is achieved through some experimental or quasi-experimental testing of elements of the product – through a process rather than through a person. This is the form of reviewing which might be most familiar in relation to consumer items, rather than cultural products *per se*, with results being presented in numerical or tabular form, allowing for comparison. Practically it might be that connoiseurial reviews are cheaper, requiring a reviewer and a product or event, and the time to reflect about it. Procedural reviews might be more expensive and logistically complex, requiring specialist equipment and facilities. What Blank's work suggests is that the weight of sociological forms of analysis on this topic has really focused on the former frame, but it might be that contemporary reviewing culture is increasingly moving towards the latter, at least at the level of representation where, on sites such as Amazon, the same numerical system for scoring reviews is applied to great works of literature, film or television, clothing or other consumer goods. The differences between them, then, are indicative of different versions of authority and different guiding logics about the needs of their presumed audience. These kinds of difference recur in two further strategies of evaluation.

Prizes

Explicit practices of promotion within the cultural industries are a source of some suspicion and anxiety among academic and intellectual discussion of culture. As with the relations between culture and the forces of supply and demand discussed above, it seems that the idea that tastes can be shaped by the techniques and technologies of advertising and public relations sits uneasily with a vision of the arts and culture as concerned with higher things. For those in the cultural know, at least, the marketing of cultural goods is more often understood as something that is done to other people, who might be more susceptible to the forms of manipulation or surreptitious persuasion present in the advertising or public relations worlds because cultural goods are of a different, special order. The case of the cultural prize

illustrates this tension quite neatly. Such prizes can illustrate, in different contexts, expert expressions of judgement between myriad cultural products, a source of content for the cultural media and a signal of quality for consumers in the cultural realm. English (2005) describes a 'cultural politics' of the contemporary arts prize which enables them to be decried by both radical and conservative cultural critics as, at the same time, trivializing critical responsibility and as extensions of the marketing and promotional practices of industries in which they operate. He also, though tellingly, describes the rise and proliferation of the cultural prize across the twentieth century – and intensifying from the 1980s onwards – to suggest an increasingly solid infrastructural aspect of awards and prizes. Within the cultural industries themselves they can be interpreted as key organizing points within the year, and also as a means of providing some kind of credible information and sign of 'quality' in a vastly diversified market. Arguably, though, they are more than this and have become, in the commercial cultural industries at least, not periodical moments of reflection on the best that an industry might have to offer (although the periodic nature of prizes is significant, as we'll discuss below), but a constitutive part of the process of production itself. As discussed above, Baumann's account of the development of the contemporary film industry identifies the rise of awards and festivals as being central to an emerging narrative in the late twentieth century about the status of film as an art. English's analysis of the rise of prizes suggests that they have become even more fundamental. By identifying a sample from the festival and awards mentioned in the Internet Movie Database (numbering more than 900 different festival events worldwide), and assuming an average of just nine prizes per festival (he reports that the Academy Awards, for example, involve some 37 different prizes), English reasonably estimates that, with worldwide film production at around 4,000 a year, 'the number of movie prizes presented each year is somewhere in the neighbourhood of 9,000 or more than double the number of full length movies produced' (English, 2005: 325). In this light, the production of prizes might be interpreted as being as significant as the production of films for the film industry – and given the roles of prizes as assumed markers of quality, guides for audiences and promotional tools, prizes are central to the production of tastes. The tensions between these competing roles of the prize – as authoritative and credible indicator of quality and as promotional strategy – is reflected by Street (2005), who describes the dilemma experienced by the organizers of literary prizes between choosing judges with the appropriate levels of credibility within the literary world to mean that

their decisions would be accepted, but also with enough recognition within the broader media world to mean that their decisions can be translated into a visible opportunity to promote the sales of nominated and victorious titles. This interaction with the promotional, media and news branches of the cultural industries in relation to prizes is useful to consider in relation to the infrastructure of tasting. One visible manifestation of this is the *calendar* of cultural prizes, the relatively regular unfolding of major festival and prize events over the course of a year. In the UK this 'season' might be identified as beginning with the presentation of the Mercury Prize for music or the Man Booker Prize for literature in the autumn, followed by the BAFTA film awards and the BRIT music awards in early to mid-February. The regularity and predictability of these and other awards ceremonies in the calendar year allow them to act as organizing points in the production and promotion schedules of the diverse actors in particular industries but also, importantly, as regular sources of material to write about and discuss for the cultural media. Here the unfolding of cultural production can be understood as one manifestation of 'news values' (Gultung and Ruge, 1965) in which stories which can be identified *predictably* and well in advance by news organizations helps to ease the risks and costs of news coverage. Arts reporters at the ritualistic award ceremonies here might be akin to correspondents in front of Parliament, symbolically located where the drama of events is assumed to occur.

The construction of the media, as a kind of monolith that exists somehow outside processes of cultural production, is difficult to sustain analytically both because, as the above discussion of reviews indicate, critics and reviewers are media actors as well as 'cultural' actors, and because the organizational distinctions between different branches of the media are rather porous. One need not sign up entirely to a political economy critique of the media industries to see the benefits of, say, the same company owning a film studio or publishing house (as in the case of News Corp with the suite of Twentieth Century Fox studios and HarperCollins) and also having access to newspapers (*The Times*, *The Sun*) through which to cover them. Leaving aside the possibility of any judgement about whether this relationship troubles the credibility of media coverage, the possibility for one arm of an institution to editorially select from another can be seen to support a symbiotic relationship of mutual need – of sites of *promotion* on the one hand, and sources of *content* on the other.

In Bourdieu's work the media as we might recognize it is rather absent, and in his later work *On Television and Journalism* (1998b) it

is conceptualized as a kind of polluting 'other' to, rather than a central part of, cultural life. Rodney Benson's development of this work asserts that the mediating role of the media – 'its unique mandate to enter into and explore other fields and then publicly share its findings – allows it to actively influence the relations of power throughout contemporary societies' (Benson, 1998: 466). A subsequent collection (Benson and Neveu, 2005) demonstrates the mediating influence on the fields of the academy, the judiciary and medical research and, in each case, the results of mediation tend towards the increased influence of commercial pressures. The media here becomes a synonym for the forces of the market. Media controversies are also central to successful cultural prizes. English describes the general 're-shaping of the relationship between journalistic and cultural capital, celebrity and canonicity' (English, 2005: 207) in the practices of sponsors and administrators of prizes, as scandal and controversy around the processes of judging and awarding cultural prizes became increasingly central to their operation in guaranteeing the kinds of media coverage which contribute to the improved visibility and saleability of items under consideration. In the career of the UK's Man Booker Prize, for example, condemnation from the literary commentariat about the prize, the judges, or who does or does not win has become an essential part of its operation. As English contends, 'far from posing a threat to the prize's efficacy as an instrument of the cultural economy, scandal is its lifeblood; far from constituting a critique, indignant commentary about the prize is an index of its normal and proper functioning' (English, 2005: 208).

Prizes then can perhaps best be understood as part of the process of attributing value within industries, but also as part of struggles within and between fields of cultural production, including between established forms of critical authority that are more closely associated with legitimating powers such as academic authority, and other fields shaped by the forces of commerce or the imperative to promote or generate controversy. These struggles can be interpreted as reflections of different kinds of trust and authority, given to different actors in the processes of production in relation to valuing and comparing cultural goods. The final strategy perhaps represents this process of valuing and comparison in its starkest terms.

List culture

For most of my lifetime, *Citizen Kane* had a strong claim to being the greatest film ever made. One basis for this that was not rooted in the aesthetic or artistic qualities of the work itself could be found in its regular

position at the top of various lists of 'the greatest films ever made', perhaps the most authoritative of which is provided by the British Film Institute's Decennial list, which is compiled through an extensive survey of film critics. Kane was made in 1941 but did not make it into the top 10 of that list in its first publication in 1952. By 1962, however, it was at the top and remained there for 50 years. In 2012, though, it was replaced at number one by Alfred Hitchcock's *Vertigo*, a film made in 1952 – a shift that generated considerable discussion and attention in the film and cultural press. *Citizen Kane* was no longer the greatest film ever made. Neither film had changed, of course, in the decades since they were first released, but their position in relation to one another could, authoritatively if not quite objectively, be claimed to have altered. The career of this list – and the uses to which it is put – is a useful starting point for considering it as a distinct and powerful strategy of evaluation in relation to the production of tastes, indicating the attempt to capture and arraign cultural authority about its objects in a visualizable way and, importantly, showing that these strategies are malleable and subject to change, depending on the mechanisms of their construction.

Lists of this kind are a staple of cultural journalism, with periodic lists of what is being read, listened to or watched coexisting alongside regular polls of the 'greatest' books, pop albums or films, according to critics, reviewers and, more recently, polls of viewers, listeners or readers themselves. Here the intrinsic qualities of specific items is replaced by an assessment of their value purely in relation to one another – notwithstanding the differences in genre, tradition or content which might make them incomparable in any meaningful way. Their prevalence perhaps perfectly exemplifies the ambiguities of contemporary forms of evaluation as laid out by Lamont. They represent an attempt to make visible and knowable the qualities of objects which might otherwise have been assumed or policed by opaque, charismatic forms of knowledge and authority. They also recast qualities as part of a competition in which different objects are measured against one another through processes which often obscure actual processes of classification. The list in this sense takes on the persuasive and rhetorical air of 'fact'.

There are, as I've written elsewhere (Wright, 2012), a variety of potential modes of list and a variety of practice of list-making in relation to the evaluation of cultural goods. One set of examples is provided the by polls of readers, listeners or viewers through increasingly interactive forms of media technology that became common in the late twentieth century, and might be understood as a process of democratizing tastes, wresting the power away from established authorities and placing it in

the hands of sovereign cultural consumers. Another might be provided by the guides to the Arnoldian 'best that is thought and said' among abundant culture, provided by early twentieth-century lists of the right books to read, benevolently inspired by a desire to shape the reading practices of an expanding literate population, such as Arnold Bennett's *Literary Taste and How to Form It* from 1909, or John Cowper-Powys *One Hundred Best Books* from 1916. The early twenty-first century equivalent of these might be the series of glossy publications from Cassel listing 1001 things, including classical music to listen to, films to watch and paintings to see, 'before you die'. These can be interpreted as particular kind of guide to the efficient acquisition of objectified cultural capital, albeit one framed through some recognition of the ultimate futility of that endeavour.

This tension between *measuring* and *guiding* coexists in the cultural list, and especially in its exemplary form, the *chart*. Charts act as what Anand and Peterson refer to as 'market information regimes' (Anand and Peterson, 2000: 271) for producers and consumers, helping to organize and inform activity within the cultural marketplace. They are rarely neutral in this process, though, and might be 'socially and politically constructed and are hence fraught with biases and assumptions that are largely taken for granted' (Anand and Peterson, 2000: 271). The primary object of their analysis, the US *Billboard* chart, emerged in the late 1950s as an explicit attempt to undermine the power of individual hit-makers or song-pluggers to determine the priorities of the music industry. The aim of the chart was to present a more objective view of what was popular or not on behalf of producers who were keen to prioritize their investment in genres and artists which could be authoritatively identified as popular. This was first achieved through a method that combined surveys of retailers with measures of most plays by disc jockeys and most plays in jukeboxes. The method was developed into a panel survey in which music retailers were asked to place songs into the categories 'top', 'strong' and 'good' selling. It was not, in other words, a measurement of what was actually sold, and when point-of-sale technology developed to enable that kind of measurement in the 1990s, the nature and content of the chart changed. Long-term popular sellers increasingly coexisted alongside the new material, which was the preferred focus of industry marketing activity. Genres that had been underestimated in the previous methodology – notably country music – suddenly appeared to be popular. This latter discovery, resulting from a rebalancing of the previous under-reporting, also provided the opportunity for a music industry promotion of a *boom* in country music.

There are echoes here clearly with debates in Chapter 2 about how methods of measurement create, rather than simply reflect, the phenomenon that is being measured. This becomes especially significant when charts become powerful promotional tools themselves. Laura Miller's (2000) work on the *New York Times* bestseller list explains that the level of trust and authority of that chart among publishers and the trade has allowed it to become part of contract negotiations with authors, with financial remuneration varying according to the position and length of time a book sustains on the list. This is despite the fact that the list is not, as a legal battle with the horror-writer William Blatty revealed in the 1980s, an objective measure of sales at all but an 'editorial product' based upon a survey of some 4,000 retailers, and some wholesalers, of relative sales of a preselected range of titles. The exact methodology remains proprietary information, and the process of how a title is selected for the list is the subject of intense speculation, and yet the list itself remains an authoritative – and useful – tool through which publishers and consumers can make sense of their producing and consuming activities. In the cases of both *Billboard* and the *New York Times* list we might imagine, within the industries that orient themselves towards them, a view that recognizes the fallibility of attempts to create and manage charts coexisting with an everyday assumption of their usefulness in judging the successes of particular products. This might be summarized as: if it's near the top it's because of 'our' efforts; if it's near the bottom it's because of the process.

From a Bourdieusian perspective on cultural production (1993, 1996), these processes might be 'heteronomizing' – recasting cultural taste as a competition in which being number one is the prize. However, dismissing lists as either marketing tools or cultural trivia also ignores the insights that they might provide into the changing processes through which tastes are constituted. The contemporary manifestations of list culture – in the circulating top tens of songs, albums, books or films that animate social media – also suggest that the expression of preference and the kinds of ranking that are enabled by the making of, and participating in, list culture is an optional extra to the pleasures of cultural consumption in the early twenty-first century. David Stark considers ironic and humorous responses to top ten lists – both 'frivolous' and 'ubiquitous' – for example, as emblematic of our recognition of the fallibility of these kinds of apparent measurement. They are amusing because they expose

a mixture of assessment criteria so ad hoc and absurd as to defy all rhyme or reason in the selection principle, whereby any element

on the list can be 'ranked' as higher or lower than any other. Such ironic lists thus evoke an unsettling sense that many of the rankings and ratings that we (along with our deans, our creditors and our regulatory agencies) use are organized on an ordinal scale but were cobbled together from disparate and incommensurable principles of evaluation.

(Stark, 2011: 326)

What such lists might also represent, particularly in the contemporary context of 'endless choice', is a way of rationalizing or mediating processes of production and consumption on the one hand, and a broadening of the conversation of consecration, which includes different fields and different forms of capital managed through different techniques and forms of authority on the other. We will return to these issues in the final chapter.

This chapter has considered the productive dimension of taste, focusing first upon the *work* of the cultural industries and then on three strategies of evaluation which might be identified as generating and shaping contemporary tastes. It did so by attempting to keep attuned to the complexities of the production and consumption of culture and the limitations of lay economic understandings of the working of the market, price or supply and demand in accounting for how tastes for culture are shaped. The chapter drew on and explored the 'production of culture' perspective to reveal how the structural and institutional architecture of the cultural industries, and the structural, contextual tensions of the societies in which they operate, serve to shape both the production of material to be tasted and the interpretation and evaluation of that material. Here the *skills* and *sensibilities* of strategic workers in the cultural industries, and the decisions that they make, become powerful arbiters for the range and characteristics of what appears before us to be tasted. In identifying three strategies of evaluation – of critics, of prizes and finally of lists – the chapter also suggested the existence of an architecture or infrastructure of tasting, which manages and regulates how and in what ways cultural products are judged to be valuable or not – some of which involve the expression of forms of cultural authority, but all of which involve some negotiation between producers and consumers, or tasters, in establishing and maintaining that authority. The pleasures of cultural consumption might involve some participation in, and tacit recognition of, the arbitrariness of these forms of evaluation. Scholarship which has attempted to understand these processes of production of tastes has grown up alongside the cultural industries

themselves in the latter part of the twentieth century. Our final dimension considers how these insights, while remaining significant to our understanding of contemporary forms of tasting, might also be placed in flux by the possibilities of a new infrastructure of tasting, requiring new skills and sensibilities.

6
Digitalizing Tastes

This chapter considers the role of digital forms of technology as a final dimension that gives shape to contemporary cultural tastes. In doing so it considers some scholarship on the social role of these technologies and characterizes them, like the critics, reviewers and intermediaries described in the previous chapter, as part of the *infrastructural* and *institutional architecture* of contemporary taste which is central to the ways in which tastes are circulated by the cultural industries of the early twenty-first century. Such technologies are not considered as simply transforming the social nature of tastes and tasting as part of the rather breathless fetishizing of the new which often accompanies the theorizing of the Internet age. Instead, the means by which tastes are produced, managed and circulated in the 'digital world' are examined in the light of the theoretical and methodological perspectives on tastes described in earlier chapters, with an emphasis on the continuities as much as the evident changes. There are good analytic reasons for this position, beyond the inherent caution of any sociological understanding of the often glacial processes of social change in relation to new technologies.

On the day I am writing this, an article has appeared in *The Guardian* newspaper celebrating the twentieth anniversary of the foundation of the online retailer Amazon, first registered as a company in November 1994 (Hooper, 2014). As the following discussion will illustrate, Amazon and its techniques and technologies of circulating cultural goods has come to stand for a range of compelling debates about the conflicting roles of digital technologies in the cultural field. An early entrepreneurial insurrection into settled and established modes of circulating books, Amazon could be celebrated as *democratizing* access to niche forms of literature and the means to share, recommend and comment on it which were previously the preserve of rarefied and relatively rare shops

or libraries and established cultural authorities. The celebration of such potentialities are tempered, as with the rise of other giants of the digital corporate world (e.g. Microsoft, Apple and Facebook), as the countercultural, insurrectionary promise of such companies to transform capitalism – a promise that was coterminous with the development of the technologies that they have produced, according to Castells (2010) and other historians of the early years of the Internet – dissipates into a 'new spirit of capitalism' (Boltanski and Chiapello, 2005). This spirit is perhaps better understood not as post-Fordist but as *hyper*-Fordist, in which rational and rigid forms of ordered knowledge are increasingly built into ever more fine-grained layers of day-to-day life. In this context the digital forms of data which are generated by and accompany our online lives of browsing, sharing and buying – and, importantly for this chapter, *liking* – are transformed into profitable, tradable commodities in themselves.

These two positions – of celebration and critique – are not necessarily entirely *opposites*. While it is beyond the scope of this chapter to do justice to the political economy of today's digitally organized cultural industries, it is central to its argument that, as the *Guardian* article intimates, such technologies can no longer be considered *new*. Instead they have, over the last three decades, become part of the mundane world of everyday life for a still increasing proportion of the population of the countries of the global North and elsewhere, and of the mundane world of tastes and tasting. As such, while their operation is clearly significant to other of our dimensions (notably of *measuring* and *globalizing* tastes), they also raise distinct questions about the contemporary *experience* of tasting, not least because the language of liking, disliking and sharing is so ubiquitous online and because the *stuff* of taste – music, films, television and books – is a significant part of how these digital media technologies are lived with and used. The liking, sharing, buying and selling of this cultural stuff is now central to the generation of the kinds of profitable data about individuals and groups which fuels online commercial activity, and increasingly shapes the parameters of wider social life.

Given this ubiquity, the digital has the potential to further challenge and complicate some established scholarly narratives about the significance of taste. This chapter will explore the tensions between the potential and reality of the digital context to alter or cement our general understanding of taste and social life, as one of the principle means by which taste is now facilitated and managed. It does this by focusing on three aspects of this dimension. First I'll consider the problem of

'cultural abundance', which is made possible by digital means of storage and distribution of cultural goods, for the understanding of taste and the role of digital technologies in both producing and managing this abundance. This has created, I'll argue, a new space in which control over what culture means, and therefore how tastes for culture can be managed, is more difficult to exercise than it has been in the recent past. I'll then go on to consider the significance of a specific strategy of managing abundant culture in the digital context – the 'softwaring' of taste and the algorithmic circulation of tastes – before concluding with a consideration of what has been termed 'the like economy' (Gerlitz and Helmond, 2013), reflecting on the ways in which the language of liking and sharing, and by extension the production, management and performance of cultural tastes in the digital context, has become especially loaded in, and further emphasizes the centrality of, taste to social and economic life in the early twenty-first century.

Cultural abundance, choice and 'the digital age'

While the essence of this chapter is to emphasize the continuities in the understanding of contemporary forms of tasting with the ways of understanding the cultural tastes of the recent past, there is one unprecedented aspect of contemporary cultural life which should be foregrounded in understanding contemporary cultural tastes. Notions of taste and tastefulness – as Chapter 1 indicated – have, historically, been bound up with the development of moral notions of restraint rather than opulent excess. The display of restraint in the context of abundant resources became, in the development of the structures of taste and tastefulness described by Elias, a powerful symbolic indication of how to discipline and manage the body and, by extension, the self. Given this, and given the conceptual, semantic relations between these corporeal forms of self-discipline and the general understanding of cultural taste identified by Bourdieu, it is apposite to contemporary debates about cultural taste to point out that, in the societies of the early twenty-first century global North, to put it in its crudest terms, there is *more* culture for *more* people to choose between than ever before. Partly, of course, this is an inevitable result of the accumulation of the cultural production of the past in the present. It also, though, reflects the rise and spread of the industrial production of culture from the mid- to late twentieth century, and the rise and spread of technologies of cultural circulation and storage which enable cultural products to move more easily between producers and consumers in the early twenty-first

century. The consequences of this increase in the range and volume of easily accessible cultural goods have largely been felt in relation to their significant implications for established models of distribution and circulation within the cultural industries with, for example, the ease of reproduction of digitalized images, video or music also facilitating the ease of their circulation outside regimes of intellectual property. Such changes are largely internal to the cultural industries and, while popular and scholarly discourse might construct them as pertaining to decline (of traditional book or record shops, of record labels, or of the power of a unified television or cinema audience compared with a fractured and dispersed multimedia one), they might as easily be interpreted as a reorganization and rationalization of the means of cultural production. What has been less reflected on, I contend, is the consequence of this abundant culture for the production of cultural tastes.

To illustrate this, from the desk where I write this chapter, in a medium-sized city in the East Midlands of England in the summer of 2014, I can access the kinds of databases of books in print, or music that is available to buy, that would, only 20 or 30 years ago, have been the exclusive preserve of specialist librarians or retailers, and I can read about these books and listen to this music without subscription to rare or exclusive specialist journals. Moreover, without needing to leave the house or even my seat, I'm privileged enough to be in a position in which I can purchase and listen to a wider range of music – and purchase and read an increasingly wide range of contemporary and historical literature – than even the largest library, book or record store would have been able to physically accommodate, without even waiting for them to be delivered to my home. In planning my evening's entertainment I am no longer privy to the demands of either 'mass' audience-seeking commercial broadcasters or the scheduling decisions of a few patrician public broadcasters. With access to the expanded bandwidth of the digital age, I can pick and choose between some 200 channels and, while it would be difficult for even the most ardent enthusiast for the complexities of popular culture to claim an identifiable relationship between quantity and *quality* here, these do include, should I wish it, channels dedicated to the arts (tonight, for example, I could take in a recording of a concert performance from Frank Zappa, a presentation of the Royal Opera House's 2012 production of *Swan Lake* or a documentary about the Italian filmmaker Franco Zeffirelli), to film and to sport. All of this is accessed through a medium that is more readily constructed in debates about cultural taste as the 'other' against which legitimate forms of culture must be judged. Should even this not satisfy

my immediate 'omnivorous' cultural desires, contemporary technologies also mean that I can access, through commercial 'archival' and streaming services such as NetFlix or LoveFilm, the full range of 'box sets' of groundbreaking US or Scandinavian drama series which seem to animate and dominate the conversational topics of university cafeteria and the middle-class dinner party in the early twenty-first century UK. I can also take advantage of more self-consciously exclusive streaming services, such as the UK's BFI player (managed by the British Film Institute) or the Curzon Home cinema to access, for a fee not much more than a single cinema ticket, new and 'classic' films from throughout cinematic history and throughout the cinematic world. All of these cultural riches can be brought to my desktop or television through broadband Internet technologies which are, despite important provisos of persistent 'digital divides', increasingly well spread throughout the UK population and certainly all but ubiquitous in urban centres, especially within the professional circles which have been empirically identified as the audience for what Bourdieu would term 'legitimate' cultural goods. The same technological infrastructure provides access to all of this variety, regardless of established norms of cultural hierarchy, such that I can, within not very many minutes, find a full broadcast of a 1985 television production of Samuel Beckett's *Waiting for Godot* and, using the helpful suggestions that accompany YouTube videos, follow viewing that with a glance at the US PBS children's television show *Sesame Street*'s spoof of the same *Waiting for Elmo*. This same technology can, of course, also provide access to the less apparently edifying or more morally suspect forms of cultural symbolic life – of pornography, of scurrilous celebrity journalism and of extremist or misogynist forms of political expression. The assumed problems of access to these latter forms seem to generate more visible and vocal forms of contemporary anxiety in cultural commentary and journalism on these matters than what seems to be compelling evidence that this is, if not quite the best of all cultural worlds, at the very least indicative of a kind of progress rather than of inevitable cultural decline.

Of course, the ability to access this volume and range of culture does not mean that it is actually accessed (in the four years since it was posted before I saw it in July 2014, the *Waiting for Godot* clip had a mere 160,000 views, compared with the still, on a global scale, miniscule 414,000 views in the seven years since the *Elmo* clip). And the reasons for not accessing certain forms of culture and accessing others might well resonate with established and abiding debates about the relationships between education and family experiences of culture, crystallized

into convertible cultural and symbolic capitals in Bourdieu's schema. These developments do, though, raise some potentially fundamental questions about the ways in which the notions of value which underpin questions of taste can be policed and managed in the digital context. The historical problem of abundance for questions of cultural value and authority has generated particular kinds of anxiety which might be becoming manifest in the digital context. The most obvious echoes are with the mass culture debate outlined in Chapter 1, where anxieties about the volume and the availability of cultural forms are accompanied by specific anxieties about the masses – that is, a broadened population beyond established cultural elites, having need of, and access to, any kind of 'symbolic' life at all. A key contribution to this debate is provided by Walter Benjamin's (1999) influential essay entitled 'The Work of Art in the Age of Mechanical Reproduction', which identifies, among other things, the possibility for the mass circulation of reproduced cultural forms to undermine the power of the 'priests' of the cult of culture to police access to artworks. The charismatic power of art – its 'aura', in Benjamin's terms – depends upon its uniqueness in time and space, and the control of access to art is what preserves this aura. It is in the interests of those who police this access to emphasize the distinctions between, say, visiting the *Mona Lisa* in the Louvre and buying a tea towel imprinted with the image. In contrast with colleagues in the Frankfurt School, for whom mass-produced culture tended to diminish both the cultural form and the people who consumed it, Benjamin saw considerable democratizing potential in the mass reproduction and circulation of artworks. This debate, which has resonated since in discussions about the relative value and complexity of popular culture within the cultural studies tradition, might, in this context, be interpreted as part of a broader discomfort within intellectual culture, not just about the volume and availability of culture but also its range and variety, and what that implies for the ability of individuals to manage and sift through it. This anxiety pre-dates the mass culture debate of the mid-twentieth century and connects with mid- to late nineteenth century debates about the emergence of mass-literate populations in concentrated urban environments and the perceived threats of the spread of seditious or salacious material outside the control or management of established cultural elites. The scholarly cultural canons of art and literature of this period can be interpreted precisely as, in the light of the discussion in Chapter 5, technologies of evaluation, guiding and managing the 'common reader' towards more apparently edifying and acceptable cultural products (see also Carey, 1992, Rose, 2001). Such paternal guides

for readers to the great and the good of established literature happily coincided with a desire to maintain an apparently fragile social order. Contemporary technologies of circulation of abundant forms of culture perhaps make this kind of structural or institutional management of cultural taste more difficult for cultural elites, or at least, as we'll discuss in relation to the rise of the algorithm, indicate that new forms of management might be emerging to contribute to this process in the digital context.

Anxieties about abundance can also be understood as a reflection of a general philosophical concern about the scale of human life, and how the temporal and physical limits of individual experience can make sense of the vastness of the world or the expanse of eternity. Schleifer (2000) argues that this is a key anxiety of the post-Enlightenment world, which might be made more acute in late-modern contexts in which both the knowledge and power of humans, collectively and individually, over their environment and the helplessness of humans, individually and collectively, in the face of their changing environment continue to grow. Schleifer quotes Lyotard's assertion that 'the human is sometimes too small, sometimes too big, never at the right scale' (quoted in Schleifer, 2000: 35). In this account the very successes of the Enlightenment create a 'crisis of abundance' (Kern, 1983: 9) in which the logics of, for example, the classical economics of Marx or Smith no longer hold true. If the relative value of a commodity is measured in relation to its ability to address a necessity that has been brought about by scarcity, for example, then how can that value be established in the context of abundance? Schleifer uses the example of the value of a pair of shoes in relation to going barefoot as typifying the Enlightenment understanding of scarcity. 'But', he asks, 'what about a world of abundance? How do we measure the value of a pair of Nikes compared to Reebok when, without them we still wouldn't be barefoot?' In such a situation the second, 'marginal pair' is 'neither necessary nor sufficient: as Imelda Marcos has shown, a last pair can always become the second to last pair' (Shleifer, 2000: 47). It is easier, in this light, to attribute value to objects in the conditions of scarcity when that value can be associated with an identifiable need and its satisfaction. In conditions of abundance, when immediate needs are more readily met, value is ascribed in relation to desires, which are harder to define and satisfy. This is an intriguing problematic to relate to cultural taste, not least because of Bourdieu's insistence on employing the economistic metaphor of *capital* as a resource to be struggled over, whose value might similarly be understood to rise and fall in relation to its relative scarcity. For objectified cultural capital it is the commercial distribution and relative accessibility, through television

and radio, of Petula Clarke, compared with the relative rarity of Ravel's *Concerto for Left Hand*, to use examples from *Distinction*, that might account for their position as opposites in the Correspondence Analysis of bourgeois taste. It seems significantly easier, in other words, to attribute the kind of value that can be translated into cultural or symbolic forms of capital in a situation of scarcity than it is in a situation of abundance.

A similar problem of abundant culture, this time drawing on the language of psychology, is suggested by Schwartz's evocation of his paradox of choice (2008) in the specific abundant present. Choice is equated in the late-modern consumer societies of the global North with autonomy and even *freedom*, with more choice almost always being conceptualized, at least in those societies that are most enamoured with neoclassical economics and the organizing power of the free market, as better than less. While, as previous discussion has hopefully established, *tasting* is different from and more complex than *choosing*, given the almost limitless choices available in the digital culture industries – within the vast repertoires of iTunes or Amazon, for example – following this logic makes the contemporary moment, at least potentially, the best of all possible cultural worlds. Schwartz suggests a number of reasons why this might not be so, some of which are part of the general psychology of choosing, and some of which are part of a specific problem with the characteristics of choosing, liking and tasting between cultural items. In terms of the former, increased choice requires increased resources of time in order to acquaint oneself with all that is available. It is also likely to increase the likelihood of regret at the realization of making the wrong choice – a regret that can be keener in a world of extensive choices because of the likelihood that, even according to your own criteria of preference, something *else* might have been better than the thing you have chosen. This is the anxiety, as he describes, of the Saturday-night movie-goer who is presented with and paralysed by the abundant options of the multiscreen multiplex. These aspects of choosing might be analogous to the kinds of characteristic that Bourdieu describes in relation to capital, habitus and field, especially questions of necessity, time and, as significantly, the confidence not to care about the consequences – real or imagined – of making the wrong choice, but they are distinctions that might be more keenly felt in the context of abundant choice.

Using the example of Amazon, Schwartz suggests that choosing from a large number of options is easier for people who know what they want and have the time to browse until they find it. For others, extensive choice can be bewildering without extensive information and even

guidance about what constitutes the *right* kinds of choice, or about the kinds of criteria against which the right kinds of choice are to be made. Both of these tendencies might challenge an assertion that widened access to a wider range of cultural items, such as that provided by the digital context, is likely to encourage a wider range of people to access them. 'Knowing what you're looking for', for example, implies not being open to the discovery of the things which you *aren't* looking for, and by extension implies a closing-off of engagement with the diversity of the cultural world. Not knowing what you're looking for implies relying on guidance from the cultural authorities, reviewers and experts considered in the previous chapter.

As the next section will illustrate, digital contexts such as Amazon have an additional strategy for providing this kind of guidance – the algorithmic recommendation – but Schwartz suggests that such technologies are more likely to guide the less culturally competent or confident to the familiar or the similar than to the new. So, in the discussion above, not knowing much about mid-twentieth century absurdist theatre, I was attracted to the recommended *Elmo* clip that helpfully appeared at the end of the Beckett clip, rather than being inspired to discover, say, Ionesco. In these examples, cultural abundance, for all of its potential democratizing value, *cements* existing tastes and existing patterns of participation or 'exclusion' rather than necessarily promoting new or different tastes. It is a point that is made nicely by Michael Bull's study of iPod culture in which this technology that facilitates access to potentially all music 'stands as both an example of and metaphor for a culture in which many of us close our ears to the multi-faceted world through which we move' (Bull, 2007: 4). Bull cites Richard Sennett's reflections that technologies such as the iPod 'disables its user by its very over-capacity' with the effect that 'the glut of information received by modern technology threatens to make its receivers passive' (Sennett, 2006: 172). These are compelling reasons to be cautious of cultural abundance, albeit that we may detect in Sennett's evocation of them traces of the mass-culture critique in which passivity is identified in the cultural tastes and practices of people other than the analyst and is assumed rather than illustrated. However, before dismissing its value entirely, I'll conclude this section by considering the implications of what appears to be an empirical manifestation of cultural abundance which offers a further contribution to understanding the digital dimensions of taste.

The journalist Chris Anderson's influential and controversial *Long Tail* thesis (2006) arguably predicted and prefigured many of the debates

about the role of digital technologies in transforming the cultural industries. I want to consider two of its claims in relation to understanding taste in the digital context. The first substantive claim, based upon the revelation that, at the time of writing, 98 per cent of Amazon's top-100 books sold at least one copy once a quarter, is that the cultural industries might do better to facilitate the discovery of niche, connoisseur interests rather than pursue the 'hits' which, historically, have been almost impossible to predict and even more difficult to reproduce. The limitless capacity to store music, film or text, reconstituted as code and bytes, and the construction of the interfaces through which consumers can search and ultimately purchase the things that they want to have, delivered instantly, solves a number of problems in relation to the means of cultural production, some of which might not even have been historically conceptualized as problems at all. 'Many of our assumptions about popular taste', Anderson claims, 'are actually artefacts of poor supply-and-demand matching – a market response to inefficient distribution' (Anderson, 2006: 16). In a context in which consumers have access to technologies which provide both knowledge of and access to a hugely diverse cultural offering, competitive advantage in the cultural industries might better be oriented towards selling a few of a wide variety of things, rather than selling lots of a narrow variety of things.

At the time of writing, the transformative potential of this new vision does not seem to have fed through to all cultural industries. Regardless of its empirical reality, we might speculate, from the perspective of an understanding of taste as sketched out so far, that the assumption of a desire for niche forms of taste relates most closely to an abiding vision of taste as part of a struggle for *individual* forms distinction in which escaping 'the mainstream' satisfies a particular sensibility. This denies the pleasures of *shared* taste that are available to the diverse audience for, say, a global blockbuster film or book or landmark television drama which is enjoyed precisely *because* of its scale and the scale of its audience.

At the same time, interesting questions are raised by the foregrounding of questions of supply, demand and efficiency, and their hints at the improvements of digital forms of distribution over the apparently clunky and slow-moving logistics of the recent past, characterized by the transportation and storage of physical objects in limited spaces. Such an assertion, though, might be especially jarring for those occupying historically significant roles of mediation in the cultural industries – including the critics and reviewers that were discussed in the previous chapter, and the academics whose role is to consecrate selected items into categories

of good or bad, and to police the apparent boundaries between art and entertainment. These intermediaries – and others who are closer to the moment of production, such as publishers and editors, might have seen their role not as snags in the supply chain so much as benevolent guides for consumers and critical friends of producers.

The second claim is that these intermediaries are being replaced by consumers themselves in an idealized marketplace in which knowledge of the qualities of cultural products can be more easily gleaned through recommendations. We'll go on to consider the automation of this in the next section, but a key aspect of engagement with the digital cultural industries, enabled by the interactive Web 2.0 developments of the early noughties, is the provision of a platform for the performance of tastes, through online reviews of cultural products, which appear alongside the products themselves. In Anderson's story they are of strategic importance, enabling reviewers to point potential consumers towards or away from certain artefacts in direct challenge to the structured scarcity and the promotional imperatives of the cultural industries. Such power, for example, underpins Anderson's defining myth of the *Long Tail*, the republication of the climbing memoir *Touching the Void* following customer reviews of another climbing memoir, *Into Thin Air* (for a discussion of this in the context of other processes of recommendation in the literary field, see Wright, 2012). Such processes require critical attention, and thus far empirical work on their contribution to reshaping the field of cultural authority has been partial. Verboord's (2010) account of how Dutch consumers report their relative trust in established and new forms of criticism indicates that cultural consumers who consume a lot within a particular genre of activity – in his case *readers* – are more influenced by what he characterizes as peers and Internet critics, whereas those cultural consumers who consume more widely – the omnivorous contemporary cultural consumer – maintain an affinity with the authority of established institutions of criticism. This suggests that reading about and evaluating between different cultural products remains an important part of the game of culture, and one which helps to maintain the important distance, which breathless accounts of the efficiencies of the digital context deny, between tasting, liking and *buying*.

The development of these kinds of open and broadly accessible platform in which tastes can be publicly performed does, though, mean that, in the context of cultural abundance, established cultural authorities no longer have the field of mediation to themselves. As Verboord has it, in the print-dominated era, 'institutional structures guaranteed clear boundaries between a select group of professionals and those aspiring

but not managing to become one' (Verboord, 2010: 625). In the digital era these distinctions between professional and accredited forms of critical expertise and those being expressed by, for example, fans of particular artists or genres are less marked. There is a ripple here of the debate instigated by Benjamin in relation to mass culture about the policing of access to the meaning of art and culture. The period of flux of traditional sources of cultural authority wrought by the age of digital reproduction contributes to the emergence of less hierarchical systems of value which help to muddy the distinctions between high and low forms of culture and their ability to simply attach to the bodies of 'high' and 'low' forms of people. Such developments might well represent the emergence of what some analysts have referred to as an 'aesthetic public sphere' (Roberge, 2011) in which the ability to share and perform tastes represents a broadened cultural conversation. The next section will explore how this same context and the technologies which enable it might also be closing that conversation down.

Algorithmically organized taste

In considering the digital dimension of taste, this chapter is not simply concerned with exploring how the development of digital technologies has transformed or challenged the sociological understanding of taste but also with reflecting on how such technologies have become part of the everyday world of tasting. Some time ago I received an e-mail from Amazon recommending a forthcoming book, based upon an algorithmic assessment of my browsing and purchasing history. Millions of these e-mails are sent everyday, and regular customers of Amazon can expect daily to receive two or three such messages in their inboxes. Such promotional messages can easily be ignored, but they indicate both the pervasiveness of digital technologies in organizing the contemporary practice of taste and also the kinds of powerful technologies and infrastructures which underpin these everyday practices. In part this particular e-mail was noticeable because it seemed to be 'wrong', or at least counterintuitive to a more traditional or 'analogue' way of understanding, in this case literary recommendation. 'Greetings', it proclaimed. 'We've noticed that customers who have expressed interest in *The History of Sexuality: Care of the Self Volume 3* by Michel Foucault have also ordered *Not Tonight Mr. Right: Why Good Men Come to Girls Who Wait* by Kate Taylor.' It went on to offer me a tempting 20 per cent discount on the recommended retail price. It seems unlikely that I, as a customer searching for the great and good of cultural theory, would be

especially interested in a relationship guide for young single women. An alternative reading, more sympathetic to the relative sophistication of Amazon's algorithms back in 2007, is that there were enough people doing PhDs on the role of self-help books in 'policing' contemporary sexual practices, and looking for and buying books to support this thesis, for this pattern to be identified electronically.

This latter explanation at least recognizes that the human input in the process of recommendation is of a specific type in this part of the digital context. Amazon's proprietorial algorithms for identifying customer recommendations have been one of the foundations of its success and have also come to exemplify the rise of the kinds of 'big data' which define the distinctiveness of the digital age. The general effectiveness and sophistication of this kind of data-gathering raises, as Chapter 2 explored, significant questions about the continued authority of traditional modes of *measuring* tastes. One such question relates to Pariser's (2011) claim that the attraction for Amazon founder Jeff Bezos to begin his project to digitally transform production and consumption with *books* was less to do with a desire to challenge or undermine the cultural authority of the elites of the literary world as 'guardians' of taste and more a reflection of the distinct logistical advantages of a field which had manifold individual 'lines'. Each of the very many individual books in print – some 3 million titles in 1994 compared with only 300,000 available CDs at that time (Pariser, 2011: 26) – was distinguished by an individual number (the International Standard Book Number), which was introduced in the late 1960s to help retailers with the logistical complexities of organizing an already vast and diversified range of available books. This made book retail an ideal field in which to trial, experiment with and refine the powerful logistical capabilities of late twentieth-century computing, and specifically 'collaborative filtering'. This technique, initially developed by software engineers to identify which group e-mails to reply to and which to ignore, took advantage of user interactions with mass forms of data to identify bits of information that had been more viewed. The possibilities of these technologies, applied to the retail setting, providing apparently personalized recommendations, combined with the vast catalogue of available books in print, were central to the process of persuading the book-buyers of the mid-1990s to move online.

The e-mail above, from 2007, perhaps indicates the process of refinement in action. We can imagine here that it is data crudely drawn from the classification of keywords in the titles and 'blurbs' of these two books – one a seminal cultural and historical genealogy of the category of sexuality and another a dating guide for young women – that

generates an algorithmic connection between them. In their more con-temporary iterations, as the discussion in Chapter 2 indicated, these algorithms have become so prescient as to be almost unnoticeable. For the cultural industries and especially for the media industries of television and film, algorithms are part of a longer tradition of inter-relationships between audience research and content production, in which knowledge of the tastes and preferences of the audience, mea-sured through evidence of watching on behalf of producers, helps to shape future content (Napoli, 2011). There is, in this industry story, competitive advantage to be had by producers of 'content' gaining insight, through the methods of market research, into the tastes of their audience. Knowledge of the demographic characteristics of the audience – its age, its education, its lifestyle – has a slightly different form of value for such industries, constructing the audience as a resource to be mined for, and ultimately 'sold' on to advertisers. This story is as old as the commercial media itself, but the fragmented, dispersed, active and empowered audience that is beloved of early twenty-first century media scholars is a particular kind of *problem* for the cultural industries because its tastes and habits are far more difficult to pin down and pre-dict than the assumedly inert mass audience of the recent past – and the imperative to do so is far more pressing in a commercial environ-ment in which the audience has such competing demands on its leisure time. The forms of data about television audiences' viewing habits, for example, which can be gathered through increasingly sophisticated 'offline' means, are also built on and augmented by new technological developments which include either explicit or implicit means of gath-ering some kind of feedback. The Tivo box through which I navigate the 200 channels that are available to me, for example, includes but-tons which allow me to 'like' or 'dislike' the programmes that I watch, and it has the capacity to generate data about which advertisements on which channels have been viewed or skipped. Similarly, as Allen-Robertson (2013) explains, services such as Apple's *Genius* for generating music playlists, or music-streaming services such as *Last FM*, strike a bar-gain with their users in which, in return for access to data about their libraries and listening habits, listeners will be supplied with music that fits algorithmically established profiles of the kinds of music that they like. No longer do such consumers need to face the anxiety of searching and choosing between the abundant varieties of music. The music they like will come to them.

Algorithms play multiple roles in the new media cultural environment – both measuring and generating actions. As Napoli (2014) describes it, they provide sophisticated data about audience

demographics to inform the targeted production of certain kinds of television (in the case of the digital streaming service, and latterly content producer Netflix) or even, in the case of Epagogix, providing analysis of the plot elements of prospective film projects and their relation to the box-office successes of the plots of the past. Such examples illustrate how,

> in this big-data era, media organizations have an ever expanding supply of data on audiences' media consumption patterns and preferences to draw upon, and algorithms play a central role in extracting actionable insights and producing decision outcomes from these data stores. These are the fundamental elements of the most recent – and perhaps most dramatic – step forward in this long-running process of rationalization.
>
> (Napoli, 2014: 34)

Like the market research technologies of the past, algorithms aim to render our tastes and preferences visible to gazes outside the immediate moment of tasting – principally to advertisers and marketeers for other products for which we are a potential audience.

As such, algorithms exemplify what scholars of the digital have characterized as a *hidden* infrastructure which increasingly shapes our interaction with both the digital and the 'real' world. Bowker and Star's (2000) analysis of the emergence of these kinds of infrastructure is instructive here. First, they point out the historical continuities with the infrastructures of the past, and their relation to the logistical management and storage of significant volumes of information, most readily analogous to what Weber characterized as an iron cage of bureaucracy. Bureaucracy here can be understood as a double-edged institutional innovation which both created rational and identifiable processes for the attribution of authority that undermined the forms of authority which preceded it (principally the charismatic authority of the monarch or priest) and also became a limit to freedom of action and choice. For Bowker and Star, 'information infrastructure adds another level of depth to an iron cage. In its layers and in its complex interdependencies, it is a gossamer web with iron at its core' (Bowker and Star, 2000: 320). Two particularly relevant points emerge from this work. First, it is interesting, given the persistent notion of 'the hidden' that underpins analysis of taste in the cultural sociological tradition, that analysis of contemporary strategies of managing the masses of information that circulate in the computer age also foregrounds questions of

invisibility in approaching the emerging informational architecture. The better designed, more efficient and easier to use such forms of infrastructure become, they suggest, 'the harder they are to see' (Bowker and Star, 2000: 33), and the choices – logistical, aesthetic and even moral – which have underpinned their design fall away as they become incorporated into day-to-day practice. Second, but relatedly, in thinking about how this invisibility is achieved, Bowker and Star draw an analogy with Howard Becker's work on how the worlds of art appear to be solid, natural and self-evident from the *outside* but are actually built upon long-established and contingent conventions and constraints which act as a form of *insider* knowledge for actors within the world of art, providing subtle signals and guides for how things ought to be done in shaping the practices of a range of actors. The forms of informational infrastructure which they analyse are similarly built on these kinds of assumption, and infrastructures are at their most powerful when they are, among other characteristics, 'embedded into other structural social arrangements and technologies' (Bowker and Star, 2000: 35). In the development of Amazon, Jeff Bezos's choice to focus on the possibilities that are opened up by the classification of published books via the ISBN seems to provide a revealing example of how the infrastructural arrangements and classification practices of the past can be built on and augmented, such that they disappear in the everyday practices of the present.

This has been characterized by Nigel Thrift (2005) in his analysis of *Knowing Capitalism* as being symptomatic of contemporary strategies of government and organization in which everyday decision-making practices are deferred to software located 'in the interstices of everyday life, pocket dictators that are constantly expressing themselves', which become part of what he characterizes as a 'technological unconscious' (Thrift, 2005: 156). The development of algorithms whose efficiency and accuracy improves as they respond to more inputted data, such as the billions of daily acts of buying, browsing or liking that help Amazon, iTunes and Netflix to know more about our preferences, allow them to, as Thrift predicts, 'second guess the user, becoming part of how they decide to decide' (Thrift, 2005: 184).

Systems and practices of classification are, of course, also crucial to questions of cultural tastes, be it the semi-tacit, semi-official forms of classification that underpin notions of 'good' or 'bad', 'high' or 'low' forms of culture, or the fuzzy forms of categorization which underpin the location of forms of music, literature or film in identifiable genres which are assumed to indicate shared characteristics. Previously these

classifications have been the preserve of specialists in the field of culture, including critics and academics and, more recently, in relation to forms of popular culture in particular, knowledgeable consumers or fans who decide between and place items in genres and subgenres as part of the particular pleasures of consumption. Just as Chapter 2 discussed in relation to the methodological problem of genre for producing empirical knowledge about the patterns of taste, the *automation* of these processes of classification might well be significant to our understanding of the ways in which tastes might be influenced, shaped and managed algorithmically. In his analysis of the consequences of 'new media' for cultural analysis and popular cultural practices, Beer (2013) productively reflects on the emergence of the algorithm as an active element of the formation and performance of cultural hierarchies, and the potential consequence of this for how scholars of taste might understand the real or imagined relations between contemporary questions of taste and social relations (of hierarchy and of mobility). As he describes it, 'selectivity and direction are the domain of algorithms' – that is, they 'make a reality out of a set of predictions which then become the basis for decision making' (Beer, 2013: 86). In the realm of cultural taste, these might be, as our e-mail example suggests, predictions and decisions about what you might like, based upon a calculation of probabilities that emerge from the presumed characteristics of what you have liked in the past, filtered through structures of genre, artist, style and the accumulated data of other customers who bought, searched for or recommended similar items.

It might be that this is a rather benign example of how algorithms work – and, indeed, the pay-off between allowing one's browsing and buying data to be used by companies such as Apple, Amazon or Spotify and the automation of recommendation might be a particularly effective solution to the problem of cultural abundance for contemporary cultural consumers. Algorithms do not operate neutrally, however, but as a result of the technical construction by human actors with their own goals and priorities – most obviously commercial ones to encourage customers who bought one thing to buy another. It might well be that the technical achievements in establishing an algorithmic infrastructure of choice and decision-making in relation to cultural tastes and practices in the digital age of cultural abundance has provided a model for, and allowed more insidious forms of, automated choice to become 'invisible' too. The abundant data generated through automated decision making feed back into new strategies of governing and new strategies of classification which become characteristic of new social formations – what

Thrift refers to as the potential 'mass moral engineering' (Thrift, 2005: 10) of contemporary capitalism.

Such developments also represent a further cementing of the significant roles of taste and tasting in social life, especially the potential of tastes to reflect how we live together as well as to be implicit in processes of social division. As discussed above in relation to the psychology of choosing, the *anxiety* of being presented with abundant forms of culture is significantly eased by guidance, either from established cultural authorities or by one's trusted peers. The automation of recommendation produced by data-rich algorithms eases this anxiety further by using calculations based upon an individual's electronically established preferences to predict future tastes. However, this process also creates what Pariser (2011) describes as 'filter bubbles' in which, if the extrapolation of data about behaviours of the past is a reliable guide to behaviour in the future, individuals are increasingly unlikely to be presented with radically new or different cultural genres and experiences compared with those that they have had before. Because such algorithms are at best invisible, because the criteria, assumptions and forms of classifications are inaccessible to and beyond the control of the individual consumer, and because we are addressed by them as individual consumers rather than as members of groups of shared experience or interest, the nature and consequences of cultural tastes are revised in this context.

Taste in the 'liking economy'

This chapter has attempted to explore some of the distinctive qualities of the contemporary period, characterized by the rise in influence of digital technologies which might challenge some established understandings of taste and their role in social life. Partly this reflects the mundane *centrality* of these technologies to the production and distribution of cultural life, which in itself offers a challenge to established modes of producing tastes, such as those explored in Chapter 5. Certainly the culture of online reviewing, and the processes of incorporating reviews from peers into the processes of choosing and liking cultural products, are a clear continuation with the past, in which debates about trust, authority, reliability and who gets to decide what is good or bad, tasteful or not in the cultural realm are played out in new contexts. However, as the above discussion has attempted to identify, two particular aspects of the digital dimension of taste are not well incorporated into established modes of understanding taste and tasting. The first is the notion of cultural abundance and its necessary reimagining of the traditional

mass-culture critique and the Bourdieusian model of symbolic or cultural forms of capital as a metaphor for understanding how value is attached to rare objects and things. These assumptions about popular taste are necessarily in flux in a context in which barriers to access to so much culture of such variety, incorporating both traditionally 'high' and low distinctions, are disappearing and the traditional modes of managing that access are no longer either as visible or as authoritative as they once were. The hopeful and optimistic reading of this situation of abundance is, of course, tempered by the second aspect of the digital dimension. The management of abundant choices in the digital context is, through the algorithmic processes of gathering data about likes and the translation of this into automated recommendation, *closing down* the potential value of a broadened cultural conversation. Such processes do not reflect, as perhaps they might have in the recent past, the patrician prejudices of cultural elites. Instead they reflect the commercial imperatives of large corporations with access to almost infinite archives of digitized music, film, television and increasingly literature, and the software coders with the technical skills to translate the data from browsing and buying into useful algorithms to facilitate choice.

Tastes are more especially significant to the digital context where the language of *liking* is so pervasive and insidious. The most visible manifestation of this is in the field of social media itself, where *liking*, alongside sharing, emerges as a key driver in the economic model of Facebook. This is, of course, something of a rhetorical move. As van Dijk describes, Facebook's founding mission statement is 'to make the world more open and transparent' (Facebook quoted in van Dijk, 2013: 59). However the evolution of the platform, and especially the centrality within it of the 'like' button, points to a parallel mission, exemplifying 'the profound modification of a social norm' (van Dijk, 2013: 49). There are varieties of liking in this medium. Alongside the demographic data, educational experiences, location and professional history which one is encouraged to archive as part of setting up a profile, in its current iteration, the 'about you' section includes the facility to input films and television that you have watched and books you have read (as well as 'places you have visited' and 'inspirational people'). In these former categories, information is inputted via an interactive field in which a visual icon of the film/book (represented through a still, a promotional poster or a cover) can be clicked upon to be added to your list. While the default images here might be the kinds of mainstream tastes that are characterized by highly popular blockbuster films or well-loved classic books (on the day I write this, these appear, for me as, in the former category, the comic book franchise movie *The Wolverine, Pulp Fiction*

and *Toy Story 3* and, in the latter, Stephen King's *Carrie*, *Watership Down* by Richard Adams and *The Last Battle* by C.S. Lewis), there is also the facility to search for your *actual* preferences – one which helpfully provides you with additional information about the films you might choose (a favourite of mine, the 1979 Jack Lemmon vehicle *Save the Tiger*, has, I'm told, 2,914 likes – a level of obscurity that, in this instance, reassures me of my connoisseurship). Selecting these films adds them to a profile, and clicking on the icon sends the user, if the film chosen is one made before the embedding of social media into the marketing campaigns of commercial media, to an information page that one is invited to 'like', with information about the film drawn from Wikipedia, the Internet Movie Database and Netflix. For more recent films, adding them to a profile and liking the page opens up the possibility of interaction with fellow fans, insider information about the production and its stars, and information about 'extra content'.

As this description of the process hopefully illustrates, the centrality of liking to the processes of social networking on platforms such as Facebook can be interpreted as a kind of experimental microcosm of the social world as it is imagined by Bourdieu in which not only do one's social networks cement one's social capital, but the performance of one's tastes and preferences makes visible the kinds of objectified forms of cultural capital (and through the addition of one's educational experiences, the institutionalized variant of cultural capital). As well as being judged, one is free to judge the tastes of others, and provided with the information with which to do so in a way which might exemplify the field of cultural preference as a field of struggle. What these kinds of mechanism also provide is access to the pleasures of cultural consumption – of sharing one's preferences with one's friends, of agreeing and disagreeing about the relative value of books, films or television in a way which, while rather sidelined in the academy (because questions of judgment and evaluation become so quickly bound up with broader ideological questions) are, as Frow (1995: 2) indicates, part of the 'circulating energies' of culture in the everyday world of tasting. As Nicholas Dames puts it, 'Our Facebook lists say: Look at how cannily I negotiate the field of cultural consumption; look also at how I resist definition by others nonetheless because I deliberately 'miscode' myself, finding coherence in my strategic, quirky incoherence' (Dames, 2009).

A second variety of tasting evident on Facebook is provided by the 'like' button itself. In their analysis of the development and centrality of this mechanism to Facebook's business model, Gerlitz and Helmond describe the initial status of 'liking' as an act that is performed within Facebook, to its subsequent development (post-2010) into a 'plug-in'

button that is dispersed, alongside other 'social buttons', throughout the interactive web. As they describe it,

> A click on the *Like* button transforms users' affective, positive, spontaneous responses to web content into connections between users and web objects and quanta of numbers on the *Like* counter. The button provides a one-click shortcut to express a variety of affective responses such as excitement, agreement, compassion, understanding, but also ironic and parodist liking.
>
> (Gerlitz and Helmond, 2013: 1358)

In this way the 'circulating energies' of culture can be harvested, rendered comparable and monetized – made into a saleable commodity for Facebook's advertisers. Here the rules of the game of culture, though, are changed, not least because one key aspect – both of the role of taste in structuring social life and of the pleasures of sharing one's taste – is missing. There is no equivalent means of expressing *dislikes*. The consequence of this is the creation of a 'web of positive sentiment in which users are constantly prompted to like, enjoy, recommend and buy as opposed to discuss or critique' (Gerlitz and Helmond, 2013: 1362).

Of course, liking on Facebook is not the same as *liking* per se. It is entirely possible to do one without the other. One can click 'like' on a page that advocates a particular artist, or cause, or other 'object' because doing so grants access to further information and enables participation in online discussion about it. Doing so does not entail any kind of affective attachment or affection for the object in question, even though it might be recorded as such. Facebook, then, doesn't know what we *like*, it knows what we click on, but the more general aim of strategies in this field might be, for better or worse, to train its users such that one more frequently equates with the other. For all of these limitations, though, such forms of liking are not entirely dissimilar from the kinds of liking that are undertaken before a surveyor of taste, as explored in Chapter 2 – that is, it is a form of liking which is *generative* and feeds into solid and useful forms of categorization, of things and of people in the world. Social networks can be best understood, at least in their relation to questions of taste, as machines for making these kinds of categorization. Here again, as we have seen in other contexts and at other times, the everyday practices of taste are implicit in the formation and re-formation of people in their lives and social struggles.

Conclusion: Dimensions of Taste

Taste remains an intriguing and perplexing problem for scholarly analysis – and specifically for analysis within the sociology of culture. It is also a complex problem that, as I hope the preceding discussion of the various dimensions of taste indicates, requires more than either an assumption of its equivalence to rational forms of choice and preference, or its reduction to a weapon in ongoing struggles over class and status. Some aspects of taste and tasting remain the same in the early twenty-first century global North as they were during those historical periods when the problem of taste was shaped the most. These periods were identified in Chapter 1 in the early modern Europe of Elias's (1997) account where taste was bound up with questions of conduct and the management of the body in relation to other people and, for higher social strata, with the specific performance of restraint in the presence of relative abundance. The revolutionary, Enlightenment Europe of Kant's (1790) reflections on aesthetics make taste part of a more general philosophical project about the formation of the person, and the primary means through which to understand and articulate the human sensory relationship with the external world. The nineteenth- and early twentieth century European and North American accounts of Simmel (1997a, 1997b), Veblen (1899) and Tarde (1903, 2007) introduce some further abiding concepts – that taste is related to the negotiations of life in emerging urban, market-oriented and socially diverse societies, and that competition and emulation or imitation in the practice of taste are part of the negotiation between expressions of individual identity and group membership. The final key historical stage in the formation of the problem of taste is the mid-twentieth century, when the further establishment and intensification of the mass production of cultural goods changed the character of symbolic life, including expanding

165

it beyond the realm of the 'cultured' strata of Western societies. This is also when the principle empirical attempt to identify and explore the consequences of the longer history of tastes and tasting, Bourdieu's *Distinction*, challenged the relationship, apparently established in these same societies, between a self-crafted consumerist identity and the persistent inequities of class. Taste, then, has been for centuries, and remains, related to the management of conduct and restraint, to the sensory engagement with the world, to the divisions and communalities of social life, and to the inter-relationships between inner and outer symbolic worlds.

Together these assertions about the complexity of the theoretical problem of taste act as the stepping-off point for the exploration of the dimensions of taste as they have appeared in the preceding discussion. First they were tested in relation to another fundamental dimension in shaping the problem of taste – how it has been, and how it continues to be made knowable or *measured*. Broader disputes within sociology, and between sociology and other disciplines, concerned with defining and interpreting social and cultural life were explored, largely through critical attention to the processes which researchers in taste have gone through in order to establish their claims. As well as considering the skills and sensibilities of these researchers in the design of their empirical work, and the bits of the problem of taste that they were most keen to solve, this discussion also involved engagement with the big epistemological and ontological questions about the kind of *stuff* that taste might be. In a spirit of recognition of the difficulties of conducting empirical work on such a multidimensional subject, this chapter also argued that, for all of the limitations to the sociological understanding of taste that have been identified, and for all that its established toolkit might be feeling its age, there is still much of value in the attempt to *know* taste sociologically, given its position as a mediating concept between the individual, their nervous system and the social world in which they taste. This is especially the case in comparison with new forms of knowing tastes, including from the natural neurosciences and from the post-'empirical crisis' (Savage and Burrows, 2007) forms of big data management that is redolent of contemporary attempts to define social life. These methods, somewhat paradoxically given the historical relation between taste and the imaginary of personhood, reduce or even remove the person in all of their complexity, replacing them with an image of a brain scan or an accumulation of categorical code. As this chapter explored in relation to contemporary reflections on sociological knowledge, methods also help to *make*, rather than just *measure*,

the world, and sociology has certainly been complicit in the process of reformulating taste as a culmination of variables and as manipulatable data, separate from the bodies doing the tasting. However, if taste is partly bound up with how the person is imagined, then the complex and contradictory version of the person who emerges from the imperfect sociological attempts to capture their tastes should still be preserved.

Subsequent chapters developed these themes in relation to the government, globalization, production and digitalization of taste, using notions of sense, skill and sensibility as links between them. These elements of taste, in each of these apparently discrete dimensions, served as reminders of the complexity of the concept. In Chapter 3 our discussion focused on how questions of taste were at play in contemporary political debates, related to an assumption that the identification and performance of tastes can provide some deep insight into the character of individuals, including those standing for political office. More significantly, tastes are also part of the processes of identifying and managing the kinds of person suited to life in a particular national space, whether through the relation between tastes and national values implied by contemporary cultural canon initiatives, or by citizenship tests, both of which might be wrought by anxieties, in the European political imaginary, about the national space in a context of multiculturalism. Chapter 4 went on to consider these anxieties as part of a more widespread transformation in the concept of the nation through global flows of people and things, but this governmental project has an extensive past. Throughout its history, the modern state has had an abiding concern with the formation and management of its citizens – a concern which has been expressed in relation to their tastes. Again, sociology has, more recently, been complicit in this story as Bourdieu's identification of a relation between taste, understood as the kinds of cultural activity which the state legitimizes and the unequal distribution of the capacities (or capitals) required to access and engage in these activities, has been partially translated and cemented into a deficit model of cultural policy-making. In Chapter 3 this was also reflected through consideration of the relationship between *literacy* – itself a process of training a *sensory* engagement with the world – and the formation of *literary* taste, which can be better understood as a *sensibility* in relation to aspects of print culture. This example also shows that the skills and sensibilities of good citizenship, as expressed through assumptions about the right and wrong ways to spend one's leisure time, can change over time as the versions of useful or productive personhood also change.

The affinities between the characteristics of the cosmopolitan subjectivity outlined in Chapter 4 – such as openness, tolerance and a curiosity about rather than fear of the other – and the more recent attempt to empirically identify taste as revealed through the emergence of the omnivore, detailed in Chapter 2, might well make the 'creative class' (Florida, 2002), with their broadened palates for new aesthetic and cultural experiences and their heightened skills of symbolic manipulation, a harbinger of a new mode of post-national personhood. However, Chapter 4 also considered how the uneven development and spread of this cosmopolitan subjectivity might also be interpreted as a reworking of the relations of cultural capital from a national to a global scale. In this light the cosmopolitan can be seen as the emergence of a new kind of person to thrive in the conditions and productive requirements of the global, mobile capitalism of the early twenty-first century. This is not to claim that tolerance and openness are not preferable to intolerance and closure, but to recognize that the raising of the game of culture to a global scale has more than one consequence. A global theory of taste must consider the infrastructure that underpins the distribution of the people who taste and the things which are tasted. This infrastructure includes both the frequent-flying creative class as well as diasporic and migrant populations who preserve their 'home' cultures through food or music, the hybridity of cultures that emerge from these forms of travel, as well as the possibility of local populations taking up the products of the global cultural industries in unexpected or unanticipated ways in their own cultural and identity work. Taste remains here, as it was precisely in Elias's account of early modern Europe, and in the accounts from Simmel about the diversity of the modern city, an important part of the process of negotiating how we live together, now in a global space. A global theory of taste also needs to remain cognisant of the things and people that are left behind by, or outside, that infrastructure. Attempts to empirically identify this global dimension of taste have so far found it difficult to find an analytic container that is big enough for the task. It is important to continue to look for this if the promise of global cosmopolitan taste cultures is to be fulfilled.

Questions of infrastructure also underpinned the discussion in the final two chapters. In Chapter 5 this is the infrastructure of production in which the role of workers in the commercial cultural industries was foregrounded. The simple assertion of the presence of the 'hidden' system of these workers – the 'validation chorus' in Grayson Perry's (2014) terms or the 'celebrants and believers' in Bourdieu's (1996: 169) – further challenges the idea that taste is ever, really, a matter of individual choice

in any simplistic way. The 'production of culture perspective' in the soci-
ology of culture has contributed most to this challenge by revealing the
people and processes that are involved in shaping the range of things
that is available for individuals to choose from. The skills and sensi-
bilities of cultural intermediaries, critics and the promotional strategies
of the cultural industries are all at play in the process of attributing
value to cultural goods. Given the size, significance and complexity of
these industries in the early twenty-first century, and the accompanying
sophistication of cultural consumers who are aware of what is at stake
for them in the game of culture, attention to the processes of production
can be an important part of understanding the continued significance of
cultural consumption. The pleasures of evaluation and judgement that
are reflected, for example, in list culture might be reflective of a more dif-
fuse and dispersed form of cultural authority in which notions of good
and bad are contestable and in which traditional sources of legitimacy
coexist with alternative sources, including from subcultures. At the same
time, though, the ease with which the complexities and diversities of the
contemporary cultural field has been transformed into the apparently
objective classification of the numerical list, for promotional purposes,
suggests that this might also be a cautionary model for the attribution
of value to things – and people – in other fields.

Chapter 6 considers the most recently formed dimension of taste,
wrought by the role of digital technologies in the production, circula-
tion and consumption of culture. Although the relative novelty here is
important, it is equally significant in understanding this dimension to
remember that, some 20 years since the launch of Amazon, these tech-
nologies are now embedded in the everyday practices of choosing and
tasting. This makes them, as Bowker and Star (2000) and Beer (2013)
have outlined, like all of the most powerful forms of infrastructure,
somewhat taken for granted and invisible. Attention to them reveals
some intriguing paradoxes. Taste has historically been bound up with
self-management in the presence of diversity and abundance, assisted by
established norms and rules of conduct. This model of restraint, in defer-
ence to authoritative rules, spills over into approaches to cultural taste,
and it is cemented in cultural hierarchies and in the various forms of
authority which police and manage correct forms of cultural taste. One
consequence of the digital production and circulation of culture is that
these correct forms are harder to manage and police through the institu-
tions of the past. The notion of scarcity, which underpinned Bourdieu's
economistic metaphor of capital, has been replaced with a kind of cul-
tural abundance in which, in the connected societies of the global North

at least, more people have access to more culture –including more legitimate culture – than ever before. The recognition of this empirical reality has significant consequences for some certainties about taste, cultural and social hierarchies. It also raises important questions for those groups and authorities that are most invested in the value that accompanied cultural scarcity. It is perhaps a hopeful by-product of abundance that it enables a broadened, if more chaotic, cultural conversation. It can be interpreted as a step along the *Long Revolution* (Williams, 1961), in which access to the possibility of a symbolic life is widened by the development of what has been characterized as an 'aesthetic public sphere' (Roberge, 2011), where established forms of cultural authority must coexist and negotiate with new and emergent forms.

Less hopeful is the role of algorithmic forms of managing this cultural abundance. Such strategies rely on more sophisticated forms of making tastes known, in which word-of-mouse and collaborative filtering technologies that feed off online browsing and purchasing behaviours coalesce to generate a sophisticated, data-rich vision of the person. For those who are concerned to explore the continuing importance of taste to social life, such tools are undeniably powerful. They have, for example, the potential to generate a more complex and nuanced version of the habitus than has been achieved so far. One such technology, a 'profiler' launched in November 2014 by the polling company YouGov, is able to use the assumption that tastes reveal deep insight into the character and motivations of consumers as a tradable commodity for brands looking for insight into their potential customers, drawing on data from over 200,000 panellists. There might be nothing revealed through these methods that would surprise or contradict a nuanced reading of *Distinction*. As a fan of the singer Nick Cave, for example, I am unsurprised to find myself revealed, through this profiler, to be relatively affluent and educated, working in the public sector and inclined to the left politically. The authority and usefulness of these categorizations and the corralling of the powerful logistical technologies of computing to generate them is significant, however. One consequence is revealed by their application to algorithmic recommendation and the role of data about past activity in framing future forms of cultural engagement. Relying on such forms of recommendation cements social division in potentially more efficient and exclusionary ways than even Bourdieu predicts, and it undermines the democratizing promise of the ease of access to abundant culture. They have the potential to culminate in a technologically managed form of homology. If, for example, as proponents of the omnivore thesis explored in Chapter 2, or the advocates of cosmopolitanism

as a taste formation considered in Chapter 4, might contend, there is some normative relationship between the encountering of a variety of culture which is socially beneficial (in developing tolerance and understanding of others, for example), then the constant reinforcement of tastes and preferences generated by algorithmic recommendations alone is damaging.

The vision of the person who emerges from this final dimension of taste, as a culmination of their preferences, is one that is perfectly suited to the organizational, logistical and governmental potential of contemporary computing technologies. As such it should remind us that tastes remain socially loaded and bound up with questions of struggle, power and inequality in ways which remain important to reveal and reflect on. Tastes are also shaped by techniques of measurement, strategies of government, global flows of people and things, and new and established technologies of production and circulation. Being a person of good taste is, in some ways, different in the early twenty-first century from how it was in early modern or Enlightenment Europe, in the modern city or in the mass society of the mid-twentieth century. A perspective that takes seriously the intersections between sensation, skill and sensibility in this multidimensional experience of contemporary tasting also seems more likely to reveal the abiding continuities that are attached to that label too, and to raise questions about whether it is one to which we should really continue to aspire.

Notes

3 Governing Tastes

1. See *Life in the UK Official Study Guide* (TSO, 2013) and practice test at http://www.officiallifeintheuk.co.uk/test/.
2. I'm grateful to my colleague Clive Gray for pointing out here that the revelation about Brown's musical preferences were something of an invented media storm. In response to a question from an interviewer from *New Woman* magazine about whether he liked *Arctic Monkeys*, Brown replied: 'they'd certainly wake you up in the morning'. He wasn't declaring a preference so much as acknowledging their existence and an appreciation of their relative volume.
3. It is worth reflecting here that Bourdieu developed the concept of cultural capital as an ironic riposte to the metaphors generated in US economics in the post-war period (Robbins, 2005). Ben Fine's work (2010) is also useful in critiquing the many forms of metaphorical capitals at play in contemporary economic and policy discourses.
4. C2DE is a categorization used in the UK's National Readership Survey. It includes skilled and unskilled manual workers and the unemployed.

Bibliography

ACORN (2014) *The ACORN User Guide: The Consumer Classification.* London: CACI, available at http://acorn.caci.co.uk/downloads/Acorn-User-guide.pdf.

Adorno, T. and Horkheimer, M. (1944) 'The Culture Industry: Enlightenment As Mass Deception' in J.B. Schor and D.B. Holt (eds) (2000) *The Consumer Society Reader.* New York: The New Press, pp. 3–19.

Ahearne, J. (2004) 'Between Cultural Theory and Policy: The Cultural Policy Thinking of Pierre Bourdieu, Michel de Certeau and Regis Debray', *Centre for Cultural Policy Studies Research Papers,* No.7. Warwick: University of Warwick.

Alasuutari, P. (2001) 'Art, Entertainment, Culture and Nation', *Cultural Studies/Critical Methodologies* 1: 157–184.

Allen-Robertson, J. (2013) *Digital Culture Industry: A History of Digital Distribution.* Basingstoke: Palgrave Macmillan.

Amin, A. and Thrift, N. (eds) (2004) *The Blackwell Cultural Economy Reader.* Oxford: Blackwell.

Anand, N. and Peterson, R.A. (2000) 'When Market Information Constitutes Fields: Sensemaking of Markets in the Commercial Music Industry', *Organization Science* 11(3): 270–284.

Anderson, B. (2006) *Imagined Communities,* Rev. edn. London: Verso.

Anderson, C. (2006) *The Long Tail.* London: Random House.

Anderson, C. (2008) 'The End of Theory: The Data Deluge Makes the Scientific Method Obsolete', *Wired Magazine* 16(7): 23 June 2008, available at http://archive.wired.com/science/discoveries/magazine/16-07/pb_theory.

Ang, I. (1985) *Watching Dallas: Soap Opera and the Melodramatic Imagination.* London: Methuen.

Arendt, H. (1960) 'Mass Culture and the Mass Media', *Daedalus,* 89(2): 278–287.

Arts Council England. (2007) *Literature Policy.* London: Arts Council England.

Atkinson, W. (2011) 'The Context and Genesis of Musical Taste: Omnivorousness Debunked, Bourdieu Buttressed', *Poetics* 39: 169–186.

Auge, M. (1995) *Non-Places: Introduction to an Anthropology of Supermodernity.* London: Verso.

Barry, A. and Thrift, N. (2007) 'Gabriel Tarde: Imitation, Invention and Economy', *Economy and Society* 36(4): 509–525.

Barthes, R. (1993) *Mythologies.* London: Vintage.

Baulch, E. (2002) 'Creating a Scene: Balinese Punk's Beginnings', *International Journal of Cultural Studies* 5: 153–177.

Bauman, Z. (1998) *Globalization: The Human Consequences.* Cambridge: Polity.

Baumann, S. (2007) *Hollywood Highbrow: From Entertainment to Art.* Princeton: Princeton University Press.

Beck, U. (2000) 'The Cosmopolitan Perspective: Sociology of the Second Age of Modernity', *British Journal of Sociology* 51: 79–105.

Beck, U. (2004) 'Cosmopolitical Realism: On the Distinction Between Cosmopolitanism in Philosophy and the Social Sciences', *Global Networks* 4(2): 131–156.

Becker, H.S. (1982) *Art Worlds*. Berkeley, CA: University of California Press.
Beer, D. (2013) *Popular Culture and New Media: The Politics of Circulation*. Basingstoke: Palgrave Macmillan.
Belfiore, E. and Bennett, O. (2008) *The Social Impact of the Arts*. Basingstoke: Palgrave Macmillan.
Belfiore, E. and Bennett, O. (2009) 'Researching the Social Impact of the Arts: Literature, Fiction and the Novel', *International Journal of Cultural Policy* 15(1): 17–33.
Bellevance, G. (2008) 'Where's High? Who's Low? What's New? Classification and Stratification Inside Cultural "Repertoires"', *Poetics* 36: 189–216.
Benjamin, W. (1999) *Illuminations*. London: Pimlico.
Bennett, T. (1995) *The Birth of the Museum*. London: Routledge.
Bennett, T. (1998) *Culture: A Reformer's Science*. London: Sage.
Bennett, T. (2006) 'Distinction on the Box: Cultural Capital and the Social Space of Broadcasting', *Cultural Trends* 15(2–3): 193–212.
Bennett, T. (2007) 'Habitus Clivé: Aesthetics and Politics in the Work of Pierre Bourdieu', *New Literary History* 38(1): 201–228.
Bennett, T., Savage, M., Silva, E.B., Warde, A., Gayo-Cal, M. and Wright, D. (2009) *Culture, Class, Distinction*. London: Routledge.
Benson, R. (1998) 'Field Theory in Comparative Context: A New Paradigm for Media Studies.' *Theory and Society*, 28(3): 463–498.
Benson, R. and Neveu, E. (2005) *Bourdieu and the Journalistic Field*. Cambridge: Polity.
Berns, G.S. and Moore, S.E. (2012) 'A Neural Predictor of Cultural Popularity', *Journal of Consumer Psychology* 22: 154–160.
Biskind, P. (1998) *Easy Riders, Raging Bulls*. London: Bloomsbury.
Blank, G. (2007) *Critics, Ratings and Society*. New York: Rowman and Littlefield.
Bloom, H. (1994) *The Western Canon: The Books and School of the Ages*. New York: Harcourt Brace.
Boltanski, L. and Chiapello, E. (2005) *The New Spirit of Capitalism*. London: Verso.
Bostridge, I. (2011) *A Singer's Notebook*. London: Faber.
Bourdieu, P. and Passeron, J. (1979) *The Inheritors*. Chicago: University of Chicago Press.
Bourdieu, P. (1984) *Distinction: A Social Critique of the Judgment of Taste*. London: Routledge.
Bourdieu, P. (with A. Darbel and D. Schnapper) (1990) *The Love of Art*. Oxford: Polity.
Bourdieu, P. and Wacquant, L. (1992) *An Invitation to a Reflexive Sociology*. Cambridge: Polity.
Bourdieu, P. (1993) *The Field of Cultural Production*. Cambridge: Polity.
Bourdieu, P. (1996) *The Rules of Art*. Cambridge: Polity.
Bourdieu, P. (1998a) *Practical Reason: On the Theory of Action*. Cambridge: Polity.
Bourdieu, P. (1998b) *On Television and Journalism*. London: Pluto Press.
Bourdieu, P. (2005) *The Social Structures of the Economy*. Cambridge: Polity.
Bowker, G.C. and Star, S.L. (2000) *Sorting Things Out: Classification and its Consequences*. Cambridge, MA: MIT Press.
Bratlinger, P. (1998) *The Reading Lesson: The Threat of Mass Literacy in Nineteenth Century British Fiction*. Bloomington: Indiana University Press.

Bryson, B. (1996) ' "Anything But Heavy Metal": Symbolic Exclusion and Musical Dislikes', *American Journal of Sociology* 102(3): 884–899.

Bull, M. (2007) *Sound Moves: Ipod Culture and Urban Experience*. London: Routledge.

Calhoun, C. (2003) 'The Class Consciousness of Frequent Travellers: Towards a Critique of Actually Existing Cosmopolitanism' in S. Vertovec and R. Cohen (eds) *Conceiving Cosmopolitanism: Theory, Context and Practice*. Oxford: Oxford University Press, pp. 86–109.

Carey, J. (1992) *The Intellectuals and the Masses: Pride and Prejudice Among the Literary Intelligentsia*. London: Faber.

Carey, J. (2006) *What Good are the Arts?* London: Faber.

Carter, D. (1999) 'Good Readers and Good Citizens: Literature, Media and the Nation', *Australian Literary Studies* 19: 136–151.

Casanova, P. (2007) *The World Republic of Letters*. Cambridge, MA: Harvard University Press.

Castells, M. (2010) *The Rise of the Network Society*, 2nd edn. Oxford: Blackwell.

Chan, T.W. and Goldthorpe, J. (2006) 'Social Stratification and Cultural Consumption: Music in England', *European Sociological Review* (1): 1–19.

Chan, T.W. (ed.) (2010) *Social Status and Cultural Consumption*. Cambridge: Cambridge University Press.

Chaney, D. (2002) 'Cosmopolitan Art and Cultural Citizenship', *Theory, Culture and Society* 19(1–2): 157–174.

Charlesworth, S. (2000) *A Phenomenology of Working-Class Experience*. Cambridge: Cambridge University Press.

Chernilo, D. (2006) 'Social Theory's Methodological Nationalism: Myth and Reality', *European Journal of Social Theory* 9: 5–22.

Clough, P.T. and Halley, J. (eds) (2007) *The Affective Turn*. Durham and London: Duke University Press.

Collins, J. (2010) *Bring on the Books for Everybody: How Literary Culture Became Popular Culture*. Durham and London: Duke University Press.

Condry, I. (2001) 'A History of Japanese Hip-hop: Street Dance, Club Scene, Pop Market' in T. Mitchell (ed) *Global Noise*, Middletown: Wesleyan University Press, pp. 222–247.

Corse, S.M. and Westervelt, S.D. (2002) 'Gender and Literary Valorization: The Awakening of a Canonical Novel', *Sociological Perspectives* 45: 139–161.

Costandi, M. (2014) 'Shared Brain Activity Predicts Audience Preferences', *Guardian*, 31 July.

Cowen, T. (1998) *In Praise of Commercial Culture*. London: Harvard University Press.

Cvetacinin, P. and Popescu, M. (2011) 'The Art of Making Classes in Serbia: Another Particular Case of the Possible', *Poetics* 39: 444–468.

Dames, N. (2009) 'Forget Bourdieu: The iPod of the Hidden Self' in *n+1, Recessional*, 8, Fall.

DeNora, T. (1995) *Beethoven and the Construction of Genius*. Berkeley: University of California Press.

Deranty, J.P. (2010) *Jacques Rancière: Key Concepts*. Durham: Acumen.

Desrosières, A. (2012) 'Mapping the Social World: From Aggregates to Individuals', *Limn: Crowds and Clouds* (2), available at http://limn.it/mapping-the-social-world-from-aggregates-to-individuals/ (downloaded 26 February 2014).

DiMaggio, P. (1982) 'Cultural Entrepreneurship in 19th Century Boston: The Creation of an Organizational Basis for High Culture in America', *Media, Culture and Society* 4: 33–50.

Dorfman, A. and Matterlart, A. (1975) *How to Read Donald Duck*. New York: I.G. Editions.

Douglas, M. (1966) *Purity and Danger*. London: Routledge.

Dubois, V. (2011) 'Cultural Capital Theory vs. Cultural Policy Beliefs: How Pierre Bourdieu Could Have Become a Cultural Policy Advisor and Why He Did Not', *Poetics* 39(6): 491–506.

Du Gay, P. and Pryke, M. (2002) *Cultural Economy: Cultural Analysis and Commercial Life*. London: Sage.

Dugdale, G. and Clark, C. (2008) *Literacy Changes Lives: An Advocacy Resource*. London: National Literacy Trust.

Elias, N. (1994) *The Civilizing Process*. Oxford: Blackwell.

English, J.F. (2005) *The Economy of Prestige: Prizes, Awards, and the Circulation of Cultural Value*. Cambridge, MA: Harvard University Press.

Falconer, I. (2010) 'Fairy Tales of Resistance: The Danish Culture Canon, Lars Von Trier and the Emperor's New Clothes', *Conditions*, July 2010, available at http://www.conditionsmagazine.com/archives/1803 (accessed January 2014).

Fernandez, R. (2001) *Imagining Literacy*. Austin: University of Texas Press.

Fine, B. (2001) *Social Capital versus Social Theory*. London and New York: Routledge.

Fine, B. (2010) *Theories of Social Capital: Researchers Behaving Badly*. London: Pluto Press.

Florida, R. (2002) *The Rise of the Creative Class: And How It's Transforming Work, Leisure, Community and Everyday Life*. London: Basic Books.

Foucault, M. (1973) *The Birth of the Clinic*. London: Tavistock.

Frank, T. (1997) *The Conquest of Cool: Business Culture, Counter-Culture and the Rise of Hip Consumerism*. Chicago and London: University of Chicago Press.

Friedman, S. (2012) 'Cultural Omnivores or Culturally Homeless? Exploring the Shifting Cultural Identities of the Upwardly Mobile', *Poetics* 40: 467–489.

Frisby, D. (1997) 'Introduction to the Texts' in D. Frisby and M. Featherstone (eds) *Simmel on Culture*, London: Sage, pp. 1–28.

Frow, J. (1995) *Cultural Studies and Cultural Value*. Oxford: Clarendon Press.

Frow, J. (2006) *Genre: The New Critical Idiom*. London: Routledge.

Fuller, D. and Rehberg Sedo, D. (2013) *Reading Beyond the Book: The Social Practices of Contemporary Literary Culture*. London: Routledge.

Fuller, S. (2006) *The New Sociological Imagination*. London: Sage.

Galtung, J. and Ruge, M. (1965) 'The Structure of Foreign News: The Presentation of the Congo, Cuba and Cyprus Crises in Four Norwegian Newspapers', *Journal of International Peace Research* 1: 64–91.

Gans, H. (1999/1974) *Popular Culture and High Culture: An Analysis and Evaluation of Taste*, Rev ed. New York: Basic.

Gerlitz, C. and Helmond, A. (2013) 'The Like Economy: Social Buttons and the Data Intensive Web', *New Media and Society* 15(8): 1348–1365.

Gibson, L. (2008) 'In Defence of Instrumentality', *Cultural Trends* 17(4): 247–257.

Giddens, A. (2002) *Runaway World*, 2nd edn. New York: Profile Books.

Gilroy, P. (1993) *The Black Atlantic: Modernity and Double Consciousness*. London: Verso.

Graff, H.J. (1979) *The Literacy Myth: Literacy and Social Structure in the Nineteenth Century City*. New York: Academic Press.

Gregg, M. and Seigworth, G.L. (eds) (2010) *The Affect Theory Reader*. Durham and London: Duke University Press, pp. 118–137.

Griswold, W. (2008) *Regionalism and the Reading Class*. Chicago: University of Chicago Press.

Gronow, J. (1997) *The Sociology of Taste*. London: Routledge.

Grunitzky, C. (2004) *Transculturalism: How the World Is Coming Together*. New York: True Agency.

Guillory, J. (1993) *Cultural Capital: The Problem of Literary Canon Formation*. London: University of Chicago Press.

Hage, G. (2000) *White Nation: Fantasies of White Supremacy in a Multicultural Society*. London: Routledge.

Hakim, C. (2011) *Honey Money: The Power of Erotic Capital*. London: Allen Lane.

Hall, S. and Jefferson, T. (1975) *Resistance Through Rituals*. London: Hutchinson.

Hall, S. (1996) 'Who Needs Identity?' in S. Hall and P. Du Gay (eds) *Questions of Cultural Identity*. London: Sage, pp. 1–17.

Hallé, D. (1993) *Inside Culture: Art and Class in the American Home*. Chicago and London: University of Chicago Press.

Halsey, A.H. (2004) *A History of British Sociology*. Oxford: Clarendon.

Hebidge, D. (1979) *Subculture: The Meaning of Style*. London: Routledge.

Hebdige, D. (1998) *Hiding in the Light: On Images and Things*. London: Routledge.

Hennion, A. (2001) 'Music Lovers: Taste as Performance', *Theory, Culture and Society* 18(5): 1–22.

Hennion, A. (2007) 'Those Things That Hold Us Together: Taste and Sociology', *Cultural Sociology* 1(1): 97–114.

Highmore, B. (2010) 'Bitter After Taste: Affect, Food and Social Aesthetics' in M. Gregg and G.J. Seigworth (eds) *The Affect Theory Reader*. Durham and London: Duke University Press, pp. 118–137.

Hill, J. (2007) 'UK Film Policy, Cultural Capital and Social Exclusion', *Cultural Trends* 13(2): 29–39.

Hirsch, E.D. (1987) *Cultural Literacy: What Every American Needs to Know*. New York: Houghton Mifflin.

Hirsch, P.M. (1972) 'Processing Fads and Fashions: An Organization-set Analysis of Cultural Industry Systems', *American Journal of Sociology* 77: 639–659.

Hoggart, R. (1957) *The Uses of Literacy*. London: Chatto and Windus.

Holt, D.B. (1997) 'Distinction in America? Recovering Bourdieu's Theory of Taste From Its Critics', *Poetics* 25: 93–120.

Hood, T. (1852) *Up the Rhine*. New York: GP Putnam and Co.

Hooper, M. (2014) 'Amazon at 20: Billions, Bestsellers and Legal Battles', *Guardian*, 21 July.

Inglehart, R. (1990) *Culture Shift in Advanced Industrial Society*. Princeton, NJ: Princeton University Press.

Inglis, D. (1993) *Cultural Studies*. Oxford: Blackwell.

Joyce, P. (2003) *The Rule of Freedom: Liberalism and the Modern City*. London: Verso.

Kahma, N. and Toikka, A. (2012) 'Cultural Map of Finland 2007: Analysing Cultural Differences Using Multiple Correspondence Analysis', *Cultural Trends* 21(2): 113–131.

Katz-Gerro, T. (2002) 'Highbrow Cultural Consumption and Class Distinction in Italy, Israel, West Germany, Sweden, and the United States', *Social Forces* 81(1): 207–229.

Katz-Gerro, T. and Sullivan, O. (2007) 'The Omnivore Thesis Revisited: Voracious Cultural Consumers', *European Sociological Review* 23(2): 123–137.

Kant, I. (1987 [1790]) *Critique of Judgement* (trans. W.S. Pluhar). Indianapolis/Cambridge: Hackett Publishing Company.

Kendall, G., Woodward I. and Skrbis, Z. (2009) *The Sociology of Cosmopolitanism*. Basingstoke: Palgrave Macmillan.

Kern, S. (1983) *The Culture of Time and Space: 1880–1918*. Cambridge, MA: Harvard University Press.

Kuhn, T. (2012) *The Structure of Scientific Revolutions*, 4th edn. Chicago: University of Chicago Press.

Lahire, B. (2008) 'The Individual and the Mixing of Genres: Cultural Dissonance and Self-Distinction', *Poetics* 36: 166–188.

Lahire, B. (2011) *The Plural Actor*. Cambridge: Polity.

Lamont, M. (1992) *Money, Morals, and Manners: The Culture of the French and the American Upper-Middle Class*. Chicago: University of Chicago Press.

Lamont, M. and Aksartova, S. (2002) 'Ordinary Cosmopolitanisms: Strategies for Bridging Racial Boundaries among Working Class Men', *Theory, Culture and Society* 19(4): 1–27.

Lamont, M. (2012) 'Towards a Comparative Sociology of Valuation and Evaluation', *Annual Review of Sociology* 38: 201–221.

Law, J. (2009) 'Seeing like a Survey', *Cultural Sociology* 3(2): 239–256.

Lebaron, F. (2009) 'How Bourdieu "Quantified Bourdieu": The Geometric Modelling of Data' in K. Robson and C. Sanders (eds) *Quantifying Theory: Pierre Bourdieu*. Berlin: Springer, pp. 11–29.

Lena, J. and Peterson R.A. (2008) 'Classification as Culture: Types and Trajectories of Music Genres', *American Sociological Review* 73: 697–718.

Lena, J. (2012) *Banding Together: How Communities Create Genres in Popular Music*. Princeton: Princeton University Press.

Levi-Strauss, C. (1983) *The Raw and the Cooked: Mythologiques* Vol.1. Chicago: University of Chicago Press.

Levitas, R. (2005) *The Inclusive Society*. Basingstoke: Palgrave Macmillan.

Liebes, T. and Katz, E. (1990) *The Export of Meaning: Cross Cultural Readings of Dallas*. New York: Oxford University Press.

Lietchy, M. (2003) *Suitably Modern: Making Middle-class Culture in a New Consumer Society*. Princeton: Princeton University Press.

Maltby, R. (2004) 'Introduction: The Americanisation of the World' in M. Stokes. and R. Maltby. (eds) *Hollywood Abroad: Audiences and Cultural Exchange*. London: BFI, pp. 1–20.

Matarasso, F. (1997) *Use or Ornament? The Social Impact of Participation in the Arts*. Stroud: Comedia.

McGuigan, J. (2009) *Cool Capitalism*. London: Pluto Press.

McFall, L. (2002) 'What About the Old Cultural Intermediaries? An Historical Review of Advertising Producers', *Cultural Studies* 16(4): 532–552.

McLuhan, M. (1962) *The Gutenberg Galaxy*. Toronto: University of Toronto Press.

McClure, S.M., Li, J., Tomlin, D., Cypert, K.S., Montague, L. and Montague, P.R. (2004) 'Neural Correlates of Behavioural Preference for Culturally Familiar Drinks' *Neuron* 44(11): 379–387.

Merli, P. (2002) 'Evaluating the Social Impact of Participation in Art Activities: A Critical Review of Francois Matarasso's *Use or Ornament?'*, *International Journal of Cultural Policy* 8(1): 107–118.

Miller, D. (1994) 'The Young and the Restless in Trinidad' in R. Silverstone (ed.) *Consuming Technologies*. London: Routledge, pp. 92–103.

Miller, L. (2000) 'The Best-Seller List as Marketing Tool and Historical Fiction', *Book History* 3: 286–304.

Miller, P and Rose, N. (1990) 'Governing Economic Life', *Economy and Society* 19(1): 1–31.

Miller, T., Govil, N., McMurria, J. Maxwell, R. and Wang, T. (2005) *Global Hollywood 2*. London: BFI.

Miller, W. (1997) *The Anatomy of Disgust*. Cambridge, MA: Harvard University Press.

Mintz, S.W. (1986) *Sweetness and Power: The Place of Sugar in Modern History*. London: Penguin.

Moor, L. (2008) 'Branding Consultants as Cultural Intermediaries', *The Sociological Review* 56(3): 408–428.

Napoli, P. (2011) *Audience Evolution: New Technologies and the Transformation of Media Audiences*. New York: Columbia University Press.

Napoli, P. (2014) 'On Automation in Media Industries: Integrating Algorithmic Media Production into Media Industries Scholarship', *Media Industries Journal* 1(1): 33–38.

National Endowment for the Arts (NEA) (2004) *Reading at Risk: A Survey of Literary Reading*. Research Division Report 46, Washington, DC.

National Endowment for the Arts (NEA) (2007) *To Read or Not to Read: A Question of National Consequence*. Research Division Report 47, Washington, DC.

National Endowment for the Arts (NEA) (2009) *Reading on the Rise: A New Chapter in American Literacy*. Washington, DC: NEA.

Negus, K. (2002) 'The Work of Cultural Intermediaries and the Enduring Distance Between Production and Consumption', *Cultural Studies* 16(4): 501–515.

OECD (2002) *Reading for Change*. Paris: OECD Publications.

Ohmae, K. (1995) *The End of the Nation State*. New York: Free Press.

Ollivier, M. (2008) 'Modes of Openness to Cultural Diversity: Humanist, Populist, Practical and Indifferent', *Poetics* 36: 120–147.

Onians, J. (2007) *Neuroarthistory*. New Haven: Yale University Press.

Osborne, T. and Rose, N. (1999) 'Do the Social Sciences Create Phenomena? The Example of Public Opinion Research', *British Journal of Sociology* 50(3): 367–396.

Pariser, E. (2011) *The Filter Bubble: What the Internet Is Hiding From You*. London: Viking.

Parkhurst Clarke, P. (1987) *Literary France: The Making of a Culture*. Berkeley, CA and Los Angeles: University of California Press.

Perry, G. (2014) *Playing to the Gallery*. London: Penguin.

Peterson, Richard A. (1972) 'A Process Model of the Folk, Pop and Fine Art Phases of Jazz' in C. Nanry (ed.) *American Music*. New Brunswick, NJ: Transaction, pp. 135–151.

Peterson, R. (1976) 'The Production of Culture: A Prolegomenon', *American Behavioural Scientist*, 19: 669–684.

Peterson, R.A. (1992) 'Understanding Audience Segmentation: From Elite and Mass to Omnivore and Univore', *Poetics* 21: 243–58.

Peterson, R.A. and Simkus, A. (1992) 'How Musical Tastes Mark Occupational Status Groups' in M. Lamont and M. Fournier (eds) *Cultivating Differences*. Chicago: University of Chicago Press, pp. 152–186.

Peterson R.A. and Kern, R.M. (1996) 'Changing Highbrow Taste: From Snob to Omnivore', *American Sociological Review* 61: 900–909.

Peterson, R.A. (2005) 'Problems in Comparative Research: The Example of Omnivorousness', *Poetics* 33: 257–282.

Peterson, R.A. and Rossman, G. (2008) 'Changing Arts Audiences: Capitalizing on Omnivorousness' in S. Tepper and B. Ivey (eds) *Engaging Art: The Next Great Transformation in American Life*. New York and London: Routledge, pp. 307–342.

Peterson, R.A. and Anand, N. (2004) 'The Production of Culture Perspective', *Annual Review of Sociology* 30: 311–334.

Pettinger, L. (2004) 'Brand Culture and Branded Workers: Service Work and Aesthetic Labour in Fashion Retail', *Consumption, Markets and Culture* 7: 165–184.

Pieterse, J.N. (2009) *Globalization and Culture: A Global Mélange*, Second edn. Lanham, MD: Rowman and Littlefield.

Prieur, A., Rosenlund, L. and Skjott-Larsen, J. (2008) 'Cultural Capital Today: A Case Study from Denmark', *Poetics* 36(1): 45–71.

Purhonen, S. and Wright, D. (2013) 'Cultural Capital in the UK and Finland: Methodological Issues in National-Comparative Work on Tastes', *Cultural Sociology* 7(2): 257–273.

Putnam, R. (2000) *Bowling Alone*. New York: Simon and Schuster.

Radway, J. (1997) *A Feeling for Books: Literary Taste and Middle-Class Desire*. Chapel Hill and London: University of North Carolina Press.

Rancière, J. (2004) *The Philosopher and His Poor*. Durham and London: Duke University Press.

Rancière, J. (2012) *Proletarian Nights: The Workers' Dream in Nineteenth Century France*. London: Verso.

Regev, M. (2013) *Pop-Rock Music: Aesthetic Cosmopolitanism in Late Modernity*. Cambridge: Polity.

Rhys-Taylor, A. (2013) 'The Essences of Multiculture: A Sensory Exploration of an Inner-city Street Market', *Identities: Global Studies in Culture and Power* 20(4): 393–406.

Rimmer, M. (2012) 'Beyond Omnivores and Univores: The Promise of a Concept of Musical Habitus', *Cultural Sociology* 6(3): 299–318.

Robbins, D. (2005) 'The Origins, Early Development and Status of Bourdieu's Concept of "Cultural Capital" ', *British Journal of Sociology* 56(1): 13–30.

Roberge, J. (2011) 'The Aesthetic Public Sphere and the Transformation of Criticism', *Social Semiotics* 21(3): 435–453.

Rose, J. (2001) *The Intellectual Life of the British Working Classes*. New Haven and London: Yale University Press.

Rose, N. and Abi-Rached, J.M. (2013) *Neuro: The New Brain Sciences and the Management of the Mind*. Princeton: Princeton University Press.

Sapiro, G. (2003) 'The Literary Field Between the State and the Market', *Poetics* 31: 441–464.

Savage, M., Barlow, J., Dickens, P. and Fielding, T. (1992) *Property, Bureaucracy and Culture: Middle Class Formation in Contemporary Britain*. London: Routledge.

Savage, M., Bagnall, G. and Longhurst, B. (2001) 'Ordinary, Ambivalent and Defensive: Class identities in the North-West of England', *Sociology* 35(4): 875–892.

Savage, M. (2010) *Identities and Social Change in Britain Since 1940: The Politics of Method*. Oxford: Oxford University Press.

Savage, M. and Burrows, R. (2007) 'The Coming Crisis of Empirical Sociology', *Sociology* 41(5): 885–899.

Savage, M. and Gayo, M. (2011) 'Unravelling the Omnivore: A Field Analysis of Contemporary Musical Taste in the United Kingdom', *Poetics* 39: 337–357.

Savage, M. and Silva, E.B. (2012) 'Field Analysis in Cultural Sociology', *Cultural Sociology* 7(2): 111–126.

Savage, M., Wright, D. and Gayo-Cal, M. (2010) 'Cosmopolitan Nationalism and the Cultural Reach of the White British', *Nations and Nationalism* 16(4): 598–615.

Save The Children (2014) *Read on Get On: How Reading Can Help Children Escape Poverty*. London: Save the Children.

Scarpellini, E. (2011) *Material Nation: A Consumer's History of Modern Italy*. Oxford: Oxford University Press.

Schleifer, R. (2000) *Modernism and Time: The Logic of Abundance in Literature, Science and Culture 1880–1930*. Cambridge: Cambridge University Press.

Schwartz, B. (2008) 'Can There Ever Be Too Many Flowers Blooming?' in S. Tepper and B. Ivey (eds) *Engaging Art: the Next Great Transformation in American life*. New York and London: Routledge, pp. 239–256.

Selwood, S. (2006) 'Unreliable Evidence: The Rhetorics of Data Collection in the Cultural Sector' in M. Mirza (ed.) *Culture Vulture: Is UK Arts Policy Damaging the Arts*. London: Policy Exchange, pp. 38–52.

Senior, C. and Lee, N. (2008) 'A Manifesto for Neuromarketing Science', *Journal of Consumer Behaviour* 7: 263–271.

Sennett, R. (2006) *The Culture of the New Capitalism*. New Haven: Yale University Press.

Shrum, W. (1991) 'Critics and Publics: Cultural Mediation in Highbrow and Popular Performing Arts', *American Journal of Sociology* 97(2): 347–375.

Shrum, W. (1996) *Fringe and Fortune: The Role of Critics in High and Popular Art*. Princeton: Princeton University Press.

Silva, E.B. and Wright, D. (2008) 'Researching Cultural Capital: Complexities in Mixing Methods' *Methodological Innovations Online* 2(3): 50–62.

Silva, E.B., Warde, A. and Wright, D. (2009) 'Using Mixed Methods for the Analysis of Culture: Cultural Capital and Social Exclusion', *Cultural Sociology* 3(2): 299–316.

Simmel, G. (1997a) 'The Sociology of the Senses' in D. Frisby and M. Featherstone (eds) *Simmel on Culture*. London: Sage, pp: 109–119.

Simmel, G. (1997b) 'The Philosophy of Fashion' in D. Frisby and M. Featherstone (eds) *Simmel on Culture*. London: Sage, pp. 187–205.

Singh, J.P. (2011) *Globalized Arts: The Entertainment Economy and Cultural Identity*. New York: Columbia University Press.

Skeggs, B. (1997) *Formations of Class and Gender*. London, Sage.

Skeggs, B. (2004) *Class, Self, Culture*. London and New York: Routledge.

Smith Maguire, J. and Matthews, J. (2014) *The Cultural Intermediaries Reader*. London: Sage.

Stark, D. (2011) 'What's Valuable' in P. Aspers and J. Beckert (eds) *The Worth of Goods: Valuation and Pricing in the Economy*. Oxford: Oxford University Press, pp. 319–338.

Starr, G.G. (2013) *Feeling Beauty: The Neuroscience of Aesthetic Experience*. Cambridge, MA: MIT Press.

Stevenson, N. (2010) 'Education, Neo-liberalism and Cultural Citizenship: Living in *X-Factor* Britain', *European Journal of Cultural Studies* 13(3): 341–358.

Street, J. (2005) 'Showbusiness of a Serious Kind': A Cultural Politics of the Arts Prize', *Media, Culture and Society*, 27(6): 818–840.

Stuckey, J.E. (1991) *The Violence of Literacy*. Portsmouth, NH: Heinemann.

Szerzynski, B. and Urry, J. (2002) 'Cultures of Cosmopolitanism', *Sociological Review*, 50(4): 461–481.

Tallis, R. (2011) *Aping Mankind: Neuromania, Darwinitis and the Misrepresentation of Humanity*. Durham: Acumen.

Tanke, J.J. (2011) *Jacques Rancière: An Introduction*. London: Continuum.

Tarde, G. (1903) *The Laws of Imitation*. New York: Henry Holt.

Tarde, G. (2007) 'Economic Psychology', *Economy and Society* 36(4): 614–643.

Teo, S. (2010) 'Film and Globalization: From Hollywood to Bollywood' in B. Turner (ed.) *The Handbook of Globalization Studies*. London: Routledge, pp. 412–428.

Thompson, J.B. (1995) *The Media and Modernity*. Cambridge: Polity.

Thomson, A. (2008) *National Year of Reading: Reading the Future*. London: National Literacy Trust.

Thornton, S. (2009) *Seven Days in the Art World*. London: Granta.

Thrift, N. (2005) *Knowing Capitalism*. London: Sage.

Thrift, N. (2010) 'Understanding the Material Practices of Glamour' in M. Gregg and G.J. Seigworth (eds) *The Affect Theory Reader*. Durham: Duke University Press, pp. 289–308.

Throsby, D. (2001) *Economics and Culture*. Cambridge: Cambridge University Press.

Thussu, D.K. (ed.) (2007) *Media on the Move*. London: Routledge.

Tomlinson, J. (2001) *Cultural Imperialism*. London: Continuum.

Tonnies, F. (2002/1857) *Community and Society*. New York: Dover Publications.

Tröndle, M. and Tschacher, W. (2012) 'The Physiology of Phenomenology: The Effects of Artworks', *Empirical Studies of the Arts* 30(1): 75–113.

TSO (2013) *Life in the UK: Official Study Guide*. London: The Stationery Office.

UNESCO (1980) *Many Voices, One World*. London, Paris and New York: Kogan Page.

Van Dijk, J. (2013) *The Culture of Connectivity: A Critical History of Social Media*. Oxford: Oxford University Press.

Veblen, T. (1994/1899) *The Theory of the Leisure Class*. Basingstoke: Palgrave Macmillan.

Verboord, M. (2010) 'The Legitimacy of Book Critics in the Age of the Internet and Omnivorousness: Expert Critics and Peer Critics in Flanders and the Netherlands', *European Sociological Review* 26(6): 623–637.

Vincent, D. (1981) *Bread, Knowledge and Freedom: A Study of Nineteenth Century Working Class Autobiography*. London: Methuen.

Virtanen, T. (2007) *Across and Beyond the Bounds of Taste*. Tampere: Turku School of Economics.

Warde, A., Wright, D. and Gayo-Cal, M. (2007) 'Understanding Cultural Omnivorousness or the Myth of the Cultural Omnivore', *Cultural Sociology* 1(2): 143–164.

Warde, A. Wright, D. and Gayo-Cal, M. (2008) 'The Omnivorous Orientation in the UK', *Poetics* 36: 148–165.

Warde, A. (2008) 'Dimensions of a Social Theory of Taste', *Journal of Cultural Economy* 3(1): 321–336.

Watts, P. (2010) 'Heretical History and the Poetics of Knowledge' in in J-P. Deranty (ed.) *Jacques Rancière: Key Concepts*. Durham: Acumen, pp. 104–115.

Webber, R. (2009) 'Response to 'The Coming Crisis of Empirical Sociology': An Outline of the Research Potential of Administrative and Transactional Data', *Sociology* 43(1): 169–178.

Wicks, R. (2007) *Kant on Judgment*. London: Routledge.

Williams, R. (2001/1961) *The Long Revolution*. Letchworth: Broadview Press.

Wintour, P. (2014) 'Poor Reading Could Cost UK £32bn in Growth by 2025', *Guardian*, 8 September.

Woolf, N. (2014) 'Man Develops Powerful Love of Johnny Cash Following Deep Brain Stimulation', *Guardian*, 27 May.

Wright, D. (2005) 'Mediating Production and Consumption: Cultural Capital and "Cultural Workers"', *British Journal of Sociology* 56(1): 106–121.

Wright, D. (2012) 'List-culture and Literary Taste in a Time of "Endless Choice"' in A. Lang (ed.) *From Codex to Hypertext*. Cambridge, MA: University of Massachusetts Press, pp. 108–123.

Wright, D., Purhonen, S. and Heikkilä, R. (2013) 'Comparing "Cosmopolitanism": Taste, Nation and Global culture in Finland and the UK', *Comparative Sociology* 12(3): 330–360.

Yudice, G. (2003) *The Expediency of Culture*. New York: Duke University Press.

Zavisca, J. (2005) 'The Status of Cultural Omnivorism: A Case Study of Reading in Russia', *Social Forces* 84: 1233–1255.

Index

CPSIA information can be obtained at www.ICGtesting.com
Printed in the USA
LVOW03*1927300715

448253LV00005B/26/P